Dog

teNeues

teNeues

Portraits of 88 Dogs & One Little Naughty Rabbit

by TEIN LUCASSON

—

Porträts von 88 Hunden
& einem kleinen ungezogenen Kaninchen

—

Ritratti di 88 Pinza
& un picolo Coniglietto Cattivo

introduction

———

On the cover of this book is Salty, a rescue greyhound who was abused in dog races. When she was no longer of any use, she was left behind not discarded. It reminds me of myself last year. My existence was turned upside down as well. Burnout, a failed marriage, and meanwhile I was preparing myself for the hardest thing I could ever imagine, saying goodbye to my biggest support during hard times: my precious dog Ventje McDoodle.

All his life my dog had seen me struggle in front of my computer; the financial crisis had hit me hard. Keeping my head above water as an independent designer was quite a struggle. I think I had been suffering from burnout for several years. Stopping a running train is not that easy. A force of nature and a prayer are the only things to do. See the crash make a wish and cross your fingers.

At the beginning of January, Ventje's kidney values were close to deadly and the vet tried to prepare me for our final goodbye. I decided I have had enough of working and I stopped everything. The time my dog and I had left was going to be "our time". I was afraid one day I would forget how soft his fur was, and what the awfully nice odor between his toes actually smelled like. Every morning we walked for two hours, and we tried to catch the late rays of winter light at the end of the day.

I could write a whole book about how much fun we had and how much love and dedication there was between human and dog, but I think I need to keep this text down to only two pages. It was a friendship that every good dog owner will recognise. This is exactly the reason why I started making these portraits. To catch a pet's character and remember this special love that is only between the owner and the pet. A pure love to remember for the rest of your life.

While outside there was a big storm, it felt like a good time inside the atelier where we lived. I will always remember it as a time of gentle goodbye in a true friendship that ended too early. Ventje was only nine when he passed away. 3 February 2019—to the day three years after I made his first l'animorphe portrait.

When Ventje had passed away I noticed how tired I was. For the last ten years I had worked for twelve hours a day seven days a week. I had seen everything I owned disappear. From a failed, unhappy marriage to losing my home and if bad luck hits you, you are not yourself anymore, so friendships slipped through my fingers. I was tired. So tired.

Because of my dog's condition it had always been difficult to travel. "See the world" was the dream I always had. I selected all my precious belongings and put them into boxes, tossed out a lot of clutter, sold all my furniture, and started my journey. The first direction was France. Some call it midlife crisis, others call it recovering from burnout. But it was just surviving. I needed to run away from it all in order to get some air, a lot of rest, and forget about the previous life I had led. While moving away, the deadline of the first book CAT came closer and closer. In the middle of my struggle, I realised what happened and I wrote my cat characters in four days. I had so many question marks and so much anger to express. It was the perfect material for creating my edgy cat characters in the cat book. I didn't realise how the cat owner must have felt when I made their sweet cat a casanova and had them die lonely.

The stories were written next to the artwork, not always about the pet. I apologised to the sweet Italian cat owner, and tried to keep it in mind while writing DOG. I knew a lot of the portrayed dogs in person, so it was more difficult to write in the same way about them. I tried to let myself be guided by the themes "recovering" and "friendship". I wrote

DOG halfway through my burnout recovery. Because my car broke down, I was stuck in a Spanish hotel that looked like a Twin Peaks setting. Another four days in which to write the core of the dogs. During writing, some anger was still there. So, some dogs have "issues", but I asked the owners if it was good to use an evil story next to their portraits. I got even with other customers that never paid for the art I made of their dog.

I really do hope teNeues (my publisher) is prepared for a follow-up on this DOG-book. I had to "kill some darlings" while selecting these 88 dog portraits for this book. Every last story is an autobiographic one.

With DOG I tried to use the actual story of the portrayed dog. My own McDoodle was the honest businessman. That is how I portrayed his first portrait. I was not strict enough and unable to tell him "no" during his life. He would have been a real spoiled arrogant royal, but this one had character and manners. He knew when to stop and what was expected from him. Two weeks before he died, I made another portrait, "the writer". I had no idea at the time that I was going to create the stories next to the artwork myself.

I miss my dog deeply but am so grateful he gave me the idea for this pet portrait project. After his passing I found a way to give myself grief therapy. I imagined him writing to me, what McDoodle would say to me looking from his cloud, I used the Instagram account I always used for my creative Ventje-outbursts. I couldn't let him go yet. This way I kept him alive. During my travels through Europe, a print of his portrait was looking through the back window. I showed him Europe. France, Germany, Switzerland, Spain, Portugal, and I made a little visit to Venice. If he could have been with me, he would have had great fun. I imagined that the beautiful coloured skies above the horizon were the "thank you" he gave after a beautiful day had ended.

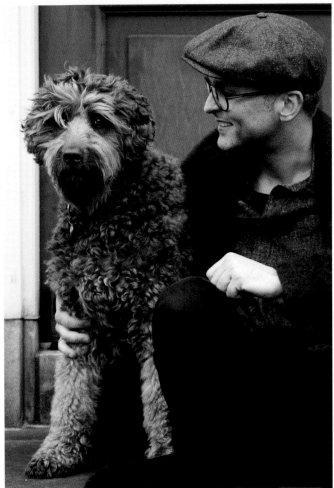

©mariebroeckman

Posing with a great and gentle businessman Ventje McDoodle. (DogPortrait #7) Ventje was the sweetest brown labradoodle and the very best friend I ever had! He never took advantage of your goodness. He protected me from pitbulls. I found out later he could sense my fears but didn't realise that caused him to act strangely. With the dogwalker, however, he played happily with the most dangerous dog breeds. He had a good sense of humour. He liked to tease chihuahuas. They responded in a hysterical manner and came after him barking. But he knew he was faster and always walked away with great flair. He caused me to change. It was my love for Ventje that inspired me to start this pet portrait project. I miss him every day. On days when I feel sad, I imagine him being around. I am so proud he came into my life.

Like Salty the greyhound who makes a wish in her story, I realise now that dreams only come true with complete focus and dedication. I thank Ventje Mcdoodle for pushing me in the right direction in following my heart. I have no idea what other force swapped me in this glorious exiting adventure.

TEIN LUCASSON

einführung

Vor etwa einem Jahr wurde mein Leben auf den Kopf gestellt. Ich bereitete mich auf das Schlimmste vor, das ich mir vorstellen konnte: darauf, von meiner größten Liebe Abschied zu nehmen, meinem geliebten Hund Ventje McDoodle.

Sein ganzes Leben lang war mein Hund bei mir, wenn ich am Computer arbeitete, daher traf mich diese Krise schwer. Mich als freier Designer über Wasser zu halten war eine echte Herausforderung. Ich glaube, ich hatte seit einigen Jahren einen Burn-out. Heutzutage ist die Vision eines Designers von den Bedürfnissen des Kunden-Egos abgelöst worden.

Anfang Januar waren Ventjes Nierenwerte gefährlich niedrig, und der Tierarzt versuchte, mich aufs Abschiednehmen vorzubereiten. Ich beschloss, dass ich genug gearbeitet hatte, und sagte alles ab. Die Zeit, die uns noch blieb, sollte uns gehören. Ich fürchtete, eines Tages zu vergessen, wie weich sein Fell war und wie der schrecklich-schöne Duft zwischen seinen Zehen roch. Jeden Morgen gingen wir ein paar Stunden spazieren, und am Ende des Tages versuchten wir, die letzten Strahlen des Winterlichts zu erhaschen.

Ich könnte ein ganzes Buch darüber schreiben, wie viel Spaß wir hatten und wie viel Liebe und Hingabe zwischen Mensch und Hund herrschten, muss mich aber hier auf zwei Seiten beschränken. Es war eine Freundschaft, die sicherlich jeder, der einen Hund hat, kennt. Genau deshalb habe ich die Porträts dieses Buches kreiert, die den Charakter einfangen und diese besondere Liebe auf eine Art in Erinnerung rufen, die nur ein Tierbesitzer versteht – eine wahre Liebe, an die man sein Leben lang zurückdenkt.

Stets werde ich mich liebevoll an meinen sanften Abschied von einer wahren Freundschaft erinnern, die zu früh endete. Ventje war erst neun, als er am 3. Februar 2019 starb, auf den Tag genau drei Jahre, nachdem ich sein erstes L'animorphe-Porträt angefertigt hatte.

Nach seinem Tod merkte ich, wie müde ich war. In den letzten zehn Jahren hatte ich rund um die Uhr gearbeitet. Ich sah, wie mir alles, was ich hatte – Haus, Ehe, wertvolle Freundschaften – entglitt. Ich war müde. So müde.

Wegen meines kranken Hundes war es bislang schwierig gewesen, zu reisen und die Welt zu sehen, wie ich es mir immer erträumt hatte. Also packte ich alles, was von Wert war, in Kisten, warf eine Menge Gerümpel weg, verkaufte meine Möbel und ging auf Reisen. Manche nennen es Midlife-Crisis, andere Erholung vom Burn-out. Ich nenne es Überleben. Ich musste fliehen, Frieden finden und mein früheres Leben vergessen. Mein erstes Ziel war Frankreich.

Während ich unterwegs war, rückte der Abgabetermin meines ersten Buches, *Cat*, immer näher. In jener schwierigen Zeit hatte ich sehr viele Fragezeichen und war voller Zorn – perfektes Material für die Gestaltung meiner Katzenfiguren im Buch *Cat*. Die Geschichten in *Dog* sind anders. Mir war vorher nicht klar, wie ein Katzenbesitzer sich gefühlt haben muss, als ich seine süße Katze zu einem Casanova machte und einsam sterben ließ.

Die Katzengeschichten wurden über das Kunstwerk geschrieben, nicht immer über die Katze selbst. Ich entschuldigte mich bei der netten italienischen Katzenbesitzerin und versuchte, diesen Ansatz beim Schreiben von *Dog* im Kopf zu behalten. Viele der porträtierten Hunde kannte ich persönlich. Es war schwieriger, genauso über sie zu schreiben wie über die Katzen. Ich versuchte, mich von „Freundschaft" leiten zu lassen. *Dog* schrieb ich, als ich halbwegs von meinem Burn-out genesen war und noch etwas Zorn in mir trug, sodass einige Hunde „Probleme" haben. Für diese Porträts nahm

ich Hunde, deren Besitzer meine Arbeit nicht bezahlt hatten – eine süße Rache dafür, dass sie einen Künstler kostenlos hatten arbeiten lassen. Ausnahmen gibt es: Ich fragte Julie, eine französische Journalistin, ob ich ihre liebe Queenie in einen dunklen, bösen Charakter verwandeln durfte. Böse Königinnen und Könige fehlten mir noch im Buch.

Ich hoffe sehr, dass der teNeues-Verlag eines Tages die Fortsetzung des *Dog*-Buches herausbringen möchte. Ich habe weit mehr als die 88 Hundeporträts, die in diesem Buch Platz finden. Deshalb hoffe ich, dass ich eines Tages die Gelegenheit erhalte, ein weiteres Hundebuch zu kreieren. Jede letzte Geschichte ist autobiografisch. Sie können sich vorstellen, wer das kleine weiße Kaninchen ist.

Bei *Dog* versuchte ich, möglichst nah am realen Charakter des Hundes zu bleiben. Mein eigener McDoodle war der Geschäftsmann – so habe ich ihn in seinem ersten Porträt dargestellt. Zu seinen Lebzeiten konnte ich nie „Nein" zu ihm zu sagen: Es fehlte mir an Rückgrat. Er hätte ein wirklich verwöhnter, arroganter Royal sein können, aber er hatte Manieren. Er wusste, wann Schluss war und was von ihm erwartet wurde. Zwei Wochen vor seinem Tod habe ich ein weiteres Porträt von ihm angefertigt: Der Autor. Ich hatte keine Ahnung, dass ich die Geschichten selbst schreiben würde.

Ich vermisse ihn sehr, bin aber zutiefst dankbar, dass er mich zu diesem Tierporträt-Projekt inspiriert hat. Nach seinem Tod stellte ich mir vor, dass McDoodle mir schrieb oder von seiner Wolke aus auf mich herabblickend zu mir sprach. Ich benutzte seinen Instagram-Account, den ich immer für meine kreativen „Attacken" nahm, um mir eine kleine Hundetherapie zu gönnen. Ich konnte ihn noch nicht gehen lassen. Also hielt ich ihn am Leben. Eine Kopie seines Porträts blickte durch die Heckscheibe. Ich zeigte ihm Europa: Frankreich, Deutschland, die Schweiz, Spanien, Portugal und in einem Kurztrip noch Venedig. Hätte er

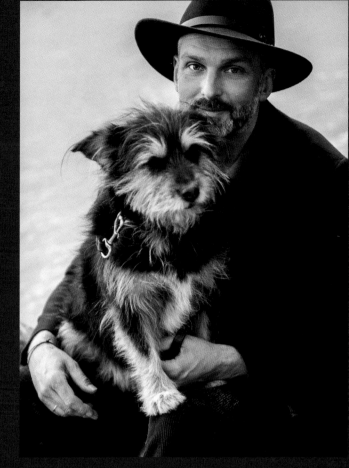

This is Coco; the dominatrix (DogPortrait #12). Traumatised Coco had evil plans and powers over my sweet and gentle Ventje. He was included in her cruel strategies to hurt other dogs. She told him who to bark at. Coco was a Romanian sweetheart with obviously a very bad pup-hood. She snapped if you offered her your hand. It was sad to see as she felt ashamed right after. I dog-watched Coco shortly after Ventje passed away. I am happy she trusted me completely and thankful I was her dog-walker those first weeks of being a dog-widower. I needed comfort and cuddles in those moments when I missed my dog so much. Coco also seemed a comical talent. I made several funny movies with her. She agreed on everything and starred in them like a pro.

dort sein können, hätte ihm die Reise gefallen. Ich stellte mir vor, dass der schöne, farbenfrohe Himmel über dem Horizont sein „Danke" am Ende eines schönen Tages war.

Ich weiß jetzt, dass Träume nur mit voller Fokussierung und Hingabe wahr werden, und danke Ventje McDoodle, dass er mich in die richtige Richtung gestoßen hat, nämlich, meinem Herzen zu folgen. Nichts anderes hat mich in diesem herrlichen, aufregenden Abenteuer angetrieben.

TEIN LUCASSON

introduzione

Circa un anno fa, la mia esistenza è stata stravolta. Mi stavo preparando all'esperienza più dura che avrei mai potuto immaginare, ovvero dire addio al mio più grande amore: il mio adorato cane, Ventje McDoodle.

Ha trascorso tutta la sua vita accanto a me, mentre lavoravo al computer; quindi questo momento è stato per me molto duro. Come designer indipendente, continuare a lavorare come se niente fosse accaduto è stata una vera sfida. Penso di aver vissuto una sorta di esaurimento per vari anni. Oggi le necessità dell'ego di un cliente superano la visione di un designer.

A inizio gennaio i valori epatici di Ventje erano pericolosamente bassi e il veterinario cercò di prepararmi al peggio. Decisi di interrompere ogni attività lavorativa. Il tempo che ci restava sarebbe stato solo nostro. Temevo che un giorno avrei dimenticato il suo morbido pelo e l'odore terribilmente meraviglioso che emanavano le dita delle sue zampe. Ogni mattina camminavamo per un paio d'ore per catturare gli ultimi raggi offerti dalla luce invernale del giorno.

Potrei scrivere un intero libro su quanto ci siamo divertiti e su quanto amore e dedizione possano esistere tra un uomo e un cane. Tuttavia mi sono impegnato a non superare le due pagine di introduzione. È stata un'amicizia a cui ogni persona che abbia avuto un cane è grata. Ed è esattamente per tale motivo che ho realizzato questi ritratti, catturando il carattere e ricordando questo amore speciale in un modo che solo chi possiede un animale può capire, un amore autentico da ricordare per il resto della vita.

Ricorderò sempre con enorme commozione il mio delicato addio a una vera amicizia, finita troppo presto. Ventje aveva solo nove anni quando mi ha lasciato il 3 febbraio 2019, esattamente tre anni dopo la realizzazione del mio primo ritratto L'animorphe.

Dopo la sua scomparsa, mi sono ritrovato molto stanco. Negli ultimi dieci anni avevo lavorato sette giorni a settimana, dodici ore al giorno. Vedevo scivolarmi tra le dita tutto quel che possedevo, la mia casa, il mio matrimonio e amicizie preziose. Ero stanco. Stanchissimo.

A causa della malattia del mio cane, mi era stato difficile viaggiare e vedere il mondo come avevo sempre sognato fare. Così ho messo negli scatoloni le mie cose più preziose, mi sono liberato di tante altre cose inutili, ho venduto i mobili e sono partito per un viaggio. Alcuni la chiamano crisi di mezza età, altri recupero dopo un esaurimento. Io la chiamo sopravvivenza. Dovevo fuggire via, cercare pace e dimenticare la mia vita precedente. La prima destinazione fu la Francia. Mentre ero in viaggio, si avvicinava sempre di più la scadenza del mio primo libro Gatto. Durante questo periodo difficile, avevo tanti interrogativi e molta rabbia, il materiale perfetto per creare i miei personaggi felini nel libro a loro dedicato. Le storie di Dog sono diverse. Non ho pensato come avrebbero reagito i proprietari quando ho fatto del loro adorabile micio un Casanova, destinato a morire in solitudine.

Le storie dei gatti sono state scritte intorno all'opera d'arte, non sempre intorno al gatto. Mi sono scusato con la gentilissima signora italiana e ho cercato di ricordarmi tutto questo nella scrittura di Dog. Sapevo molte cose dei cani ritratti grazie a contatti diretti e personali, per questo è stato più difficile scrivere di loro. Ho cercato di lasciarmi guidare "dall'amicizia". Ho scritto Dog a metà del mio percorso di recupero dall'esaurimento, quando avevo ancora dentro un po' di rabbia; per questo alcuni cani sono "problematici". Ho utilizzato i ritratti per i quali non sono mai stato pagato dai proprietari, una dolce vendetta per aver fatto lavorare gratis un artista. Vi sono tuttavia

alcune eccezioni: Ho chiesto a Julie, una giornalista francese, di poter trasformare la sua dolce Queenie in un personaggio cupo e spietato. Mi mancavano soggetti cattivi per il libro.

Spero vivamente che Teneues (il mio editore) sia pronto, un giorno, per un seguito di questo libro dedicato ai cani. Dispongo di molti di più degli ottantotto ritratti inseriti in questa pubblicazione. Spero quindi di avere la possibilità di realizzare un altro libro in futuro. Ogni ultima storia è un racconto autobiografico. Potete dunque immaginare chi sia il piccolo coniglio bianco.

Con Dog, ho cercato di restare fedele al vero carattere di ciascun cane. Il mio McDoodle è l'uomo d'affari. È così che l'ho raffigurato nel suo primo ritratto. Non sono un tipo impositivo e non sono mai stato in grado di dirgli "no" in tutta la sua vita. Sarebbe potuto essere assolutamente viziato, regale e arrogante, ma in realtà era molto educato. Sapeva quando fermarsi e cosa ci si aspettava da lui. Due settimane prima di morire, ho realizzato un altro ritratto con lui, lo scrittore. Non avevo idea che avrei scritto io stesso le storie.

Mi manca moltissimo, ma gli sono estremamente grato per avermi dato l'idea di realizzare questo progetto di ritratti di animali da compagnia. Dopo la sua morte, l'ho immaginato a scrivermi; cosa mi avrebbero detto McDoodle dalla sua nuvoletta? Ho usato il suo account Instagram, che mi è sempre servito per le mie incursioni creative per fare un po' di "dog therapy". Non potevo ancora lasciarlo andare. Così l'ho mantenuto in vita. Una stampa del suo ritratto osserva il mondo dal finestrino posteriore. Gli ho fatto conoscere l'Europa: Francia, Germania, Svizzera, Spagna, Portogallo e una breve escursione a Venezia. Se fosse stato qui, avrebbe amato questo viaggio. Ho immaginato che i meravigliosi e colorati cieli sull'orizzonte fossero il suo "grazie" al termine di una bellissima giornata.

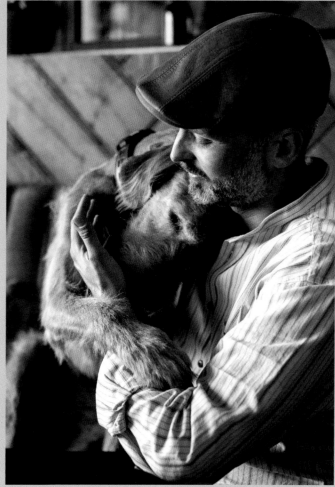

©mariebroeckman

Posing with the all-time charmer Pastis. (DogPortrait # 34) Pastis was a charmer and a cuddle nut. Ventje didn't trust him but accepted him. To Pastis it didn't matter who or what you were. Hugs were for free. But Coco couldn't stand him. She thought it was her job to watch over me especially in my time of need after Ventie died. The night before this photoshoot, both Coco and Pastis slept at my apartment because of the early start of the day. Coco, the little bitch, created a big scene which the neighbours still talk about.

Adesso so che i sogni si avverano solo con tanta attenzione e dedizione. Ringrazio Ventje McDoodle per avermi spinto nella direzione giusta per seguire il mio cuore. Non ho idea di quale altra forza mi abbia potuto condurre in questa gloriosa avventura.

TEIN LUCASSON

№ 1
salty
#*THE SALTY HOUND*

She could not remember when she was buying the ticket for that train. Slowly it went from slow to high speed. Everyone in it had no idea if going so fast was such a smart idea. It looked like a slow-motion scene from an action movie. When the train derailed, Salty crossed her fingers and made a wish. Thank dog she survived the crash. From that moment on, luck seemed to always be with her. Queen Salty may act like she was born with a silver spoon in her mouth, but she will never forget the other side of luck where she stayed. Her cool appearance inspires many digital viewers.

Sie erinnerte sich nicht, wann sie das Ticket für den Zug gekauft hatte. Er steigerte sich vom Bummeltempo zur Hochgeschwindigkeit. Keiner wusste, ob es klug war, so schnell zu fahren. Es war wie eine Actionfilmszene in Zeitlupe. Als sie entgleisten, kreuzte Salty die Finger und wünschte sich etwas. Gott sei Dank überlebte sie den Crash. Von da an war das Glück stets mit ihr. Queen Salty verhält sich, als sei sie mit einem Silberlöffel im Mund geboren worden, doch nie vergisst sie die Kehrseite des Glücks, wo sie früher war. Ihre kühle Art inspiriert viele, die Aufnahmen von ihr sehen.

Non ricordava il momento in cui aveva comprato il biglietto per quel treno. Lentamente passò da lento a velocissimo. Nessuno dei passeggeri sapeva se andare così veloce fosse una buona idea. Sembrava una scena in slow-motion di un film d'azione. Quando il treno deragliò, Salty incrociò le dita ed espresse un desiderio. Grazie al cielo (dei cani) sopravvisse all'incidente. Da quel momento la fortuna sembrò non abbandonarla mai. Potrebbe sembrare che la regina Salty sia nata con la camicia, ma non dimenticherà mai l'altro lato della fortuna, che aveva personalmente conosciuto. Il suo aspetto interessante ispira molti utenti digitali.

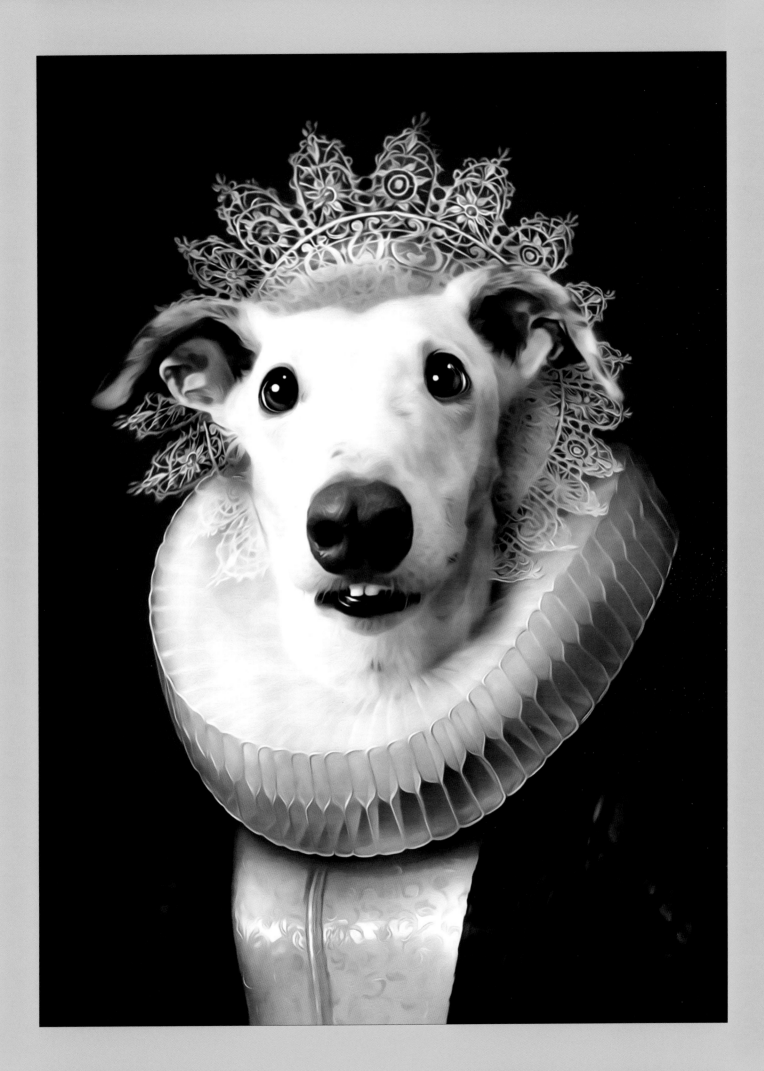

№ 2
ΛΤΗΣΝΛ

———

One misty morning, Athena and her family were
running in the woods. Running in the wild was what
she liked most. The group had no idea what horror
was about to happen when they entered the open
field with the big tree. Athena was the only one to
survive the unfair attack. When she recovered, she
decided to dedicate her energy to showing the world
what had happened, so others could unite
and prevent these kinds of horrifying rituals.

———

Eines nebligen Morgens liefen Athena und ihre
Familie durch den Wald. In der Natur umhertollen,
das taten sie am liebsten. Als sie zu einem freien Feld
mit einem Baum kamen, ahnten sie nicht, welches
Grauen ihnen bevorstand. Athena war die einzige
Überlebende des unfairen Angriffs. Geheilt, setzte sie
ihre Energie dafür ein, das Geschehene in der Welt
publik zu machen, damit andere gemeinsam solch
schlimme Rituale verhindern können.

———

Una nebbiosa mattina, Athena e la sua famiglia
stavano correndo nel bosco. Correre nella natura
selvaggia era ciò che amava di più. Il gruppo non
aveva idea di quale orrore avrebbe vissuto una volta
entrato in un campo aperto con un grande albero.
Athena fu l'unica a salvarsi in quello sleale agguato.
Quando si riprese, decise di dedicare le proprie
energie per mostrare al mondo ciò che era successo
affinché gli altri potessero unirsi ed evitare
questi orrendi rituali.

———

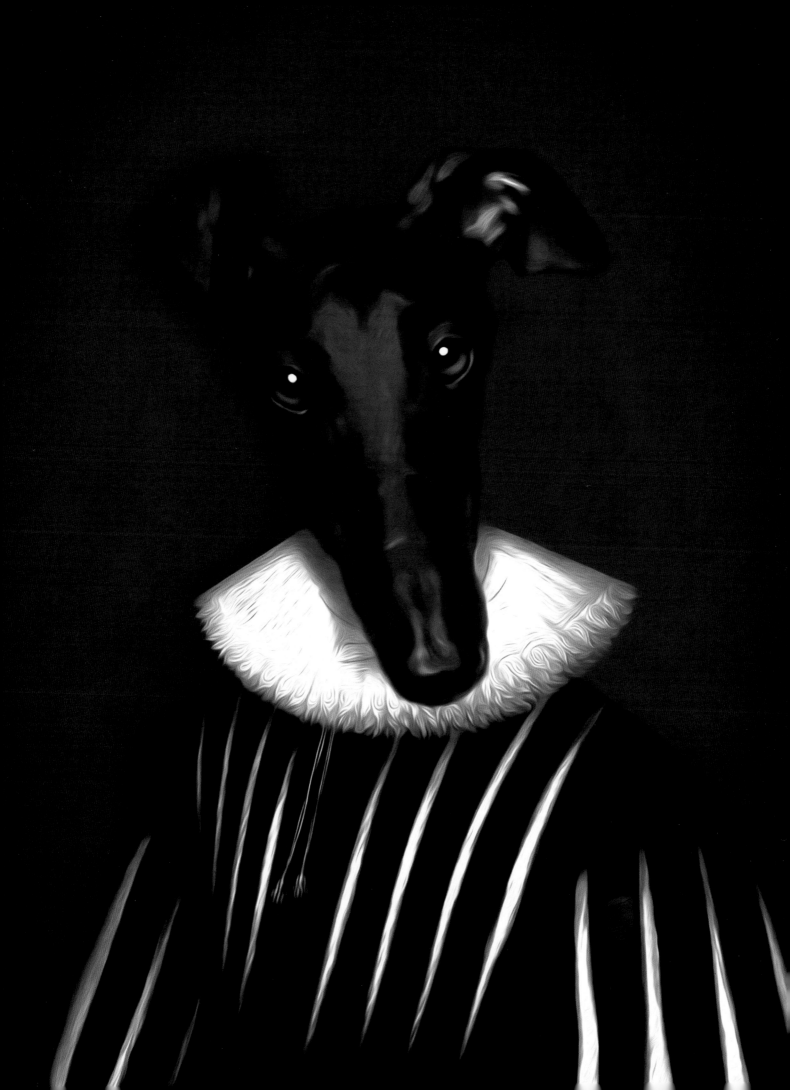

№ 3
Boris

———

He grew up on a farm, the youngest son of a big family
with lots of siblings. It was only after a long period of
studying and working in a stable but boring office job,
that he realised how wonderful life was on the farm
where he grew up. All the seasons passed by in their
own beauty. Tough but fair decisions about life, and
also death, were what really mattered to him. He didn't
have to think twice when his father asked who would
be interested in taking over the business.

———

Als jüngster Sohn einer großen Familie wuchs er mit
vielen Geschwistern auf einem Bauernhof auf. Doch
erst nach langem Studium und einem guten, aber öden
Bürojob erkannte er, wie schön das Leben auf dem
Hof gewesen war. Jede Jahreszeit kam und ging mit
der ihr eigenen Schönheit. Kompromisslose, aber faire
Entscheidungen in Bezug auf das Leben und auch den
Tod zu treffen, darauf kam es ihm an. Als sein Vater alle
fragte, wer den Betrieb übernehmen wollte, brauchte
er nicht nachzudenken.

———

Era cresciuto in una fattoria, dove era il figlio minore
di una grande famiglia con tanti fratelli. Fu solo dopo
lunghi anni di studio e impiego in un ottimo lavoro
d'ufficio - però molto noioso - che si rese conto di
quanto fosse meravigliosa la vita in quella fattoria.
Tutte le stagioni passarono con la loro bellezza. Le
decisioni dure ma giuste sulla vita - e anche la morte
- erano ciò che davvero gli importava. Non ci pensò
due volte quando suo padre chiese a tutti chi fosse
interessato a prendere in mano l'azienda di famiglia.

———

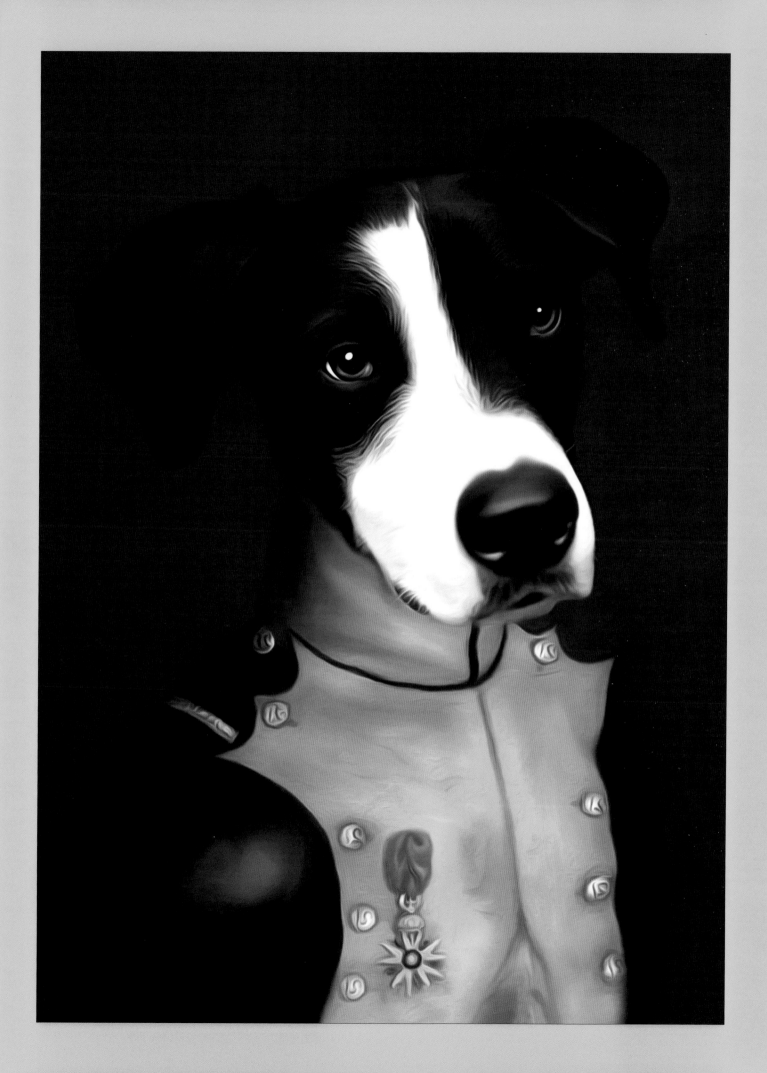

Hank

———

He was born into a family of hunters. When he was a kid, his dad already planned what his job would be. But Hank didn't have any given talents in the game of hunting. He didn't want to kill or eat meat. Not only for his own health, but also to contribute to a better world. Unfortunately, he knew he would never be able to convince the rest of his family. Hank decided to be diplomatic and not waste his wisdom on the primitive minds of his relatives. Saving the world cannot be done by only one man, so he made a plan for a far larger audience.

———

In seiner Familie waren alle Jäger. Schon als Hank noch ein Knirps war, plante sein Vater, dass er dieser Arbeit später nachgehen sollte. Doch Hank hatte kein Talent fürs Jagen. Er wollte weder töten noch Fleisch essen. Nicht nur wegen seiner Gesundheit, sondern auch, um die Welt zu verbessern. Leider wusste er, dass er die anderen nicht überzeugen konnte. Hank blieb diplomatisch und drängte den Verwandten mit ihrem primitiven Denken seine Einsicht nicht auf. Weil einer allein die Welt nicht retten kann, plante er, ein viel größeres Publikum anzusprechen.

———

Era nato in una famiglia di cacciatori. Da piccolo, suo padre aveva già pianificato quello che sarebbe stato il suo lavoro, ma Hank non aveva particolari talenti nella caccia. Non voleva uccidere né mangiare carne, non solo per motivi di salute, ma anche per contribuire a un mondo migliore. Sfortunatamente sapeva che non sarebbe mai stato in grado di convincere gli altri. Hank ha deciso di essere diplomatico e non imporre la sua saggezza sulle menti primitive dei suoi parenti. Una sola persona non può salvare il mondo, così ha fatto un piano destinato a molte più persone.

———

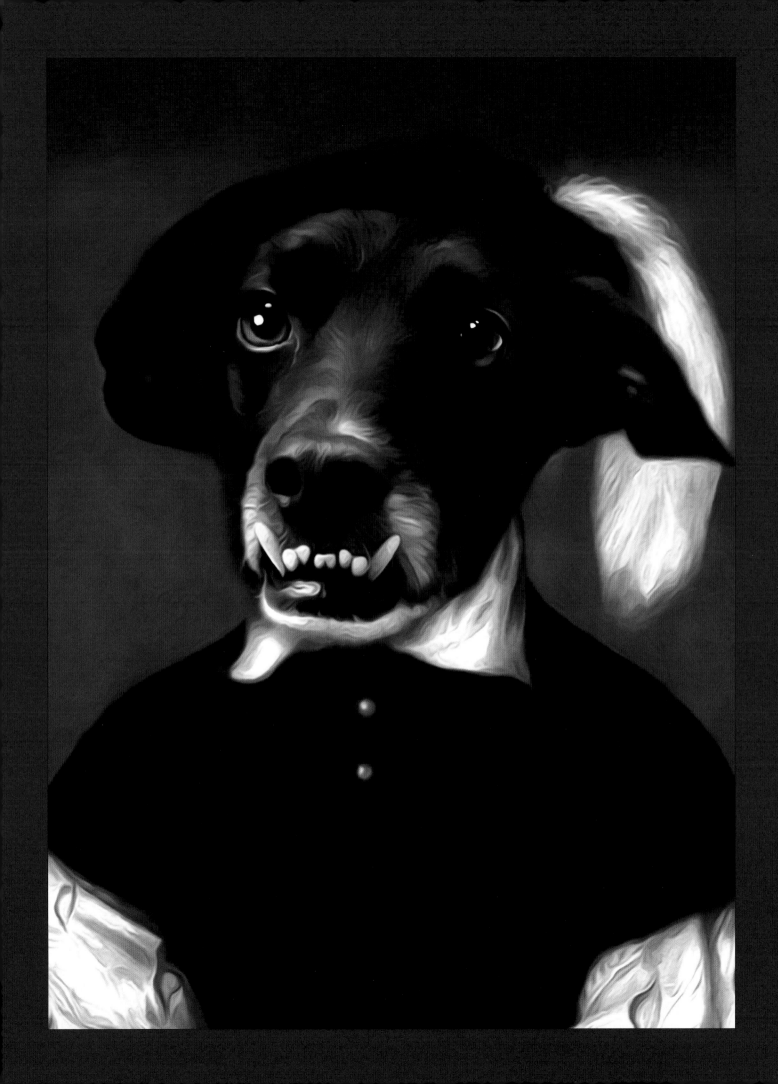

№ 5
Pepe

—

Acting like a clown was always fun for Pepe. Pretending he was the silly one worked for a long time. Then when he grew older, he realised he was thinking about things that happened and became smarter. He had something to say but no-one valued his acquired knowledge. Dropping his funny appearance and changing his entourage helped him to become a wise and respected citizen. He never spoke about being a clown in his younger years. It was only in difficult situations that he sought comfort in his old clownish repertoire.

—

Pepe spielte seit jeher gern den Clown. Sich unbedarft geben funktionierte lange. Mit dem Älterwerden merkte er aber, dass er mehr über Geschehnisse nachdachte und verständiger wurde. Er hatte etwas zu sagen — doch niemand schätzte sein erworbenes Wissen. Also gab er sein lustiges Auftreten auf, wechselte das Publikum und wurde ein Mitbürger, der für seine Klugheit respektiert wird. Er erwähnte nie, dass er in seiner Jugend ein Clown war. Nur in schwierigen Situationen kehrte er zu seinem alten Clown- repertoire zurück.

—

Comportarsi come un clown era sempre stato divertente per Pepe. Fare finta di essere lo sciocco aveva funzionato per molto tempo, ma una volta cresciuto, si accorse di pensare alle cose del passato e divenne più intelligente. Aveva qualcosa da dire ma nessuno apprezzava le sue nuove conoscenze. L'abbandono del suo buffo aspetto e un cambio di pubblico lo aiutò a diventare un cittadino saggio e rispettato. Non parlò mai più del suo ruolo di clown negli anni di gioventù. Solo nelle situazioni di difficoltà talvolta tornava al suo vecchio repertorio clownesco.

—

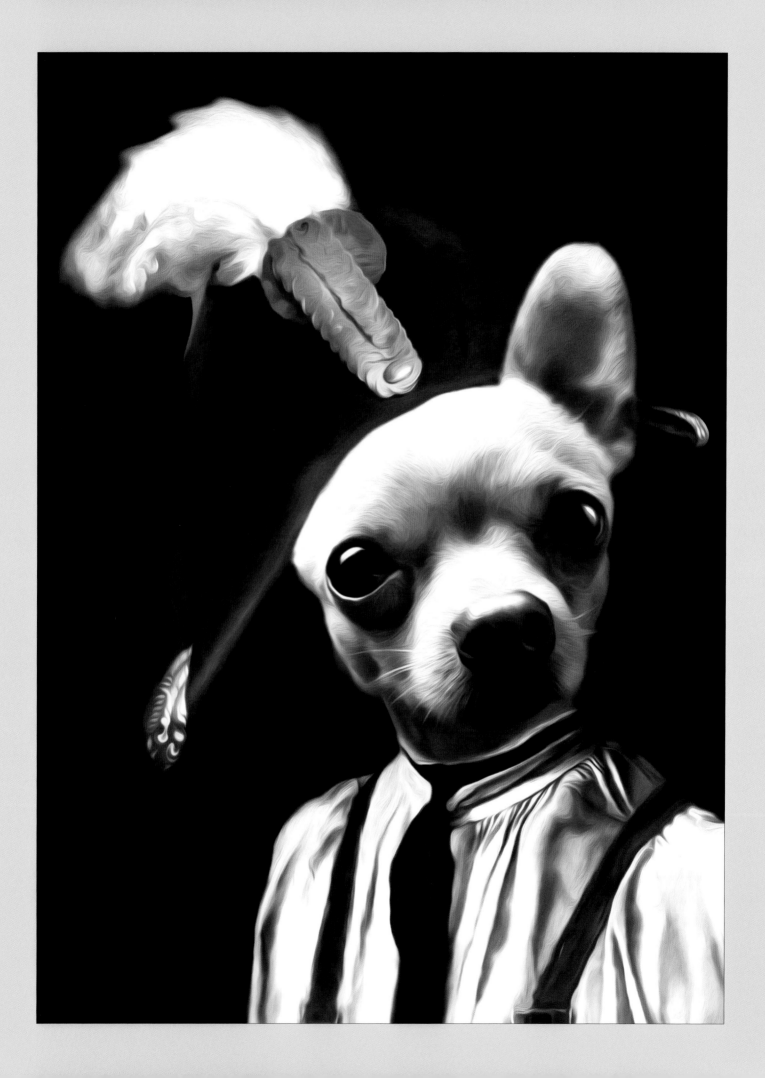

nº 6
Remendado

———

He dreamed of being on stage one day, of singing in front of a large audience. He had what was needed to achieve that: talent, dedication, and stunning looks. But being afraid of failing took over from all the rest. Meanwhile, he managed to find another way to get attention. He didn't know that having a dream and not choosing from the heart comes with nasty side effects. Trusting in himself and believing that dreams really do come true was all that he needed. Poor Remendado needed to learn to play the second violin.

———

Er träumte davon, eines Tages auf der Bühne vor großem Publikum zu singen. Dazu hatte er alles: Talent, Hingabe und tolles Aussehen. Doch die Angst zu scheitern war größer. Einstweilen fand er einen anderen Weg, Aufmerksamkeit zu erhalten. Ihm war nicht klar: Einen Traum zu haben und nicht von Herzen zu wählen hat üble Nebenwirkungen. Er brauchte doch nur auf sich zu vertrauen und zu glauben, dass Träume wirklich wahr werden. So musste der arme Remendado lernen, die zweite Geige zu spielen.

———

Sognava di salire sul palcoscenico un giorno, per cantare davanti a un grande pubblico. Aveva tutto quel che serviva: talento, dedizione e look incredibili. Ma il timore di cadere s'impose su tutto il resto. Nel frattempo trovò un altro modo per ottenere l'attenzione. Non sapeva che avere un sogno e non scegliere con il cuore può avere spiacevoli effetti collaterali. Avere fiducia in sé e credere che i sogni si realizzano davvero era tutto ciò di cui aveva bisogno. Il povero Remendado dovette imparare a suonare come secondo violino.

———

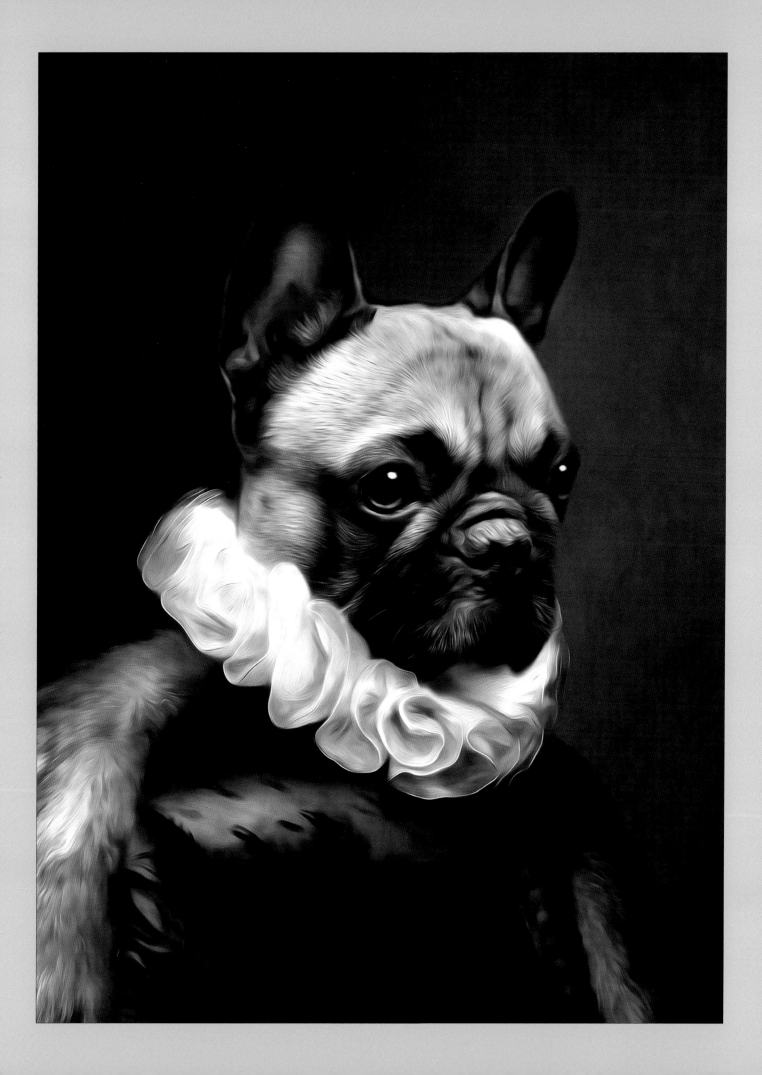

n⁰ 7
ventje

It became his hobby to get the maximum out
of a deal. With his honest-looking light-brown
eyes and gentle smile he negotiated reaching deals
where both parties were completely satisfied.
He was aware of his powerful features. Who could
say "no" to this friendly gentleman? When doing
business with him, it still feels like he is your
very best friend.

Es ist zu seinem Hobby geworden, das Maximum
aus einem Deal herauszuschlagen. Mit seinen
ehrlichen hellbraunen Augen und sanftem Lächeln
verhandelt er so, dass am Ende beide Seiten
rundum zufrieden sind. Er ist sich seiner Stärken
bewusst. Wer könnte „Nein" zu diesem netten
Herrn sagen? Bei Geschäften mit ihm ist es,
als sei er ein guter Freund.

Trarre il massimo da un affare è diventato il
suo hobby. Con il suo aspetto onesto, occhi color
marrone chiaro e un sorriso gentile, riesce a
negoziare affari in cui entrambe le parti sono
completamente soddisfatte. È consapevole delle
sue stupefacenti capacità. Chi potrebbe dire "no"
a questo gentleman cordiale? Quando fate affari
con lui avrete la sensazione di essere il suo
migliore amico.

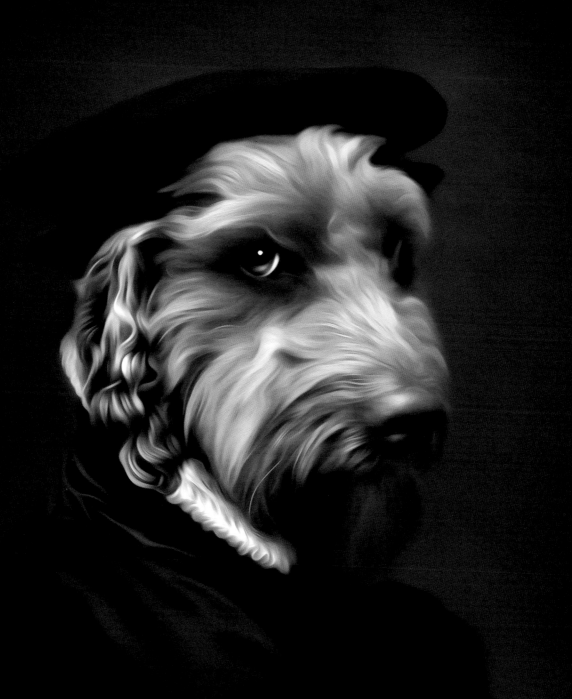

№ 8
Jelle

His mom wants him to be a big boy who stands
up for himself. Being a good kid, he really has
tried to fulfill her expectations, but it has been
very uncomfortable. He has tried to be tough,
but he is not built big and strong like his best
friend. Jelle prefers drinking tea with mom and
watching Scandinavian crime shows on
Netflix. He likes his simple life at home.

Seine Mutter will, dass er ein großer,
selbstbewusster Junge ist. Als braves Kind
hat er sich bemüht, dem gerecht zu werden,
aber mit großem Unbehagen. Er hat versucht,
hart zu sein, ist aber nicht groß und stark, so wie
sein bester Freund. Jelle trinkt lieber Tee mit seiner
Mutter und sieht dabei skandinavische Krimis
auf Netflix. Er mag ein einfaches Leben und
ist gern zu Hause.

Sua madre vuole che sia un ragazzo grande
che sa badare a se stesso. Da bravo bambino,
ha cercato davvero di soddisfare le sue attese,
ma si è sentito molto a disagio. Ha cercato di essere
duro, ma non ha un fisico grande e forte come il
suo migliore amico. Jelle preferisce bere tè con sua
madre e guardare thriller nordeuropei su Netflix.
Ama la sua vita semplice e stare a casa.

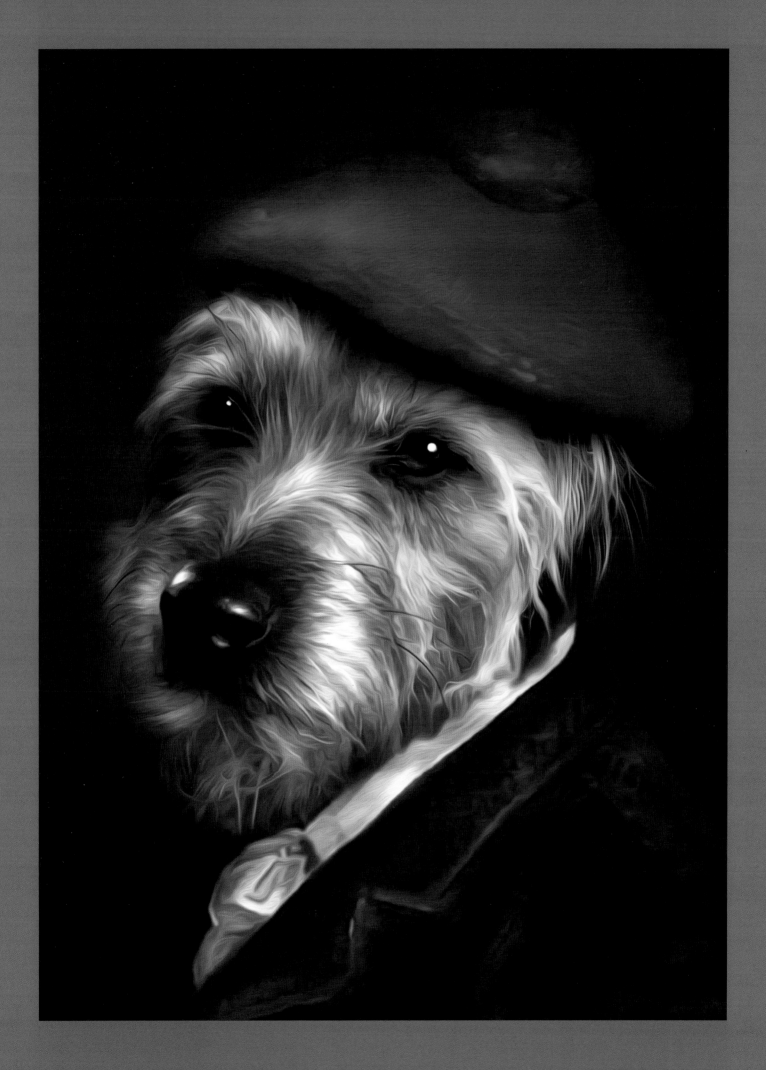

№ 9
coos

————

Little Coos knew she was not the best swimmer, but she dreamed of a life at sea far away from the boring town where she was born. It would have been useful to take some extra swimming classes before starting her journey at sea. However, a cruel act of nature caused all souls to vanish from the ship. To be able to cope with their huge loss, all her relatives imagine Coos with a big smile on her face just before the tragic incident happened.

————

Die kleine Coos wusste, dass sie nicht allzu gut schwimmen konnte, aber sie träumte von einem Leben auf See, fern von ihrer langweiligen Geburtsstadt. Einige Schwimmstunden vor ihrer Seereise hätten dazu normalerweise ausgereicht. Doch ein grausamer Akt der Natur vernichtete alles Leben auf dem Schiff. Um ihren großen Verlust zu verkraften, stellen sich all ihre Verwandten vor, dass kurz vor der Tragödie ein breites Lächeln auf Coos' Gesicht lag.

————

La piccola Coos sapeva di non essere una fantastica nuotatrice, ma sognava una vita in mare lontano dalla noiosa cittadina in cui era nata. Sarebbe stato sufficiente prendere qualche lezione aggiuntiva di nuoto prima di iniziare il suo viaggio in mare. Ma un crudele intervento della natura spazzò via tutte le anime presenti sull'imbarcazione. Per far fronte alla loro grave perdita, tutti i suoi parenti immaginano Coos con un grande sorriso poco prima del tragico incidente.

————

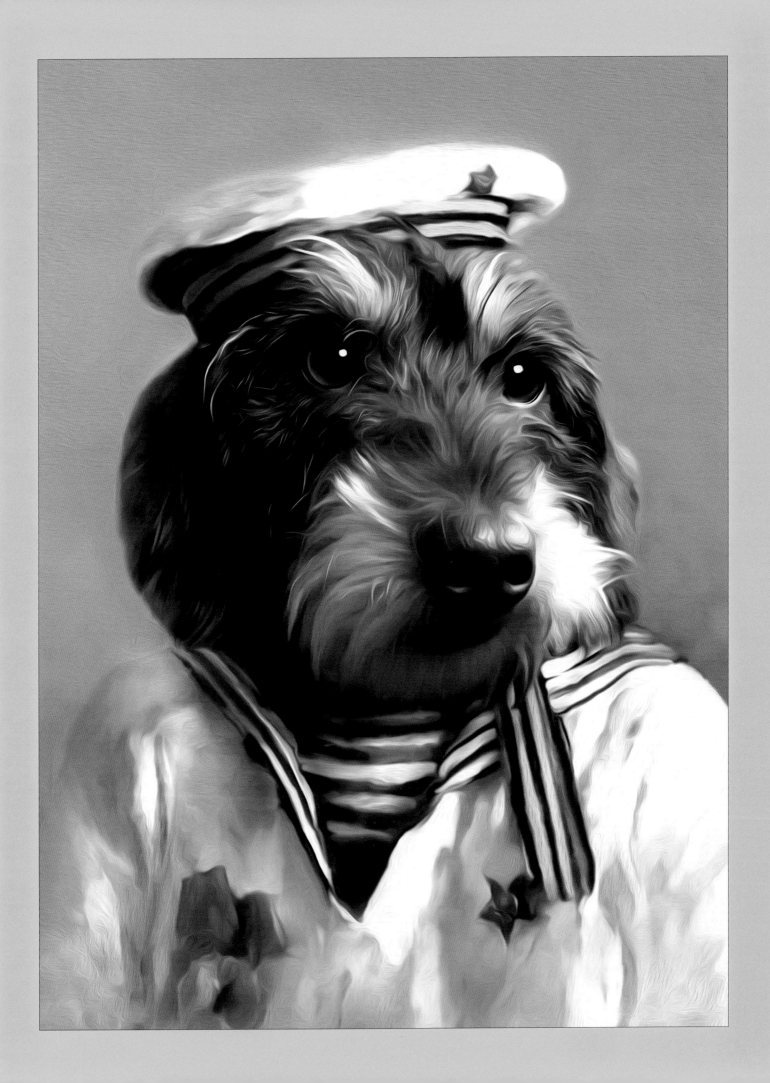

nº 10
DORA

She is a private spirit who likes to be on her own.
She doesn't dislike others, but she is careful when
selecting the people with whom she spends time.
Trust is something that is earned for Dora.
A good investment in her eyes is having good
times with the ones she has carefully chosen
herself. Dora is a wise girl who doesn't like
"clutter" in things and people.

Sie ist reserviert und gern allein. Nicht, dass sie
etwas gegen andere hätte, aber sie sucht sich die,
mit denen sie Zeit verbringen möchte, sorgfältig
aus. Vertrauen muss man sich verdienen.
Aus ihrer Sicht ist es lohnend, Spaß mit denen
zu haben, die sie selbst wählt. Dora ist ein
kluges Mädchen, „Wirrwarr" bei Dingen und
Menschen mag sie nicht.

È una persona riservata, che ama stare per conto
proprio. Non disprezza gli altri, ma sceglie con
attenzione le persone con cui ama trascorrere
il suo tempo. La fiducia va guadagnata. Un buon
investimento, ai suoi occhi, è trascorrere bei
momenti con le persone che sceglie lei stessa.
Dora è una ragazza saggia che non ama la
"confusione" nelle cose e nelle persone.

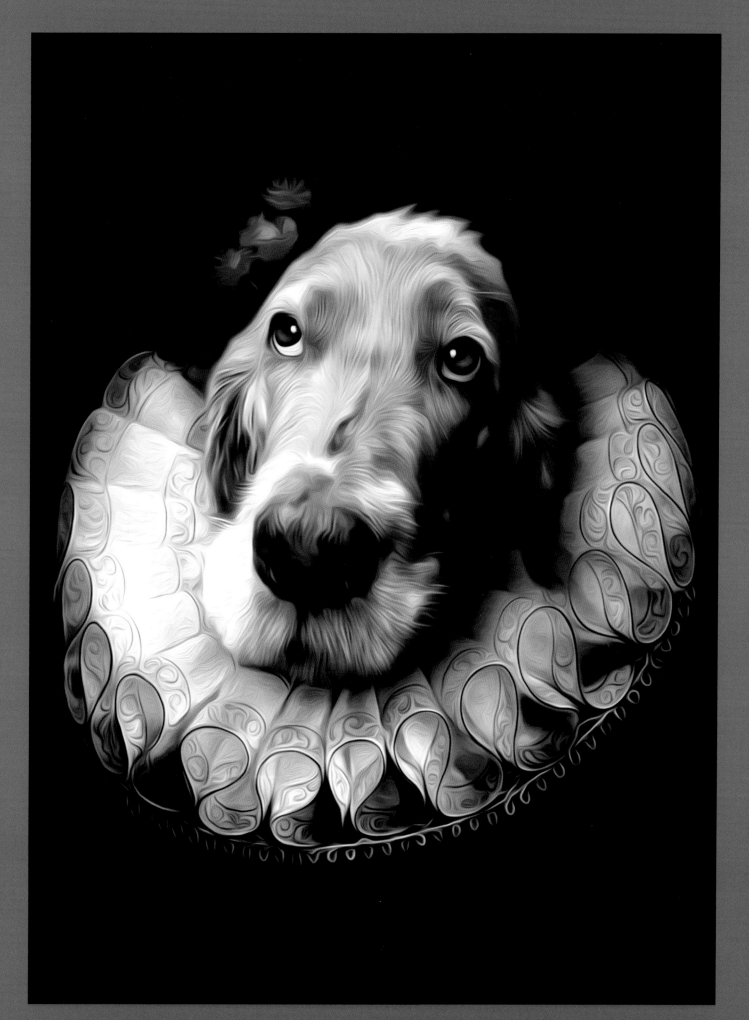

№ 11
Milo

———

He is proud and strong and has a great sense
of humour. These characteristics lead him to
places and into situations that many writers of
adventure books would like to dig into. For Max,
these funny encounters have become ordinary.
A happy spirit doesn't have the need to show off
to other beings, but loves to tell a good story
when asked for.

———

Er ist stolz, stark und hat einen tollen Humor.
Der bringt ihn an Orte und in Situationen, die viele
erfahrene Buchautoren gern ausschöpfen würden.
Für Max sind solche lustigen Begebenheiten
ganz alltäglich. Ein frohes Gemüt hat nicht das
Bedürfnis, vor anderen zu prahlen, erzählt aber
auf Bitten hin gern eine gute Geschichte.

———

È orgoglioso e forte, ha un grande senso
dell'humour, che gli consente di immergersi
in luoghi e situazioni che molti scrittori di successo
amerebbero conoscere. Per Max, questi divertenti
incontri sono materia di ogni giorno. Uno spirito
felice non ha necessità di vantarsi con gli altri,
ma sarà lieto di raccontare una bella storia
quando gli viene chiesto.

———

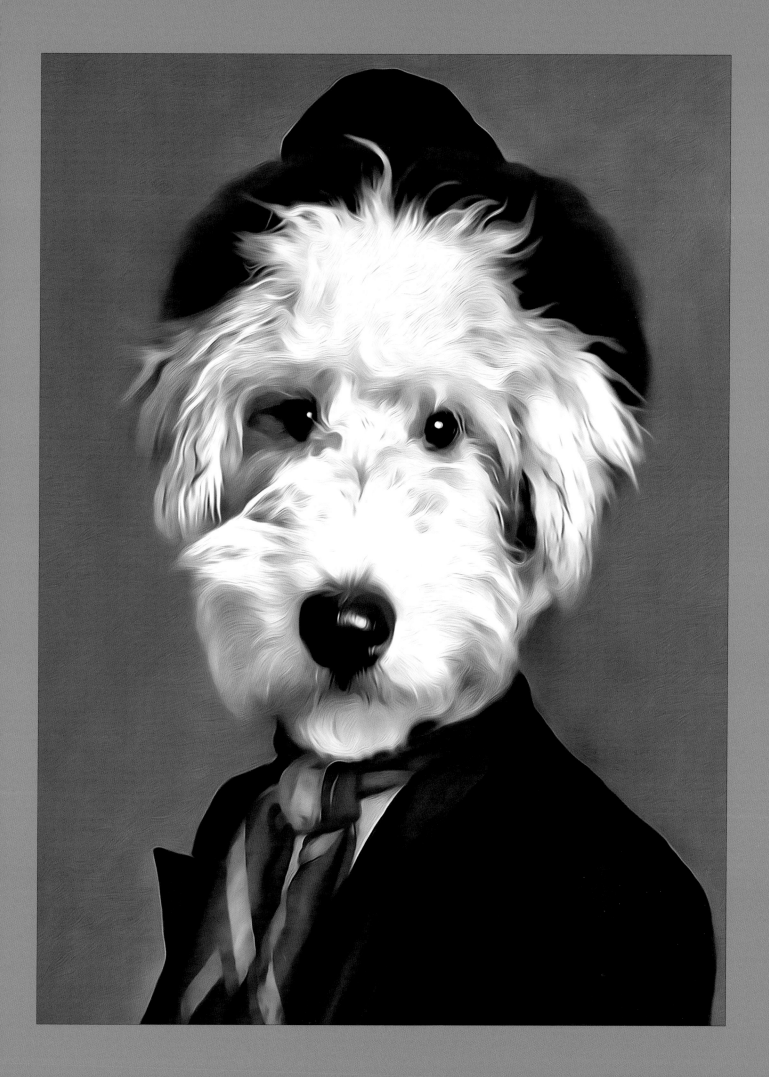

nº 12
coco

———

She is a fierce lady with a temper. She doesn't like to be touched by strangers, but she loves/hates to see others suffer from her slapping, even if she feels guilty right after doing it. Creative Coco made a job out of her bad behaviour and has noticed that others—especially those that hold big power in daily life—like a good spank from her hand.

———

Sie ist eine wilde, jähzornige Lady. Von Fremden lässt sie sich ungern anfassen, aber andere unter ihren Schlägen leiden zu sehen, liebt und hasst sie zugleich – trotz ihrer Schuldgefühle direkt danach. Die kreative Coco machte ihr übles Verhalten zu ihrem Job und merkte, dass andere – vor allem jene, die im Alltag viel Macht haben – sich gern von ihr versohlen lassen.

———

È una donna impetuosa con grande temperamento. Non ama essere toccata dagli estranei, ma ama/odia vedere gli altri soffrire dei suoi schiaffi, anche se si sente colpevole subito dopo. Quando applica il suo pessimo comportamento a lavoro, la creativa Coco nota che gli altri - soprattutto chi ha grande potere nella vita quotidiana - non disprezzano un bello sculaccione dalle sue mani.

———

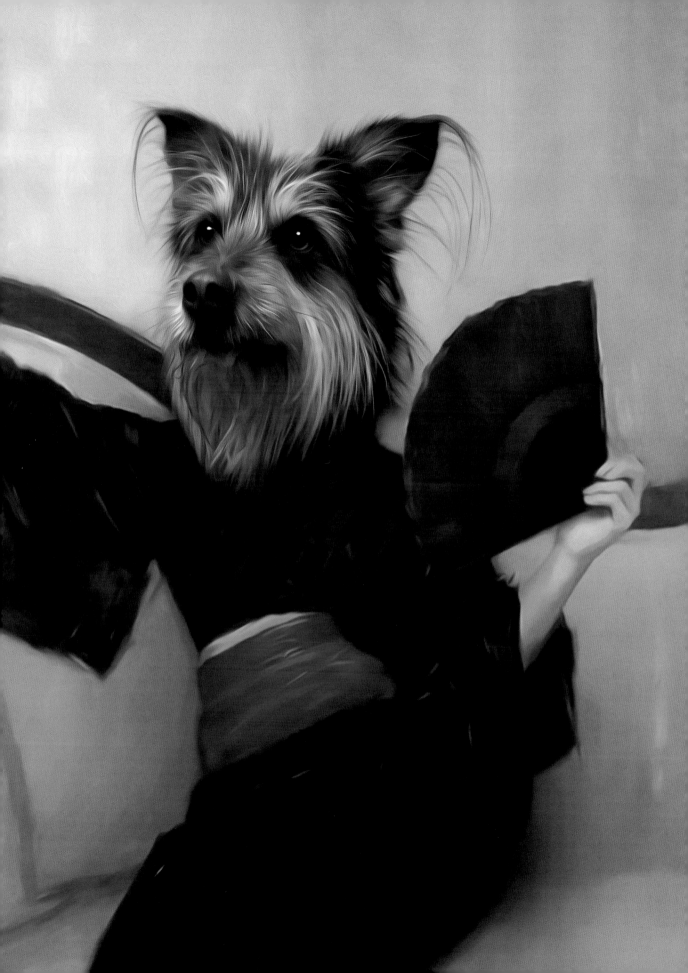

nº 13
Marcus

———

Life has been unfair to Marcus. The one who was supposed to love him the most as a newborn was unable to do so. This unfair start in life gave him a reason to harm others. It even became his favourite hobby. Because of bad choices he had made, the negative cloud above his head became bigger and bigger. It eventually ended up being the site of a hurricane, dragging innocent people into it. If he could never be happy, why should others be? Marcus died old and rich but as a hated and very lonely man.

———

Das Leben war ungerecht zu Marcus. Diejenige, die ihn als Neugeborenen am meisten hätte lieben sollen, war dazu nicht in der Lage. Dieser unfaire Start ins Leben gab ihm einen Grund, anderen zu schaden – es wurde sogar sein Lieblingshobby. Seine Entscheidung für das Böse ließ die negative Wolke über ihm immer mehr wachsen. Sie wurde zu einem Orkan, der Unschuldige mitriss. Warum sollten andere glücklich sein, wenn er es nie war? Marcus starb als reicher, aber verhasster, einsamer alter Mann.

———

La vita è stata ingiusta con Marcus. Chi doveva amarlo di più in quanto primogenito non ha potuto farlo. Questo inizio ingiusto della sua vita gli ha fornito un motivo per ferire gli altri. È persino diventato il suo hobby preferito. A causa di scelte sbagliate, la nuvola di negatività sopra la sua testa è diventata sempre più grande. Si è addirittura trasformata in un uragano, trascinando con sé persone innocenti. Se non poteva essere felice, perché dovevano esserlo gli altri? Marcus è morto ricco ma odiato e molto solo.

———

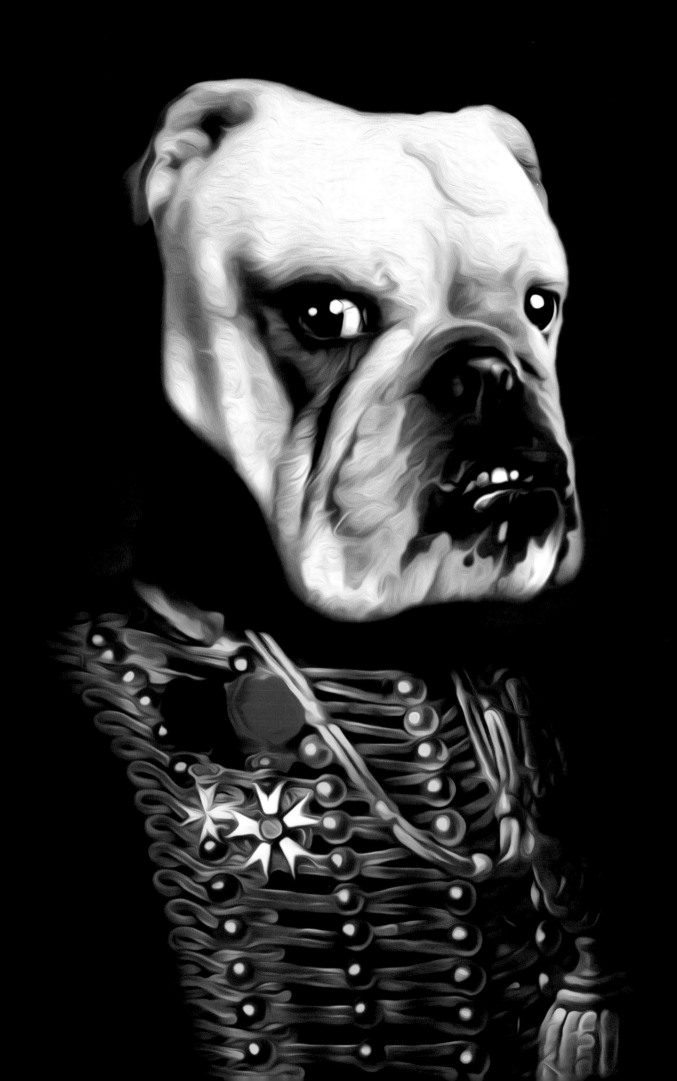

nº 14
stein
#EINSTEINBEARD

———

Stein was bored in school. He didn't care
about what the school taught him. He
preferred reading his father's books instead.
Before he went to school, he had been busy
with other important things adults think
about. Stein started to travel the world
and learn more about what it actually
was all about.

———

Stein langweilte sich in der Schule.
Was dort gelehrt wurde, interessierte ihn
nicht. Er las lieber die Bücher seines Vaters.
Bevor er in die Schule kam, beschäftigten ihn
andere wichtige Dinge, über die Erwachsene
nachdenken. Schließlich ging Stein auf Reisen
und lernte mehr über die Welt.

———

Stein si annoiava a scuola. Non gli importava
di ciò che gli veniva insegnato. Preferiva
leggere i libri di suo padre. Prima di iniziare
la scuola, era stato occupato a fare altre cose
importanti a cui pensano gli adulti. Stein
iniziò a viaggiare per il mondo e imparare
tantissime cose su ciò che esso è realmente.

———

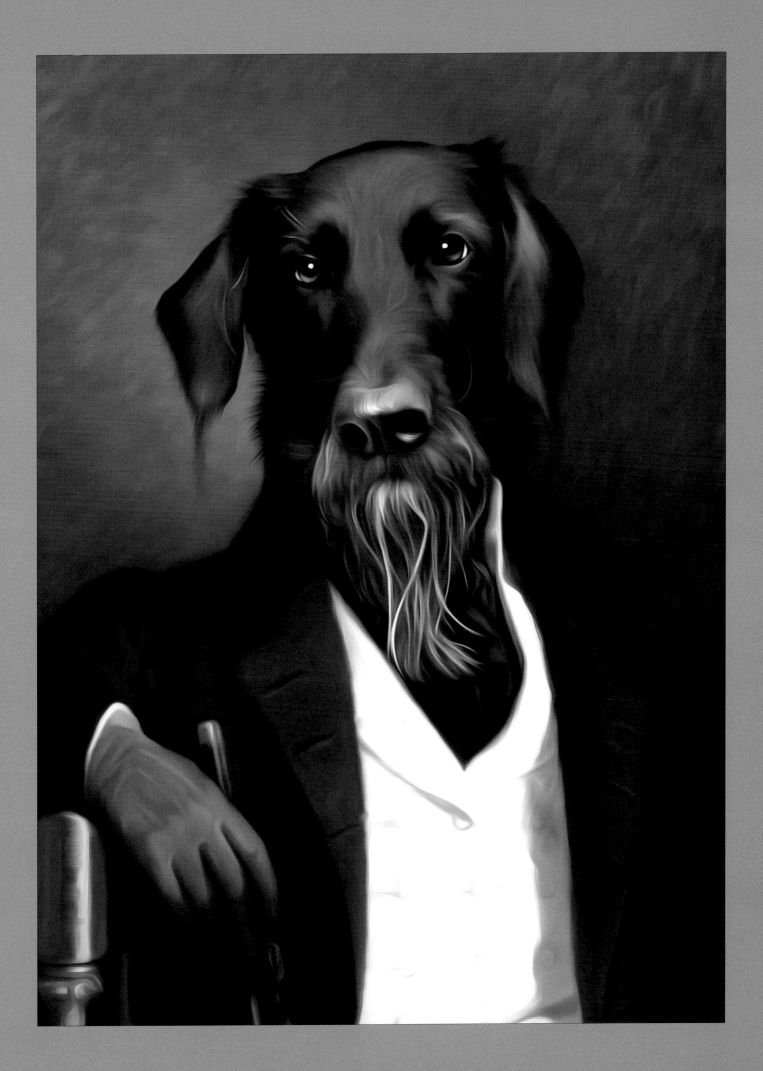

nº 15
Doesjka

———

Doesjka looks like an organised girl who seems to know what she is all about. The only weak spot she has is managing her relationship with food. To keep her beautifully curved figure, she has learned to buy only what she can eat in one day. But when stress hits her system, she explores the neighbour's trash, looking for leftovers. She hopes no-one finds out about her secret. A good reputation is a lot of work and, once ruined, it is not easily reacquired.

———

Doesjka wirkt wie eine organisierte junge Frau, die weiß, wo es langgeht. Ihre einzige Schwäche ist der Kampf gegen ihr großes Essbedürfnis. Um ihre Figur mit den schönen Kurven zu bewahren, kauft sie nur noch das, was sie an einem Tag essen kann. Doch wenn Stress sie überkommt, durchforstet sie den Müll des Nachbarn nach Resten des Vortags. Sie hofft, dass niemand von ihrem Geheimnis erfährt. Ein guter Ruf ist viel Arbeit: Einmal zerstört, lässt er sich nicht leicht zurückgewinnen.

———

Doesjka sembra una ragazza organizzata che sa il fatto suo. L'unico punto debole è che fa fatica a controllare il suo bisogno di cibo. Per mantenere la sua bellissima figura curvilinea, ha imparato ad acquistare solo quello che può mangiare in un giorno. Ma quando lo stress si impossessa di lei, rovista nella spazzatura del vicino alla ricerca degli avanzi del giorno prima. Spera che nessuno scopra il suo segreto. Una buona reputazione è dura da conquistare e, una volta rovinata, è difficile da recuperare.

———

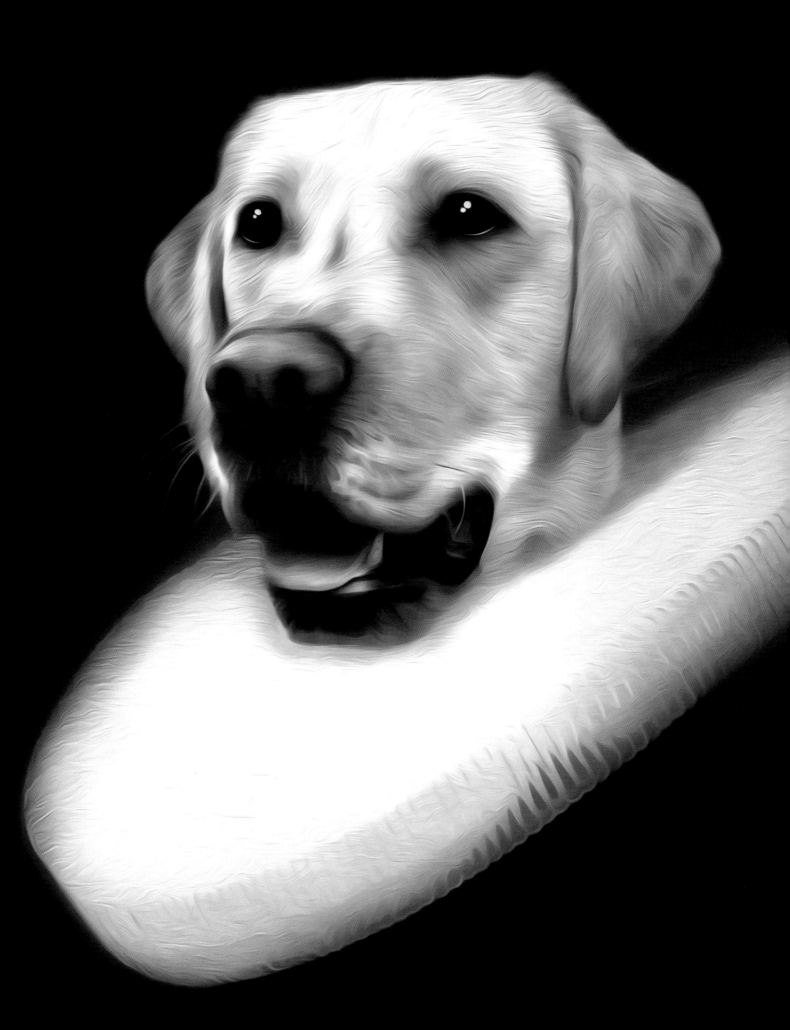

nº 16
otis

————

He presents himself as a little man with great
attitude. He doesn't want to show his week side,
because, when he was a kid, he was told that
he shouldn't be sensitive. He keeps his beautiful
thoughts and poems to himself.
Maybe one day they will discover the
warm-hearted man that he was.

————

Otis präsentiert sich als kleiner Mann mit
starkem Auftreten. Er zeigt seine sensible Seite
nicht, denn als Kind wurde ihm beigebracht,
er könne nicht einfühlsam sein. Seine schönen
Gedanken und Gedichte behält er für sich.
Vielleicht findet jemand eines Tages heraus,
wie warmherzig er ist.

————

Si presenta come un piccolo uomo con un
grande portamento. Non vuole mostrare il suo
lato delicato perché da piccolo gli è stato detto
che non può essere sensibile. Tiene per sé i suoi
bellissimi pensieri e poemi. Forse un giorno
scopriranno l'uomo cordiale che è in lui.

————

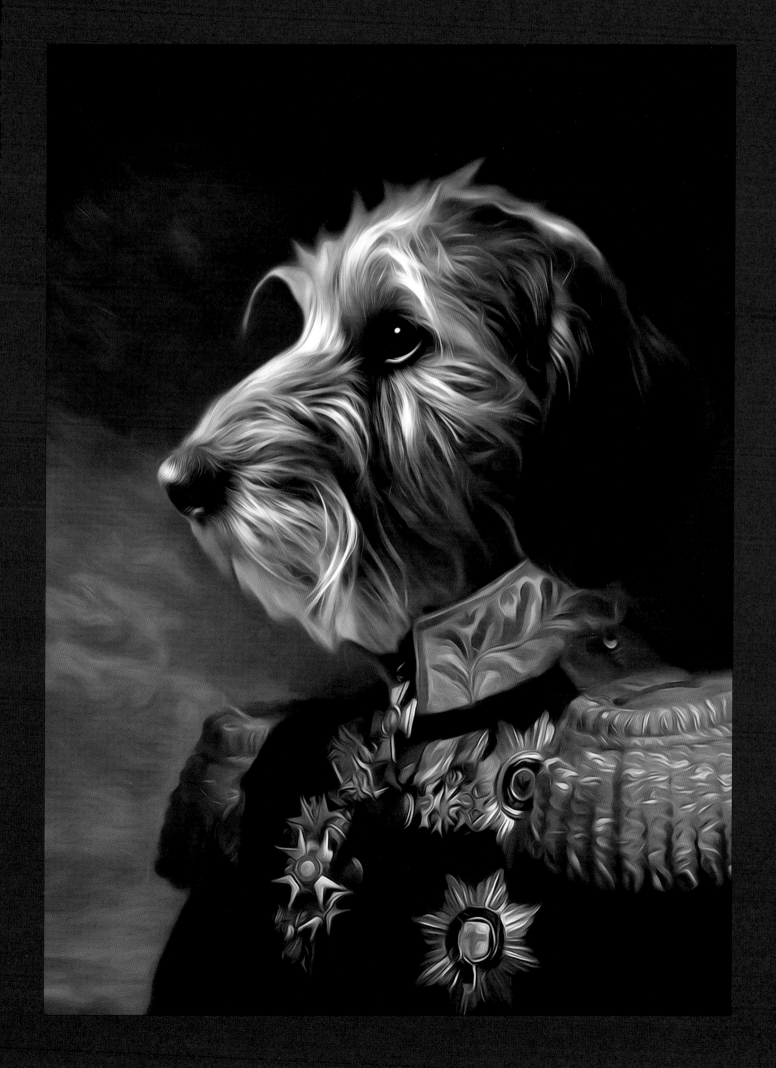

Teun

———

Sweet, loyal Teun never made the transformation
from a childish bouncing ball to becoming a wise
adult. He just didn't see any danger in little things
that seem harmless. His big dream was to become
the best master-chef, known worldwide. But,
reading that one informative book about "wild
berries in the forest" would have been very wise.

———

Der süße, treue Teun hat den Wandel von
einem kindlichen hüpfenden Fellknäuel zu einem
vernünftigen Erwachsenen nie vollzogen.
Er sah nur keine Gefahr in kleinen, vermeintlich
harmlosen Dingen. Sein großer Traum war es,
der berühmteste internationale Chefkoch
zu werden. Da hätte er gut daran getan, das
informative Buch über „Wildbeeren im Wald"
zu lesen.

———

Il dolce e fedele Teun non fece mai la
trasformazione da una cucciolosa e rimbalzante
palla di pelo a un adulto saggio e composto.
Non vedeva il pericolo nelle piccole cose che
apparivano innocue. Il suo grande sogno era
diventare il capo chef più famoso del mondo,
ma leggere quel libro didattico sui "frutti
di bosco" sarebbe stato molto saggio.

———

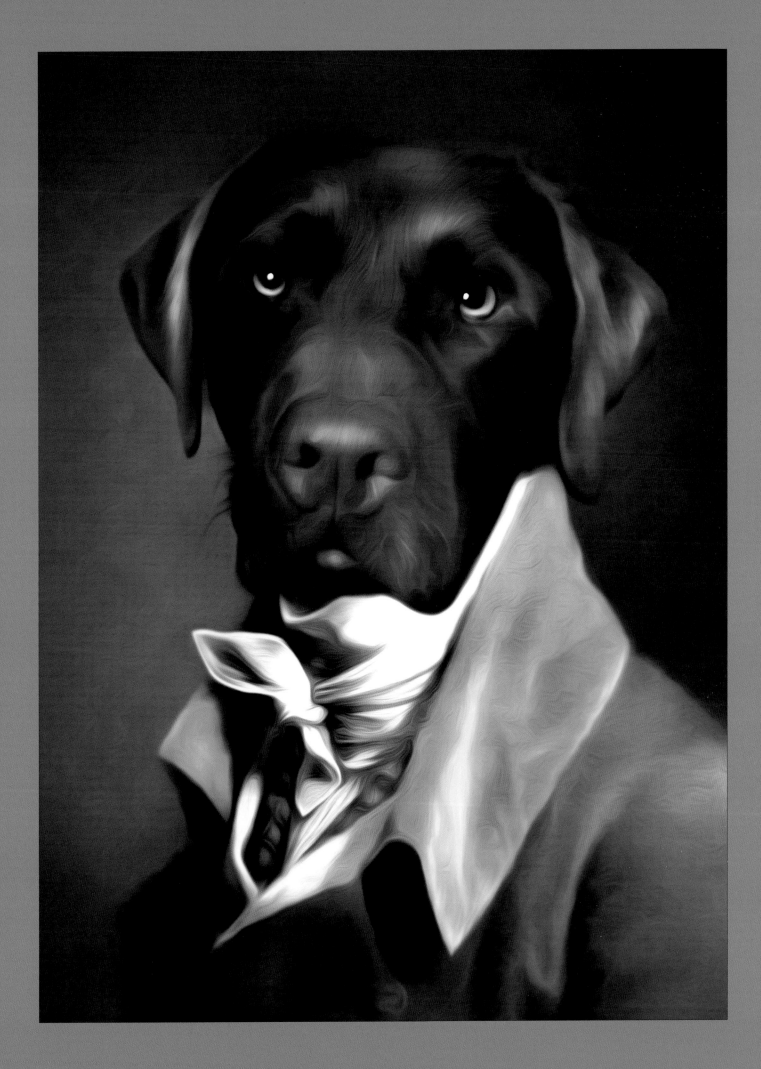

№ 18
Tedje

———

Being a therapist was not something he had
studied. Ted had to be there for a girl who was
dealing with a great loss. He learned that it was
powerful to just be present. It was a bonus that he
had a great sense of humour that cheered people
up. It was an art to make his patients see life
from the other side. Being a success simply
happened. It had worked; that was the
most important thing.

———

Therapeut sein hat er nicht studiert. Ted musste
für ein Mädchen da sein, das einen großen
Verlust zu bewältigen hatte. Er lernte, dass es
wirkt, einfach da zu sein. Ein Pluspunkt war sein
großer Humor, mit dem er Leute aufheiterte.
Es ist eine Kunst, Patienten dazu zu bringen,
das Leben von einer anderen Seite zu sehen.
Der Erfolg hat sich einfach ergeben. Es hat
funktioniert, darauf kommt es an.

———

Non aveva studiato per fare il terapista.
Ted doveva essere presente per una ragazza che
aveva subito una grave perdita. Aveva imparato
che essere semplicemente presente aveva un
grande potere. A ciò si aggiungeva il suo fantastico
senso dell'humour che rallegrava le persone.
È un'arte far vedere ai pazienti la vita da
un'altra prospettiva. Il successo arrivò e basta.
Ha potuto lavorare, e questa è la cosa
più importante.

———

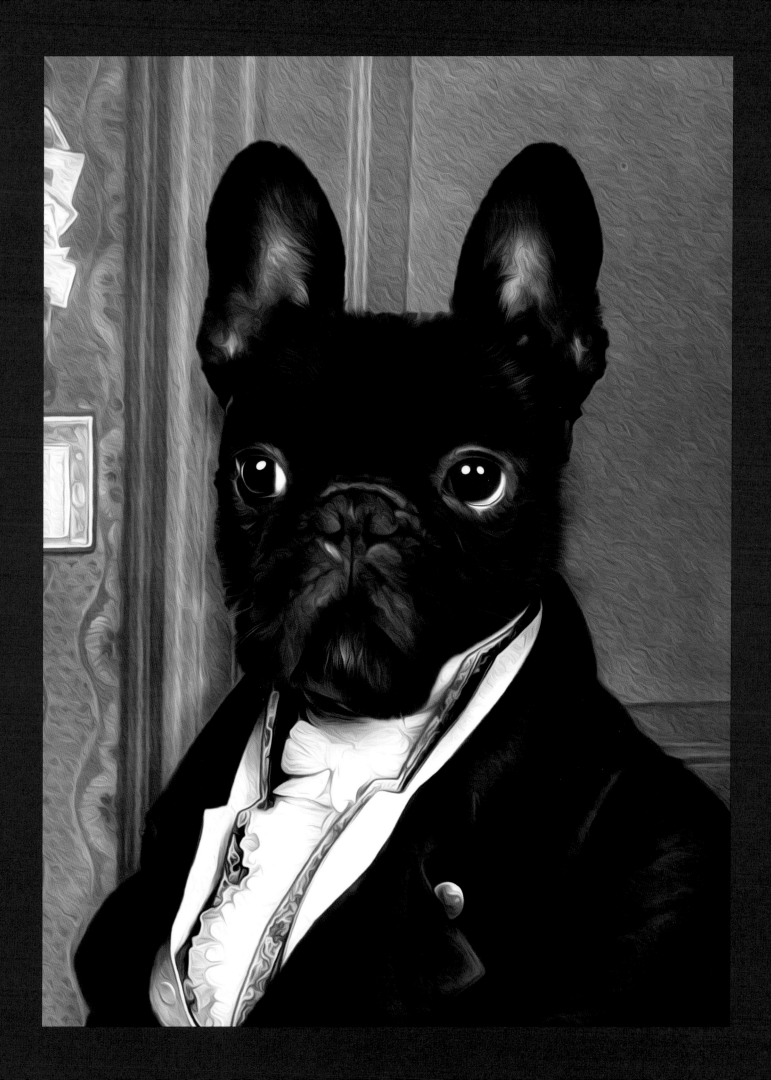

№ 19
Mimi

———

She knew the power of her eyes when she
tried to look innocent. She could even melt
the heart of a frozen polar bear. Mimi liked to
experiment with how much she can get away
with. Will Mimi find out it is very dangerous
to test the boundaries of polar bear-like
others?

———

Sie wusste um die Macht ihrer Augen, wenn sie
unschuldig wirken wollte. Selbst das Herz eines
gefrorenen Eisbären konnte sie zum Schmelzen
bringen. Mimi schaute gern, wie weit sie gehen
konnte. Wird Mimi herausfinden, dass es
gefährlich ist, die Grenzen anderer, die
wie Eisbären sind, zu testen?

———

Conosce il potere dei suoi occhi quando cerca
di apparire innocente. Può persino sciogliere
il cuore di un orso polare congelato. Mimi
ama sperimentare per vedere fino a dove
può arrivare. Scoprirà che è pericoloso mettere
alla prova i limiti degli orsi polari?

———

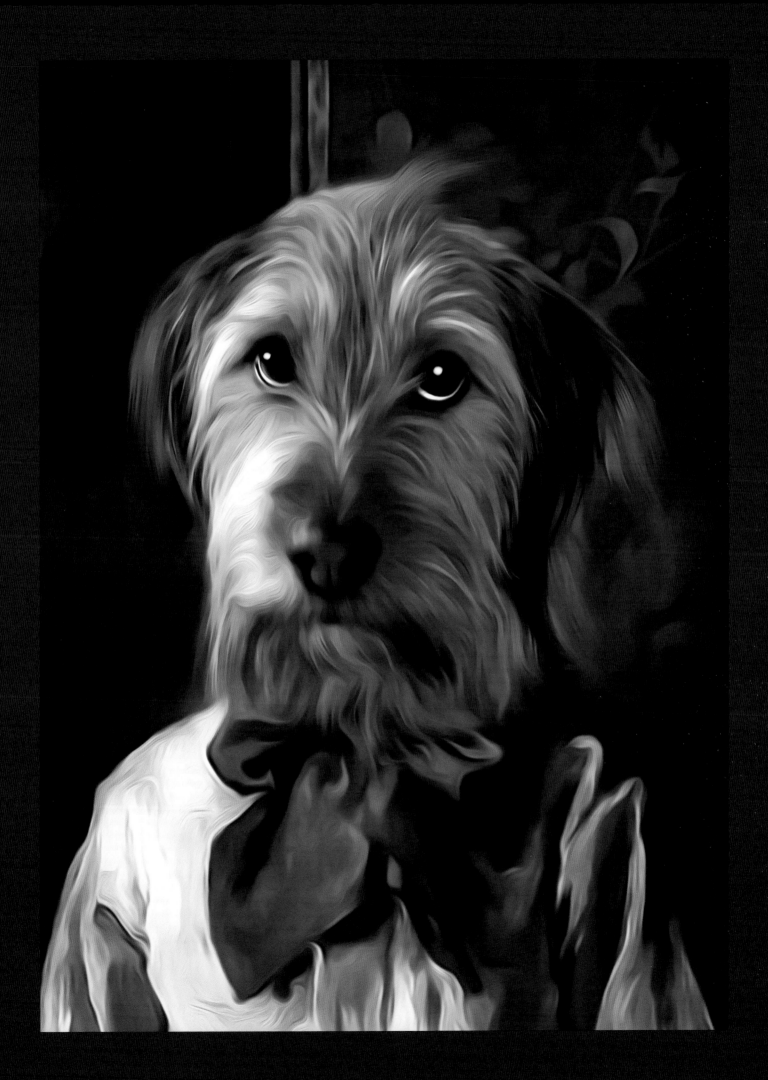

№ 20
xanath

———

A lady that has seen many places in her life. Xanath has been with many partners while traveling. And she has had the time to compare them all. She realised she feels best in the protection of the bigger ones. Maybe it is because she is petite herself. Surrendering to something bigger than her own ego is what works for her. Who could ever judge a happy lady living life like it is a party?

———

Als weitgereiste Lady war Xanath mit vielen Partnern unterwegs und hatte Zeit, alle zu vergleichen. Sie hat gemerkt, dass sie sich unter dem Schutz der Größeren am wohlsten fühlt – vielleicht deswegen, weil sie zierlich ist. Sich in die Obhut von etwas zu geben, das größer ist als ihr Ego, funktioniert bei ihr. Wer könnte eine glückliche Lady verurteilen, für die das Leben eine Party ist?

———

Xanath è una signora che ha visto molti luoghi nella sua vita e ha avuto numerosi partner in viaggio. Ha avuto il tempo di metterli a confronto. Si è resa conto di sentirsi più protetta accanto ai partner più grandi, forse perché lei è così esile. Arrendersi a qualcosa di più grande del suo ego è la soluzione perfetta per lei. Chi potrebbe mai giudicare una signora felice che vive la vita come una festa?

———

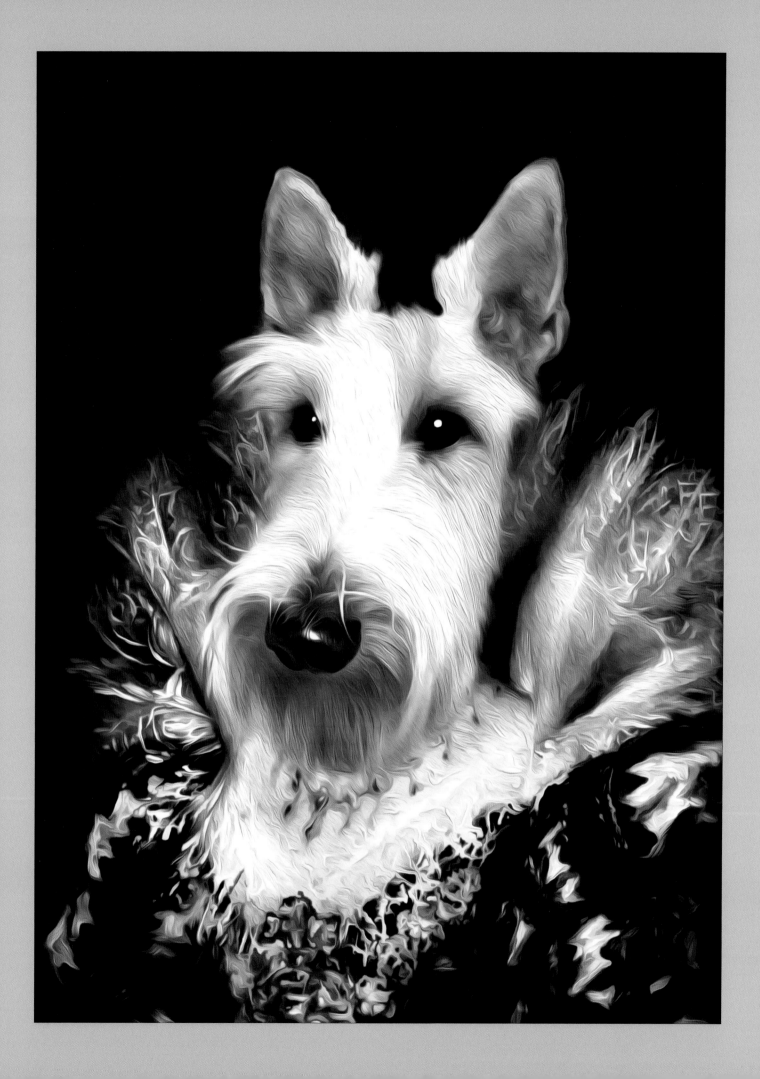

№ 21
Lenny

———

The role of being an older brother is something that Lenny fulfils with great success. He was the one who was always a little stronger, a little faster, and had just a little more guts to do the dangerous things. His younger brother wanted to be like him, for he was admired without noticing it himself. Being with him and growing up together was fun. Just playing ball games, wrestling, and fooling around. An inspiring buddy that showed true friendship.

———

Lenny erfüllt die Rolle des älteren Bruders mit großem Erfolg. Er ist derjenige, der etwas stärker und schneller ist und ein klein bisschen mehr Mumm hat, gefährliche Dinge zu tun. Sein jüngerer Bruder wollte wie Lenny sein, der gar nicht merkte, dass er bewundert wurde. Mit Lenny zusammen zu sein und aufzuwachsen hat Spaß gemacht. Einfach Ball spielen, ringen und herumalbern. Ein inspirierender Kumpel, der sich als echter Freund erwies.

———

Essere un fratello maggiore a Lenny riesce benissimo. È un po' più forte, un po' più veloce e ha un po' più di coraggio per fare le cose pericolose. Il suo fratellino voleva essere Lenny, ammirato da tutti senza rendersene conto. Stare con lui e crescere insieme è stato divertente giocando a palla, facendo la lotta e tanti scherzi. È una persona che ispira e mostra vero senso di amicizia.

———

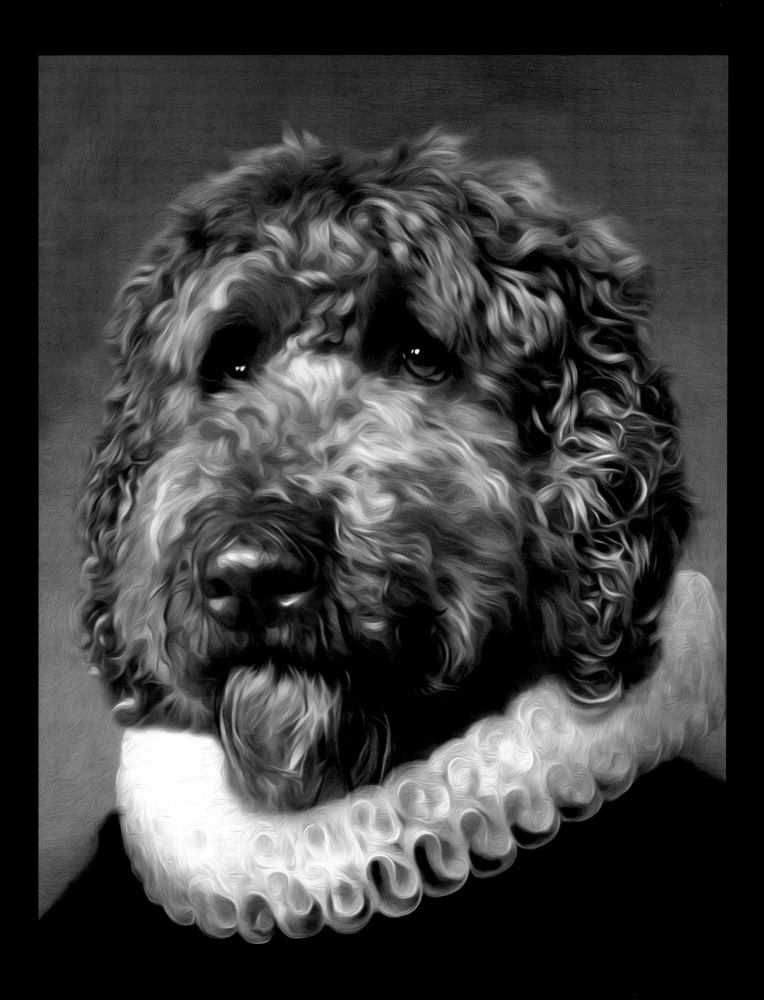

№ 22
Lupo

———

Everyone in town tried to understand who he was
and what he was doing. But Lupo didn't seem to
care about others' opinions. He knew he was doing
good and what he stood for. He has talked a lot
about big dreams and always had funny stories,
which everyone thought he made up. But no-one
could ever catch him telling a lie. "One day they
will understand who I am," Lupo thought.

———

Alle in der Stadt wollen ihn und das, was er tut,
verstehen. Doch die Meinung anderer kümmert
Lupo offenbar nicht. Er weiß, dass er Gutes tut und
wofür er steht. Oft erzählt er von großen Träumen
und er hat stets lustige Geschichten parat, die
er sich – wie alle meinen – nur ausdenkt. Doch
niemand hat ihn je bei einer Lüge ertappt. „Eines
Tages verstehen sie, wer ich bin", denkt Lupo.

———

Tutti in città hanno cercato di capire chi sia e cosa
faccia, ma Lupo non sembra curarsi dell'opinione
delle altre persone. Sa di fare bene e per cosa si
batte. Ha parlato tanto di grandi sogni e ha sempre
storie divertenti da raccontare, che tutti pensano
si inventi. Tuttavia nessuno riesce mai a coglierlo
in flagrante mentre dice una bugia. Lupo pensa
che un giorno capiranno chi è.

———

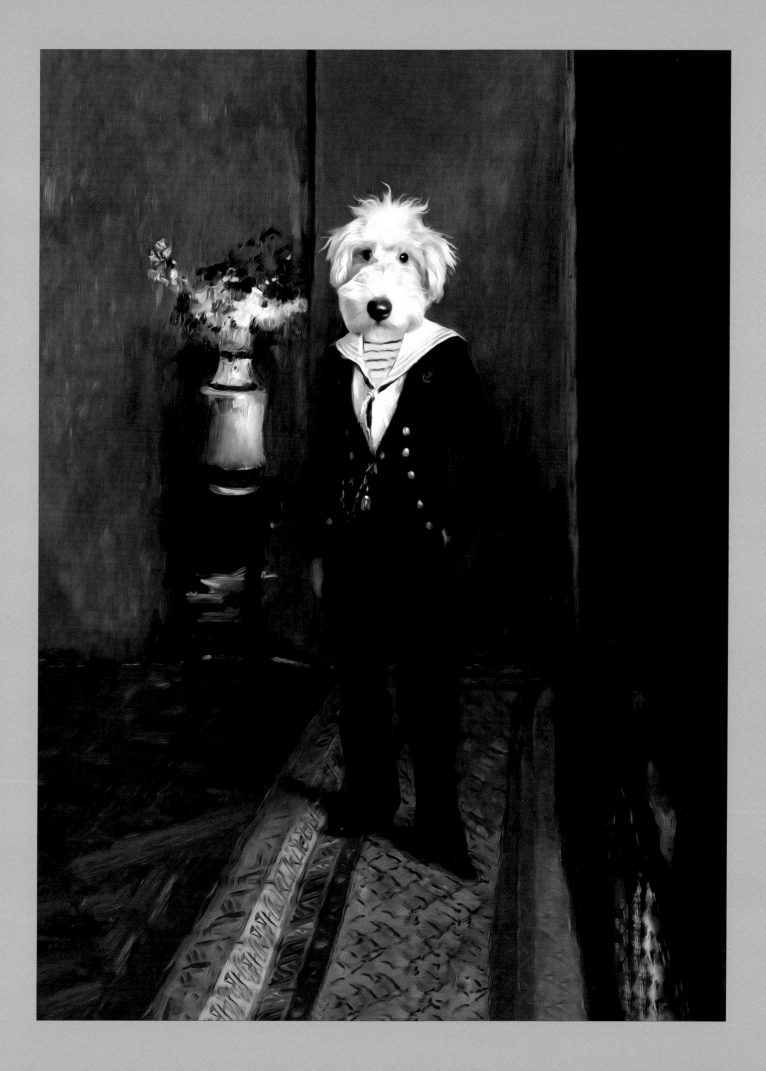

№ 23
Mozart

———

He might look like a tough guy. One that ends
up in fights in bars. Not many expected that his
appearance is a well-planned facade. On the one
hand, he knows that his looks attract the girls.
On the other hand, they also keep the boys who
fear him at a safe distance. Mozart just enjoys
life to the fullest and cherishes all the attention
he gets.

———

Er mag wie ein knallharter Typ wirken, einer,
der in Kneipenprügeleien gerät. Kaum jemand
hätte gedacht, dass sein Aussehen eine gut
geplante Fassade ist. Er weiß, dass sein Look zum
einen Mädchen stark anzieht und zum anderen
Jungen, die ihn fürchten, auf sichere Distanz hält.
Mozart genießt das Leben voll und schätzt all die
Aufmerksamkeit, die er erhält.

———

Potrebbe sembrare un tipo duro, uno che finisce
a fare a botte nei bar. Non tutti si aspettavano che
il suo aspetto fosse una facciata preparata. Da una
parte sa che i suoi look risultano molto affascinanti
per le ragazze e dall'altra mantiene i ragazziche
lo temono a distanza di sicurezza. Mozart
ama semplicemente la vita nella sua massima
espressione e adora tutte le attenzioni che riceve.

———

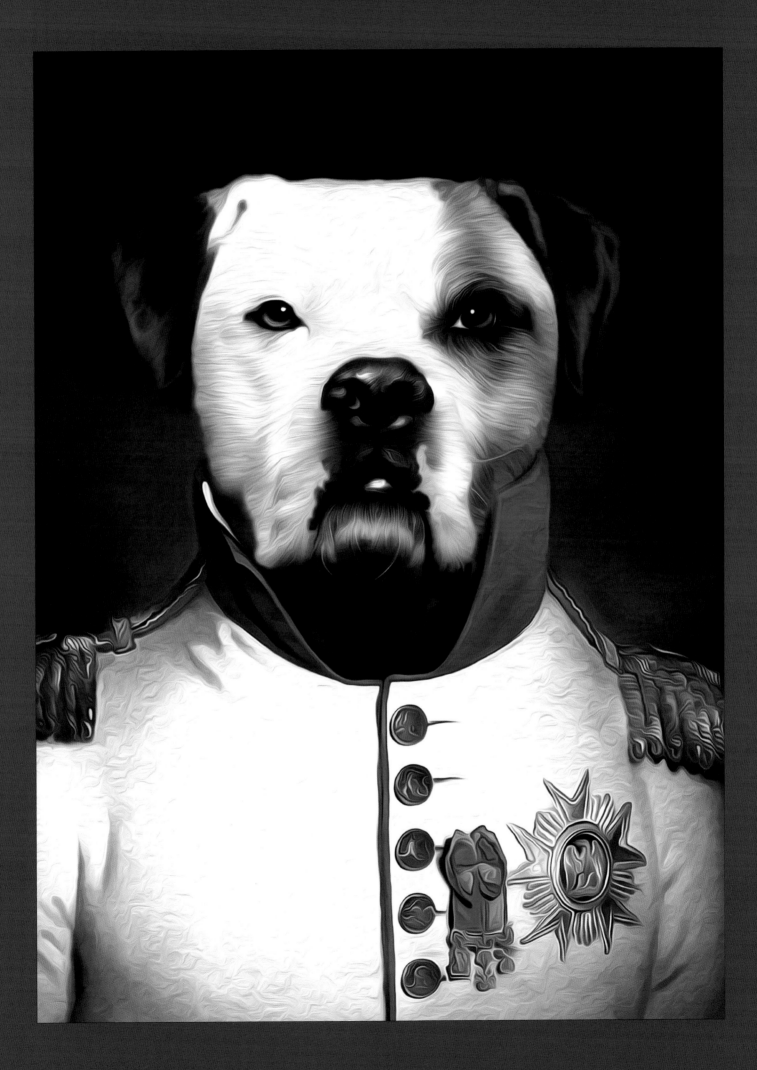

Getting into trouble seems to be what brother Stok likes best. Speaking before thinking gets him into overheated situations. Thank goodness his brother Greg is always around to intervene diplomatically afterwards to prevent situations from getting overheated. Stok would probably be a very shy and insecure little guy if he didn't have his brother around.

Sich Ärger einhandeln — das kann Bruder Stok offenbar am besten. Er spricht, bevor er denkt, und das bringt ihn in hitzige Situationen. Gott sei Dank ist Bruder Greg stets zur Stelle, um mit Diplomatie zu helfen und zu verhindern, dass Situationen eskalieren. Stok wiederum wäre ohne seinen Bruder vermutlich ein sehr schüchterner, unsicherer kleiner Kerl.

Mettersi nei guai sembra essere ciò che Stok sa fare meglio. Parlare prima di pensare lo mette in situazioni estreme. Grazie al cielo suo fratello Greg è sempre in zona per fornire assistenza diplomatica ed evitare che le situazioni degenerino definitivamente. Stok sarebbe probabilmente un tipo molto timido e insicuro se non avesse al fianco il fratello.

№ 25
Greg

———

Crossing oceans is what young Viking longed
to do. He was named after the people with big
attitude. The only obstacle that was crossing his
path to big victory was his eyes. Viking turned out
to be a cute, clumsy hero with a heart of gold.
But let's be honest, who needs a hero to conquer
the world when you can be a local hero by being
able to conquer hearts and make others laugh?

———

Der junge Viking sehnte sich danach, die
Meere zu befahren. Er wurde nach den stolzen
Seefahrern benannt. Das Einzige, was seinem Weg
zu glorreichen Siegen in die Quere kam, war sein
Blick. Viking erwies sich als süßer, tollpatschiger
Held mit einem Herz aus Gold. Aber mal ehrlich:
Wozu ein heldenhafter Welteroberer sein, wenn
man als Lokalheld Herzen erobern und andere
zum Lachen bringen kann?

———

Solcare gli oceani è ciò che il giovane Viking
desiderava fare. Il suo nome derivava da un
audace popolo di mare. L'unico ostacolo tuttavia
che "intralciava" questo ambizioso progetto erano
i suoi occhi. Viking si trasformò in un dolce e
imbranato eroe dal cuore d'oro. Ma siamo onesti,
chi ha bisogno di un eroe per conquistare il
mondo quando si può essere un eroe nel
proprio piccolo riuscendo a conquistare
i cuori e far ridere gli altri?

———

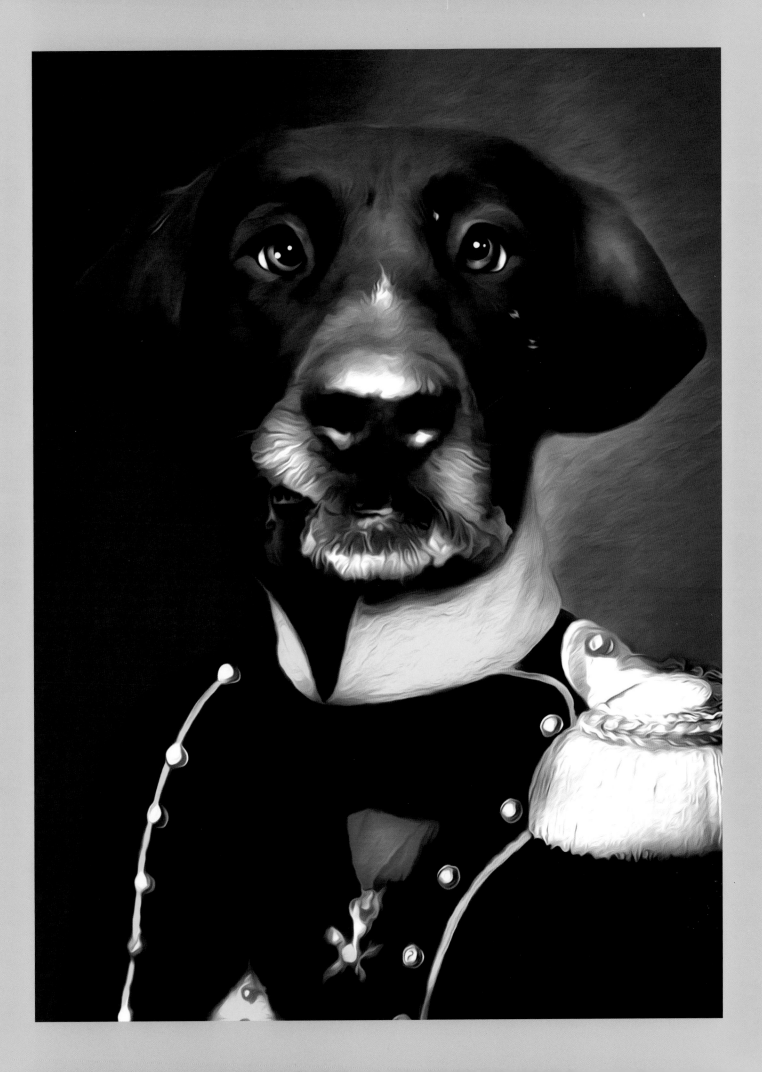

№ 27
Kees

——

Nothing can stop this funny bouncing ball
from jumping up and down. Many others are
impressed by what funny, fearless things Kees
dares to do. Unfortunately, Mr. Frog didn't survive
a challenging game he offered to play with Kees,
who took the first turn. Mr. Frog didn't get his turn
in Truth or Dare afterward. Looking "not guilty" is
all Kees could do after the green horror happened.

——

Nichts kann diesen lustigen Fellball vom Hüpfen
abhalten. Viele sind beeindruckt angesichts Kees'
Wagemut. Leider hat Mr. Frosch ein gewagtes Spiel
mit ihm nicht überlebt – er hatte angeboten, es mit
Kees zu spielen, der als Erster dran war. Daraufhin
kam Mr. Frosch bei „Wahrheit oder Pflicht" nicht
mehr an die Reihe. Nach dem grünen Horror blieb
Kees nur noch sein „Ich-war's-nicht"-Blick.

——

Niente può impedire a questa divertente e
rimbalzante palla di pelo di saltare da ogni parte.
Molti sono colpiti da ciò che l'impavido Kees riesce
a fare. Purtroppo Mr. Frog non è sopravvissuto alla
sfida lanciata a Kees, che ha fatto la prima mossa.
Mr. Frog non è arrivato al suo turno di "Obbligo o
verità". Non apparire colpevole è tutto quello che
Kees ha potuto fare dopo quell'orrore.

——

№ 28
Kerl

There are a lot of ways to hide the fact that you are actually very afraid. Kerl thinks that attacking seems to be his best defence. He trusted just a few very close friends to show his real sweet personality. He didn't care what the rest thought about him. His own safety was most important. Being ignored was a fair price to pay.

Es gibt viele Arten zu verbergen, dass man in Wirklichkeit Angst hat. Angriff ist die beste Verteidigung, meint Kerl. Er vertraut nur wenigen engen Freunden so weit, dass er sein wahres, nettes Wesen zeigt. Was der Rest von ihm hält, ist ihm egal. Wichtiger ist ihm seine Sicherheit. Ignoriert zu werden ist ein fairer Preis, den er dafür zahlt.

Ci sono molti molti di nascondere la paura. Kerl pensa che attaccare sia la miglior difesa. Si fida di pochissimi amici a cui mostra la sua vera dolce personalità. Non gli importa cosa gli altri pensino di lui. La sua sicurezza personale è più importante. Essere ignorato è il giusto prezzo da pagare.

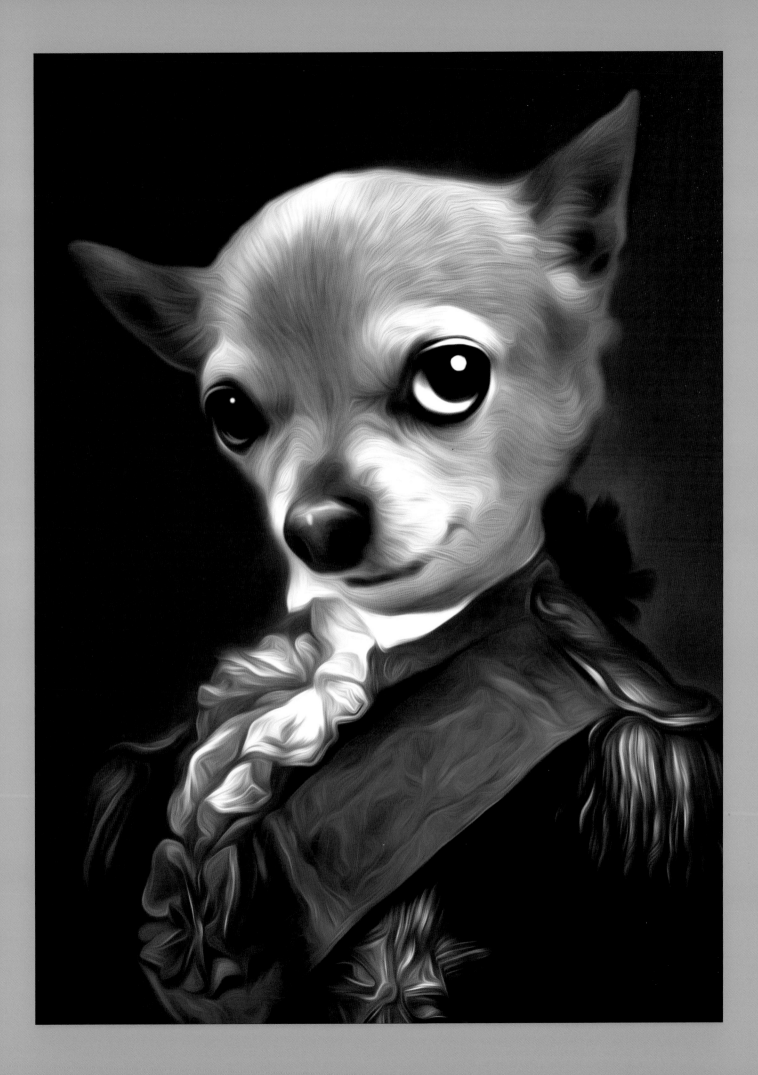

№ 29
Alfred

——

Doing business can be risky. This honest-looking businessman likes to get the best profit out of a deal. He doesn't care if his customers will never return. He is a traveler and doesn't worry about aftercare. Making money is all he longs for. He will probably never find out that money will never bring him the happiness he longs for so bad.

——

Geschäftemachen kann riskant sein. Dieser ehrlich wirkende Geschäftsmann holt gern den höchsten Profit aus einem Deal heraus. Es ist ihm egal, wenn Kunden nie wiederkommen. Er ist ein Reisender: Nachbetreuung kümmert ihn nicht. Er will nur Geld machen. Vermutlich wird er nie erkennen, dass Geld ihm nicht das Glück bringt, das er sich so ersehnt.

——

Fare affari può essere rischioso. Questo uomo d'affari dall'aria onesta ama ottenere il massimo profitto. Non gli importa se i clienti non ritorneranno. È un viaggiatore e non gli importa del domani. Fare soldi è l'unica cosa che gli interessa. Probabilmente non scoprirà mai che il denaro non gli porterà la felicità che cerca tanto alacremente.

——

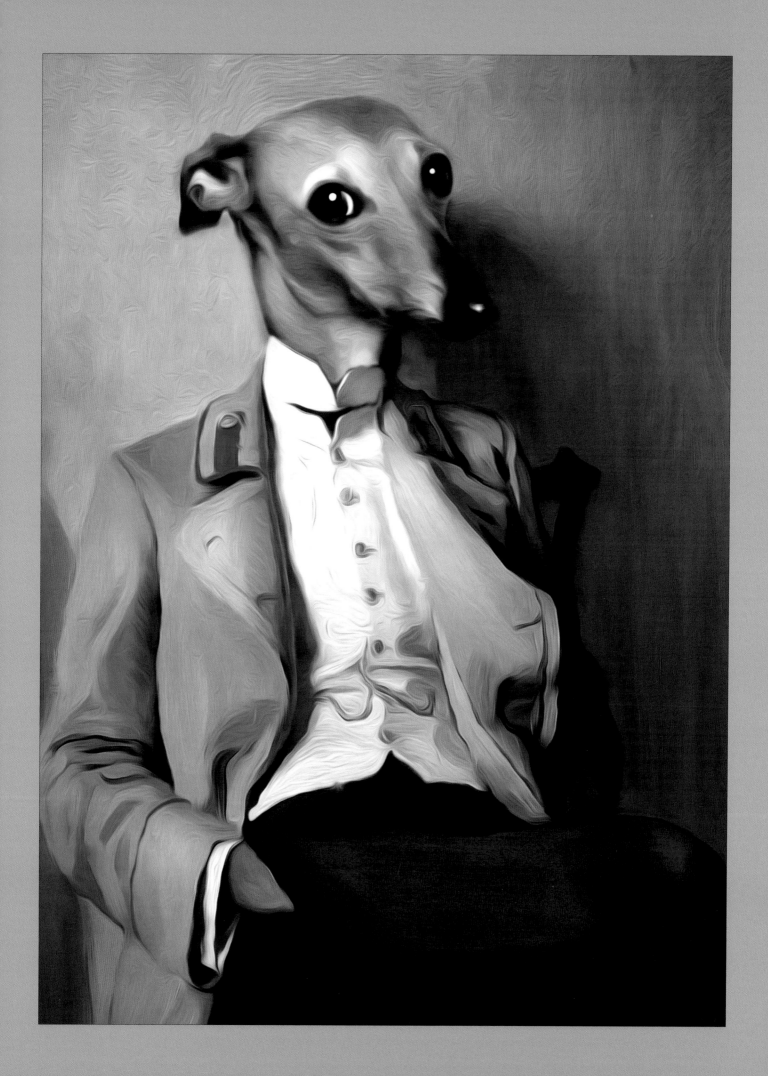

———

The always-happy and bright Mingus sometimes looks distracted for a while. His thoughts are focused on times of the past, when life didn't seem as bright as it does right now. Shortly afterward, he thanks the universe that personal growth has happened and he celebrates the rest of another beautiful day with a big smile on his face.

———

Der stets fröhliche, lebhafte Mingus wirkt mitunter geistig abwesend. Seine Gedanken richten sich dann auf vergangene Zeiten, als das Leben nicht so heiter verlief wie jetzt. Kurz darauf dankt er dem Universum für sein persönliches Wachstum und feiert den Rest eines weiteren schönen Tages mit einem breiten Lächeln im Gesicht.

———

Mignus, sempre allegro e vivace, a volte sembra distratto per qualche breve momento. I suoi pensieri si concentrano in momenti del passato quando la vita non sembrava così bella come adesso. Poco dopo, ringrazia l'universo di essere cresciuto e festeggia il resto di un'altra meravigliosa giornata con un grande sorriso sul volto.

———

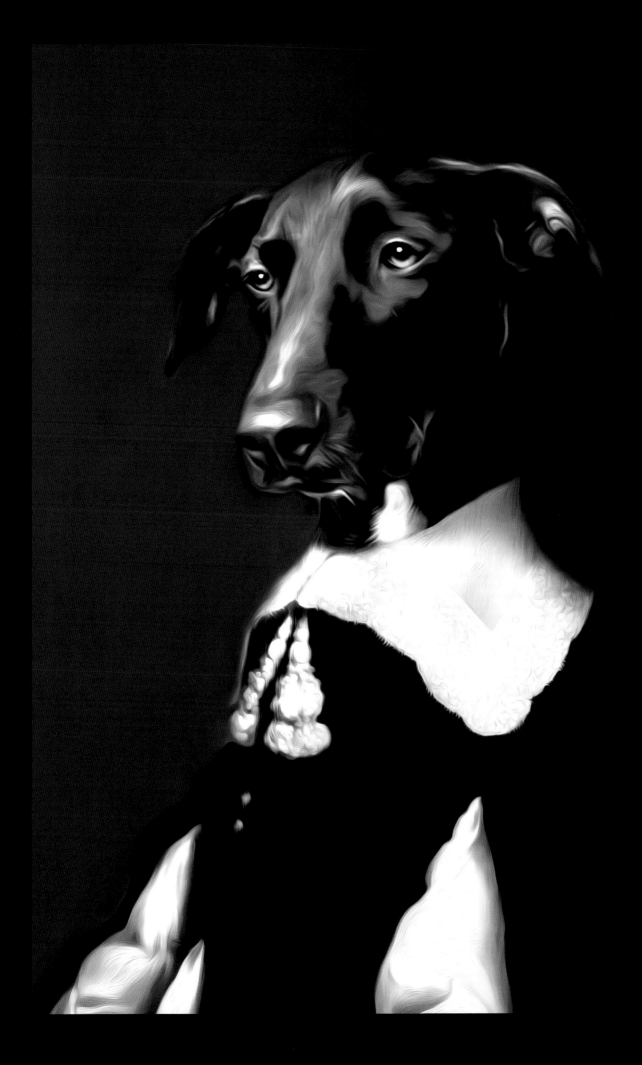

№ 31
Banjer

———

He started his career as a happy clown in the hospital. Trying to cheer up others was what he liked to do. While doing so, he found out there was another way to cure. After some education, he has become the best nurse you can imagine and he never lost his clownish approach. Banjer's vision is that—in addition to proper healthcare—happiness and laughter are the perfect combination and the best chance to win the battle against illness.

———

Seine Karriere begann als fröhlicher Krankenhaus-Clown. Er liebte es, andere aufzuheitern. Dabei entdeckte er, dass es noch einen Weg gab, andere zu kurieren. Nach einer Ausbildung wurde er der beste Krankenpfleger, den man sich vorstellen kann. Das Clowneske verlor er nie – aus Banjers Sicht bietet die Kombination aus Glück und Lachen neben einer guten Gesundheitsversorgung die besten Chancen, den Kampf gegen Krankheiten zu gewinnen.

———

Iniziò la sua carriera come un clown felice in ospedale. Cercare di rallegrare gli altri era ciò che amava fare. Così facendo scoprì che c'era un altro modo di curare. Dopo la necessaria formazione, è diventato il miglior infermiere possibile. Non ha mai perso il suo modo da clown. Banjer pensa che, insieme a buone cure sanitarie, la felicità e tante risate siano la combinazione perfetta per offrire a una persona la migliore possibilità di vincere la battaglia contro la malattia.

———

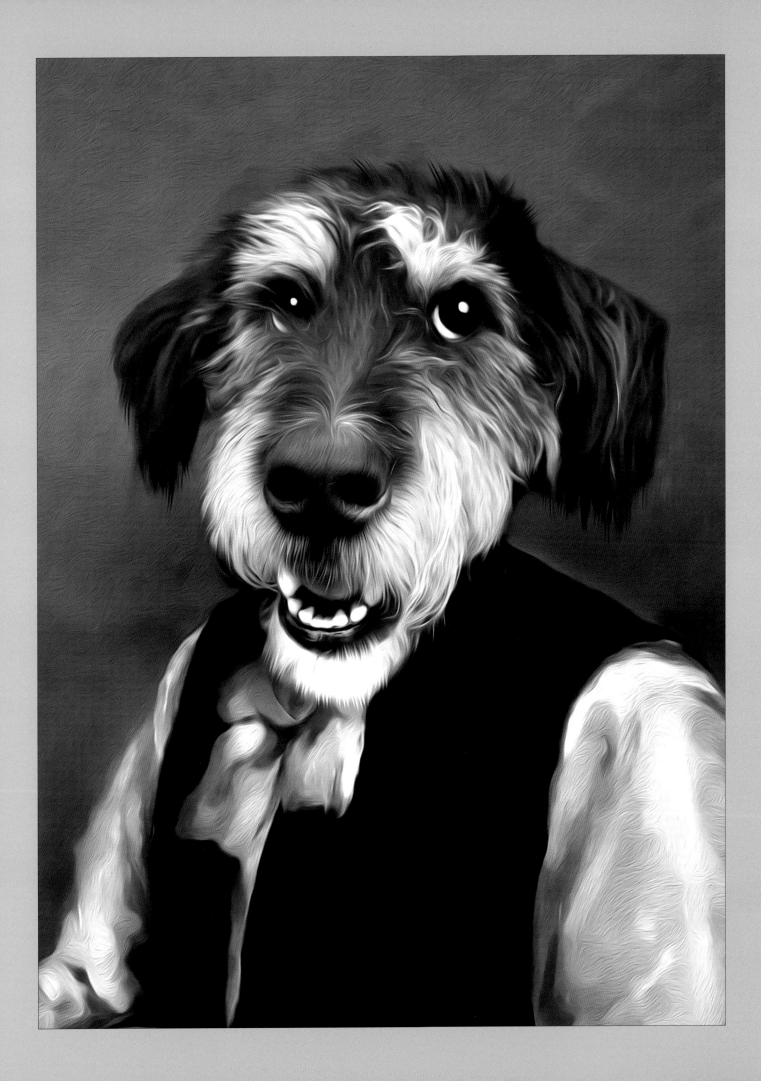

№ 32
que

―――――

Serving his country was all he dreamed of as a kid.
When his dream came true, he never realised what
it really meant. Working outdoors, playing with
big machines, and trying to shoot with powerful
weapons seemed so exiting at the time. He never
realised that tools like that could create such a mess,
which has messed up his head for the rest of his life.

―――――

Als Kind träumte er einzig davon, seinem Land
zu dienen. Als sein Traum wahr wurde, ahnte er
nicht, was das hieß. Im Freien arbeiten, mit großen
Maschinen spielen und starken Waffen schießen
schien ihm damals sehr aufregend. Ihm war nicht
klar, dass es so ein schlimmes Chaos sein würde.
Dieses Chaos zu bereinigen hat Thierrys Verstand
für den Rest seines Lebens ins Chaos gestürzt.

―――――

Servire il suo Paese era ciò che sognava da bambino.
Quando il sogno si è avverato, non ha mai compreso
ciò che significasse realmente. Lavorare fuori,
giocare con grandi macchine e cercare di colpire il
nemico con armi potenti sembrava così emozionante,
ma non aveva capito che avrebbe causato tutto
questo scompiglio. Dare ordine a questo caos
ha messo in subbuglio la testa di Thierry per il
resto della sua vita.

―――――

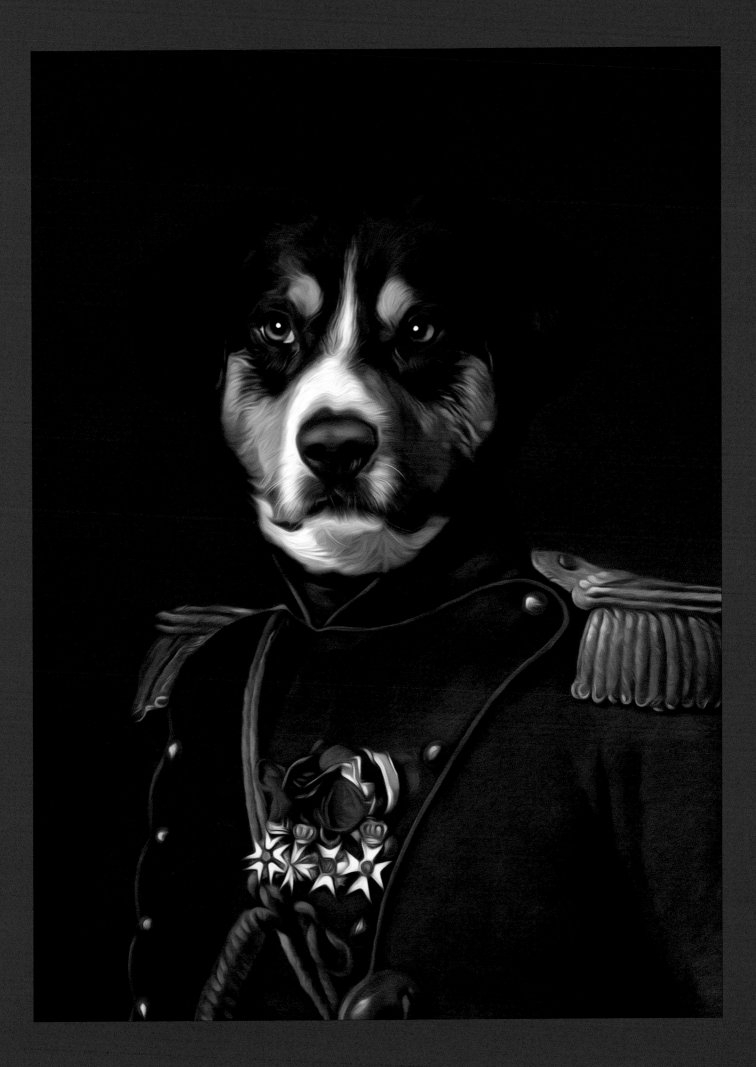

№ 33
PHilos

──────

He will always be remembered as a true and precious friend who looks so much like someone from the past. Graceful, mysterious, and loyal. His protective personality caused stability in particularly rough times. There's no doubt that good friends come along your path for a reason.

──────

Er wird stets als echter, teurer Freund in Erinnerung bleiben, wie jemand aus einer vergangenen Zeit. Seine beschützende Art – zuvorkommend, unergründlich und loyal – sorgte gerade in stürmischen Zeiten für Stabilität. Gute Freunde begegnen einem zweifellos aus gutem Grund.

──────

Sarà sempre ricordato come un amico autentico e prezioso che assomiglia a qualcuno del passato. Pieno di grazia, misterioso e fedele, la sua personalità protettiva ha creato stabilità in tempi particolarmente difficili. Non c'è dubbio che i buoni amici si incontrano per un motivo.

──────

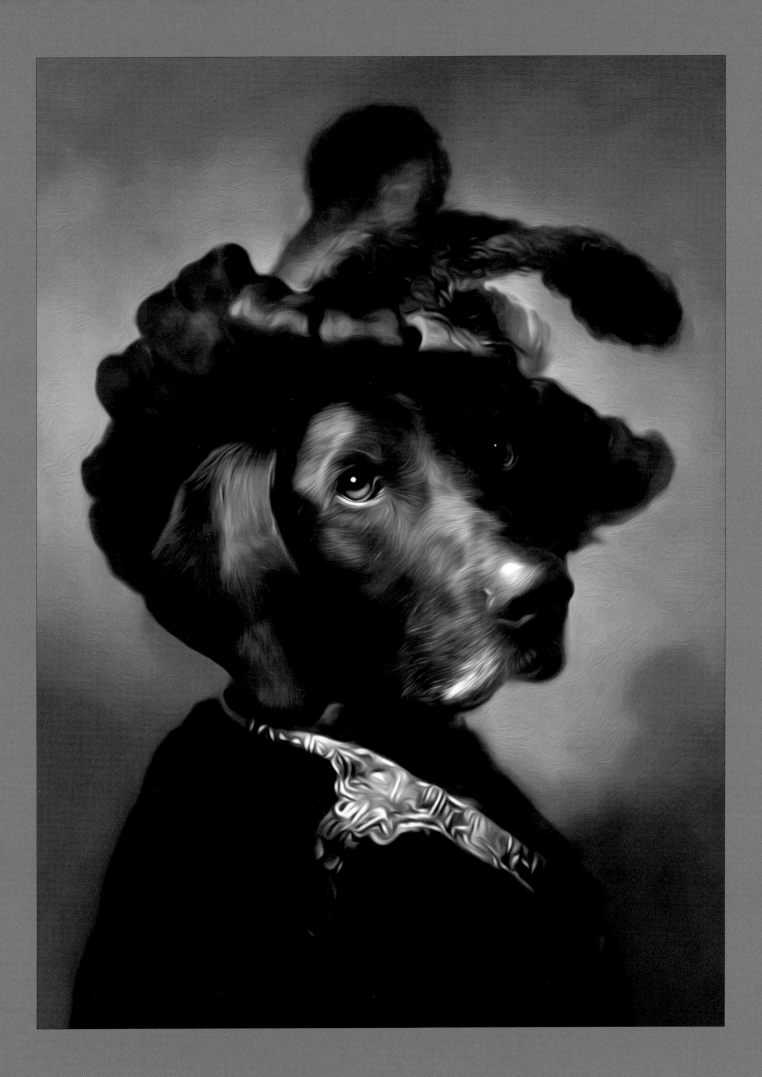

№ 34
Pastis

———

Pastis has a warm and caring personality.
Since he was little, his favorite thing has been
snuggling up. He doesn't care much about who
it is, it just makes him feel nice and needed.
Just like the old times, being on the couch between
mom and dad in front of the television.

———

Pastis ist warmherzig und fürsorglich. Kuscheln
war von klein auf seine Lieblingsbeschäftigung.
Mit wem, ist ihm gleich – er fühlt sich dadurch
wohl und hat das Gefühl, gebraucht zu werden.
Wie früher auf der Couch vor dem Fernseher
zwischen seiner Mutter und seinem Vater.

———

Pastis ha una personalità amorevole e accogliente.
Da quando è piccolo adora le coccole. Non gli
importa molto da chi provengano, comunque lo
fanno sentire bene e desiderato, proprio come ai
vecchi tempi quando stava sul divano tra papà e
mamma davanti alla TV.

———

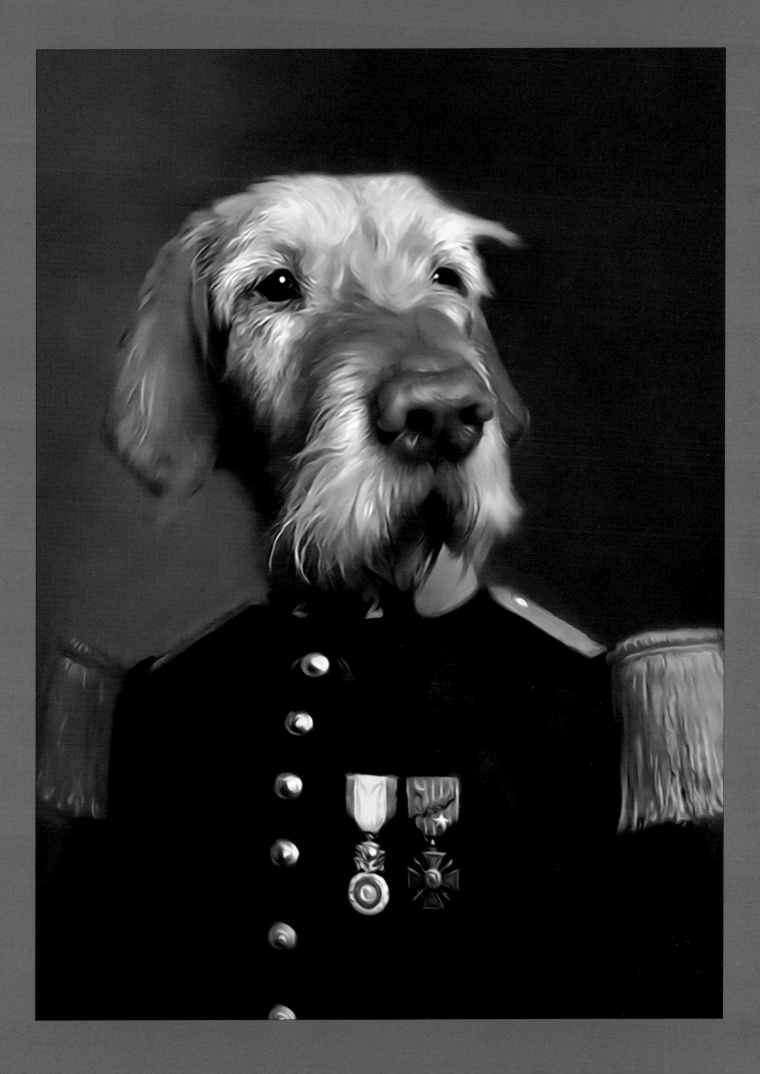

№ 35
Jack

He could never have thought that all of his dreams
would come true: being both a captain on a ship
and the head of a lovely family. When he was at
sea, he never realized how much he was missed as
a sweet and caring father.

Nie hätte er gedacht, dass all seine Träume wahr
würden: Kapitän auf einem Schiff zu sein und eine
nette Familie zu haben. Auf See war ihm gar nicht
klar, wie sehr er als lieber, fürsorglicher Vater
vermisst wurde.

Non aveva mai pensato che tutti i suoi desideri
si sarebbero avverati: diventare capitano di una
nave e capo di una bellissima famiglia. In mare
non si rese mai conto di quanto mancasse ai suoi
familiari come padre dolce e amorevole.

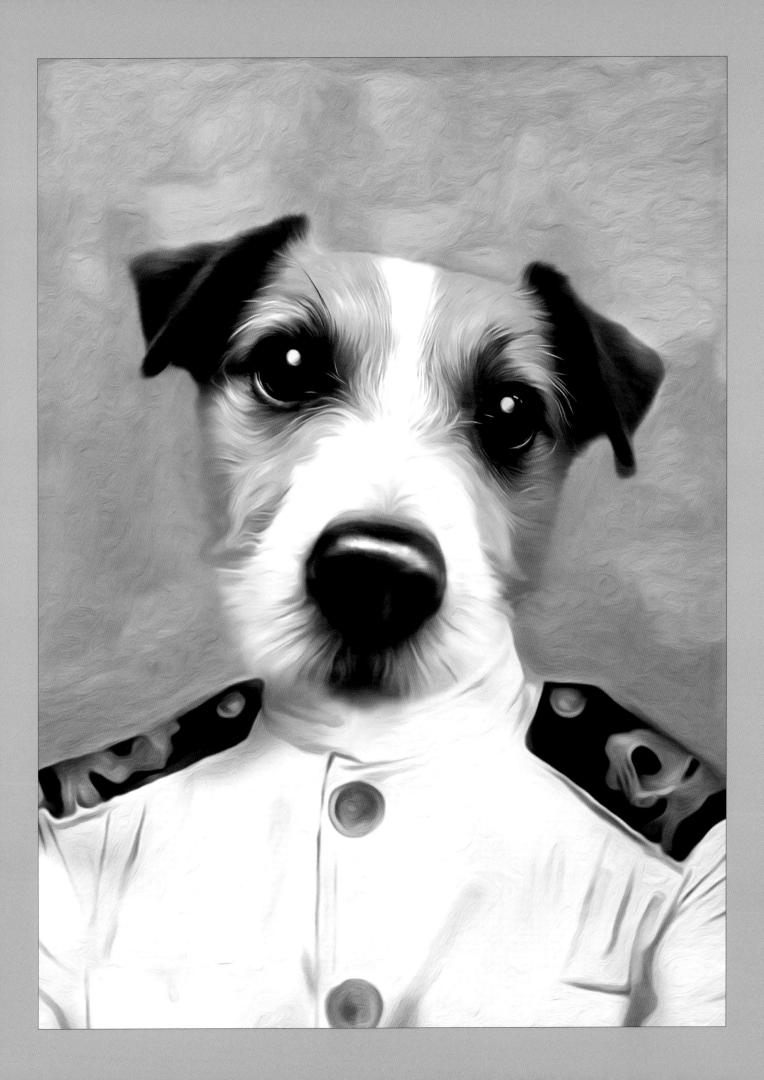

№ 36
Ladybear

———

For a long time, Ladybear's love and dedication
to her "big love" was too much. He didn't like to be
kissed. He tried to tell her many times, at first in
a polite way, and later in a very impolite way. In
the end, he chose to keep his distance from her.
Ladybear never gave up and kept on loving him
secretly. She dreamed about endless kisses in front
of the fireplace. How could she have known he
doesn't like kissing, she asked herself. Kissing was
all she could think of.

———

Lang waren Ladybears Liebe und Hingabe ihrer
„großen Liebe" zu viel. Er mochte es nicht, geküsst
zu werden. Viele Male versuchte er, es ihr zu sagen,
erst höflich und später unhöflich. Am Ende beschloss
er, sich von ihr fernzuhalten. Ladybear hat nie
aufgegeben und liebt ihn noch immer heimlich. Sie
träumt von endlosen Küssen vor dem Kamin. Woher
hätte sie denn wissen sollen, dass er nicht gern küsst,
fragt sie sich. Sie selbst kann nur ans Küssen denken.

———

Per molto tempo la passione e la dedizione di
Ladybear per il suo "grande amore" furono eccessive.
Lui non amava essere baciato. Cercò più volte
di dirglielo, prima con dolcezza e poi con modi
scortesi. Alla fine scelse di mantenersi a distanza da
lei. Ladybear non si è mai arresa e lo ama ancora
segretamente. Sogna baci infiniti davanti al camino.
Come poteva sapere che lui non amasse baciare,
continua a chiedersi. Baciare è l'unica cosa a cui
riesce a pensare.

———

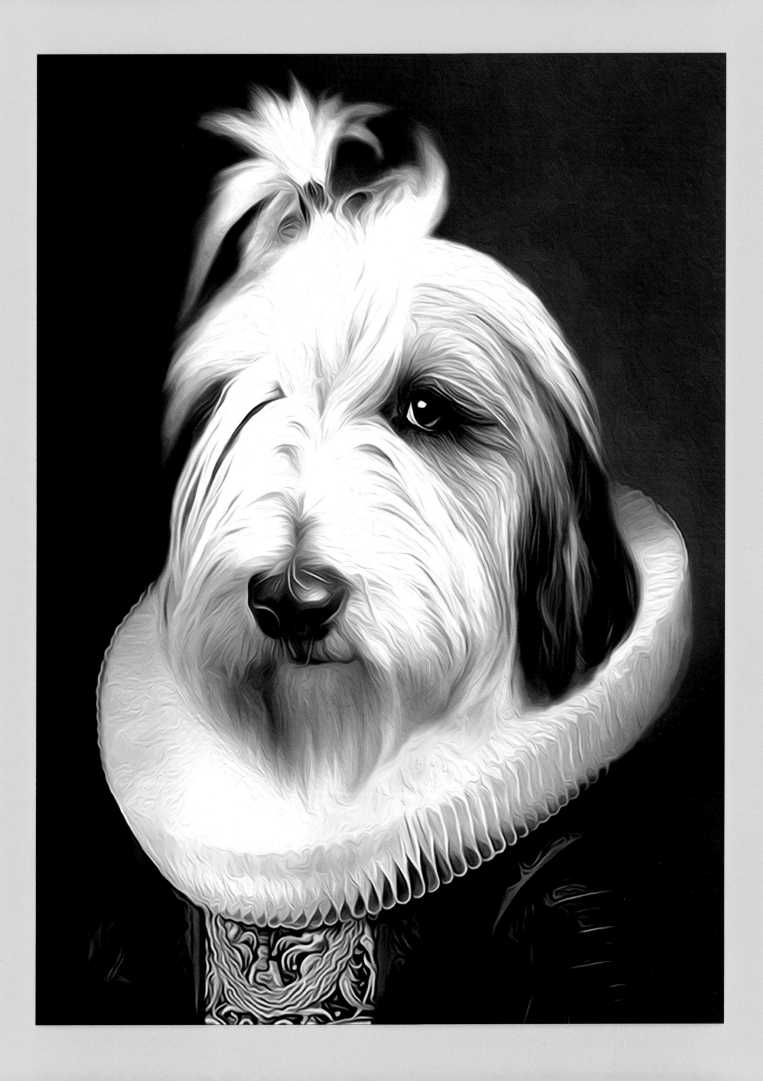

№ 37
Droop

It didn't seem to matter to him that he saw the
world with just one eye. He was grateful to see
anything at all. He had a little friend with great
attitude but poor hearing, who always sat by
his side. Together, they became a great team.
Where you saw one, the other wasn't be
far behind.

Offenbar kümmert es ihn nicht, dass er die
Welt nur mit einem Auge sieht. Er ist dankbar,
überhaupt etwas zu sehen. Sein kleiner Freund
mit großartiger Einstellung, aber schlechtem
Gehör sitzt immer neben ihm. Gemeinsam sind
sie ein tolles Team – wo man den einen sieht,
ist der andere nicht weit.

Sembra che non gli importi di osservare il
mondo con un solo occhio. È grato di poter
vedere e basta. Ha un piccolo amico, con un
bellissimo carattere ma udito scarso, che
siede sempre accanto a lui. Insieme sono un
fantastico team; se vedete uno dei due,
l'altro non sarà molto lontano.

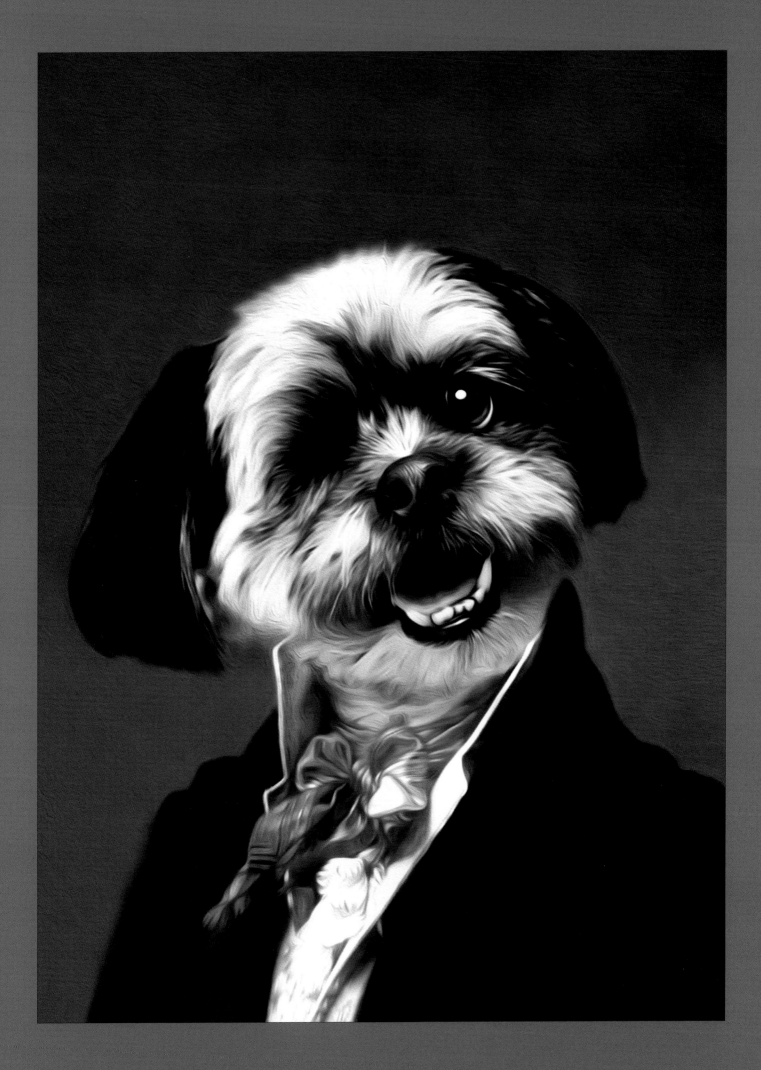

nº 38
Janice

———

All she wanted was to fit in, but to others
she looked so different. All they did was stare.
There was no one else like her around, no one for
her to compare herself with. Janice learned to be
independent. Only after moving to a big city she
discovered others that looked like her and she
understood why things happened the way they
did. After having learned to be alone, she now
values the importance of being amongst others.

———

Sie wollte nichts weiter, als sich einfügen, aber
für die anderen sah sie so anders aus. Sie starrten
sie nur an. Außer ihr gab es dort niemanden wie
sie. Janice lernte, unabhängig zu sein. Erst nach
dem Umzug in eine Großstadt fand sie andere,
die ihr ähnelten. Sie versteht, warum etwas so
passiert. Nachdem sie allein war, ist ihr der
Wert der Gesellschaft anderer bewusst.

———

Tutto quello che desiderava era sentirsi uguale
agli altri ma ai loro occhi sembrava così diversa.
Non facevano altro che guardarla. Nessuna era
come lei. Janice imparò a essere indipendente.
Solo dopo essersi trasferita in una grande città
scoprì altri con il suo stesso aspetto. Capisce
perché le cose succedono nel modo in cui
succedono. Dopo essere stata sola, apprezza
l'importanza della vicinanza degli altri.

———

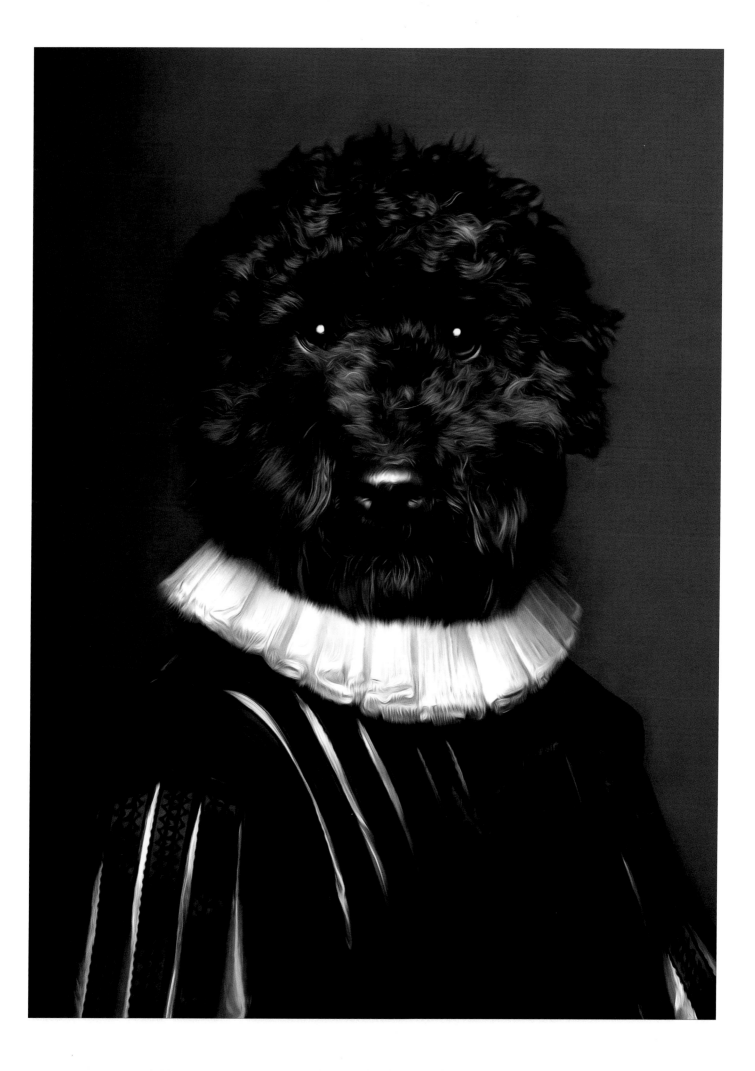

№ 39
suzy

———

Spoiled little Suzy likes to be on a stage.
Why doesn't everyone just look at her? Being
with her is nice for a while, but she'll never
understand the lesson "if you don't show interest
in others, you'll end up lonely." Will Lola one day
be smart enough to understand that the world
doesn't revolve around her?

———

Die verwöhnte kleine Suzy ist gern auf der Bühne.
Warum schaut nicht jeder nur auf sie?
Mit ihr zusammen zu sein ist zwar eine Weile
schön, aber sie lernt nie: Zeigt man kein Interesse
an anderen, endet man einsam. Hat Lola je genug
Verstand, um zu erkennen, dass sich die Welt
nicht um sie dreht?

———

La piccola Suzy è una bimba viziata, che ama
stare al centro dell'attenzione. Perché non la
guardano tutti? Stare con lei è piacevole per
un po', ma non impara mai. Se non si mostra
interesse per gli altri, si finisce per restare da soli.
Lola sarà abbastanza intelligente un giorno da
comprendere che il mondo non gira intorno a lei?

———

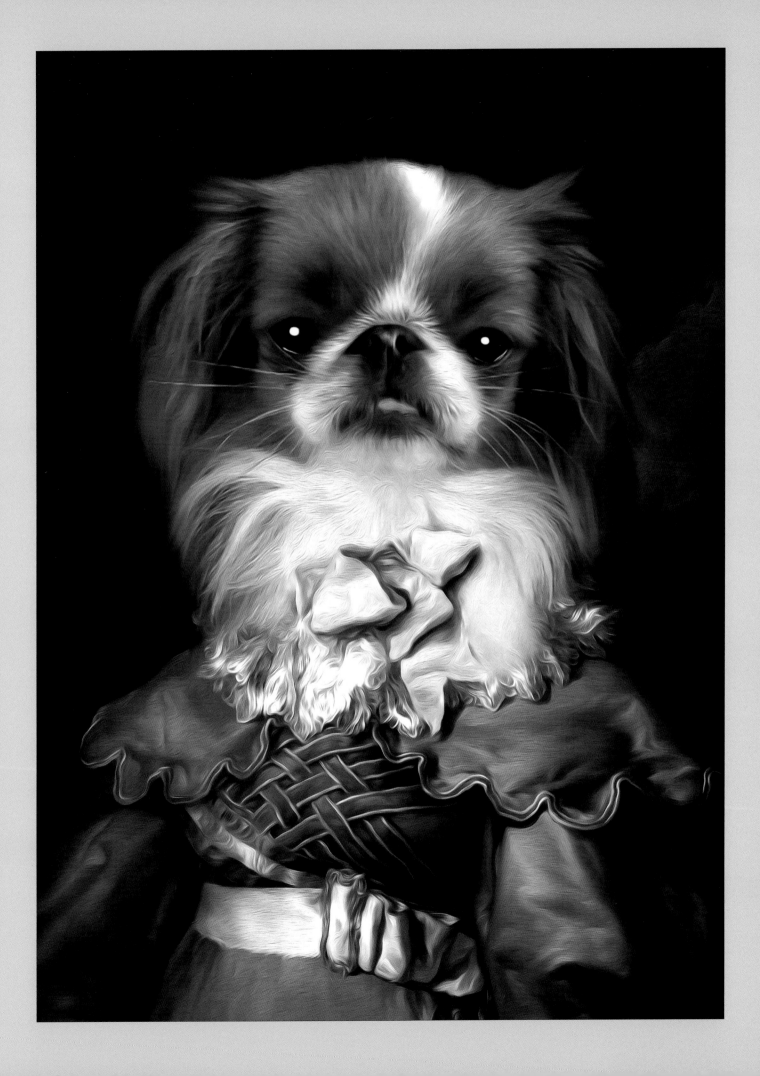

nº 40
puck

———

From the inside, she has completely recovered
from the sadness of the past. The only thing is that
every time she looks into the mirror, she sees the
scars left by the person she once was. Will she be
creative enough to face the scars and embrace
them because they shaped her into the beautiful
person she has become?

———

Innerlich hat sie sich ganz von den unglücklichen
Ereignissen der Vergangenheit erholt. Nur wenn
sie in den Spiegel schaut, sieht sie jedes Mal die
Narben derjenigen, die sie mal war. Wird sie
kreativ genug sein, um sich den Narben zu stellen
und sie anzunehmen, da sie sie zu dem schönen
Wesen gemacht haben, das sie nun ist?

———

Internamente si è del tutto ripresa dai tristi eventi
del passato. L'unica cosa è che ogni volta che si
guarda allo specchio, vede le cicatrici lasciate
dalla persona che era un tempo. Sarà abbastanza
creativa da affrontare quelle cicatrici e farle
proprie dato che ormai hanno preso la forma della
bellissima persona che è diventata?

———

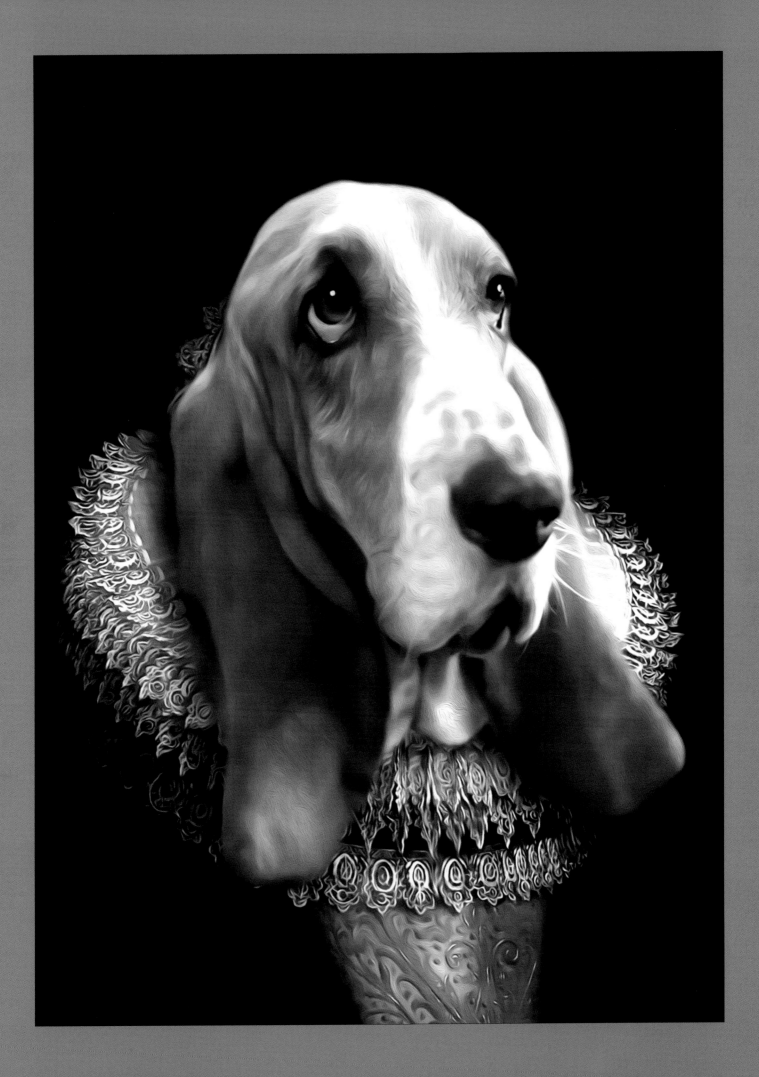

nº 41
ober

―――

As a hunter, he knew the forest was full of young
deer. His appetite for fresh meat was based on the
daily fresh meat on his plate. "Life should be about
having a good time every day," Ober thought!
He was a true hunter and a loner and didn't care
much about the feelings or opinions of others.
He thought that, as long as he just smiled, his
reputation will remain spotless.

―――

Als Jäger weiß er, der Wald ist voller junger
Hirsche. Sein Appetit auf Frischfleisch kommt
von dem täglich frischen Fleisch auf seinem Teller.
Im Leben sollte es darum gehen, jeden Tag Spaß
zu haben, denkt Ober. Er ist ein echter Jäger und
Einzelgänger, Gefühle oder Ansichten anderer
kümmern ihn kaum. Er denkt, solange er nur
lächelt, erscheint sein Ruf makellos.

―――

Da buon cacciatore, sa che il bosco è pieno di
giovani cervi. Il suo appetito per la carne fresca
si basa su quella che trova ogni giorno nel piatto.
Ober pensa che la vita dovrebbe farci divertire
ogni giorno. È un vero cacciatore e un tipo
solitario, non gli importa molto dei sentimenti o
delle opinioni degli altri. Pensa che, finché sorride,
la sua reputazione apparirà immacolata.

―――

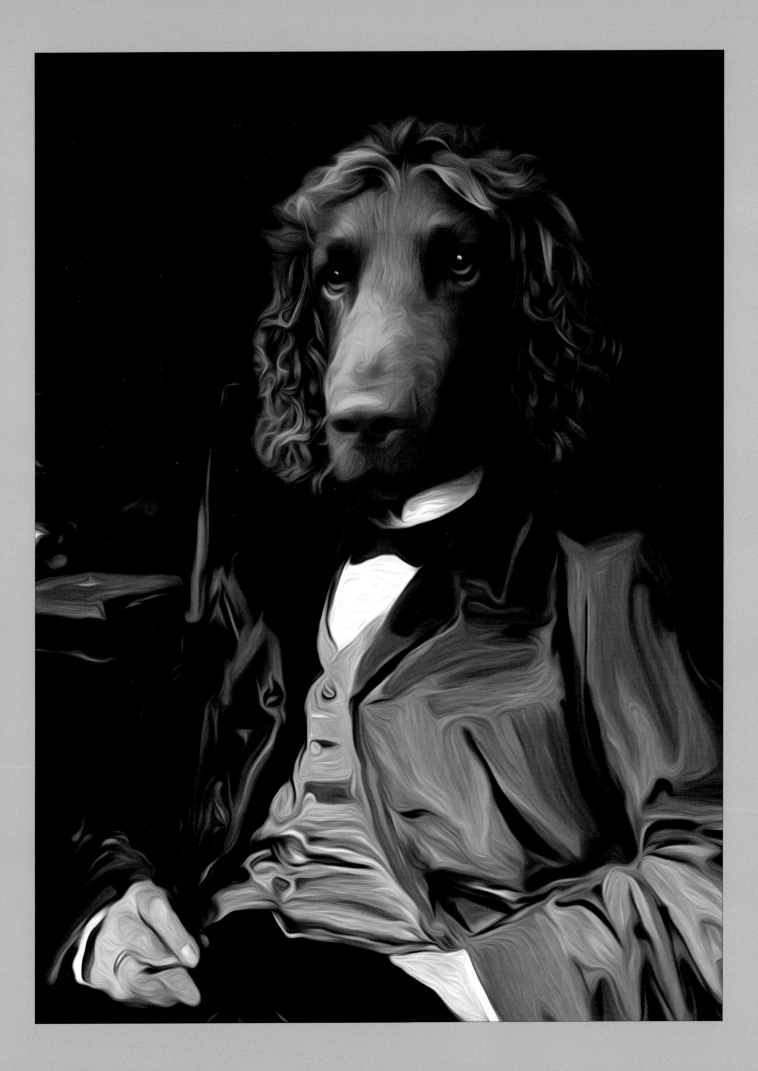

№ 42
Bram

———

He wished he could have said a proper goodbye
before leaving. He would have thanked his best
friend for the wonderful times they have spent
together and for the unlimited care and dedication
to his health during his life. Sometimes life is
not fair, especially when intense goodbyes are
necessary for special friendships to end.

———

Er wünschte, er könnte sich vor seinem Weggang
richtig verabschieden. Dann hätte er seinem
besten Freund für die tolle Zeit, die lebenslange
grenzenlose Fürsorge und das Bemühen um seine
Gesundheit gedankt. Manchmal ist das Leben
unfair, besonders wenn ein intensiver Abschied
nötig ist, damit eine spezielle Freundschaft endet.

———

Vorrebbe tanto riuscire a dire un vero e proprio
addio prima di partire. Ringrazierebbe il suo
migliore amico per il tempo fantastico passato
insieme e per le cure illimitate e la dedizione alla
sua salute che gli ha dedicato durante la vita.
Talvolta la vita è ingiusta, soprattutto quando
sono necessari addii intensi alla fine di
un'amicizia speciale.

———

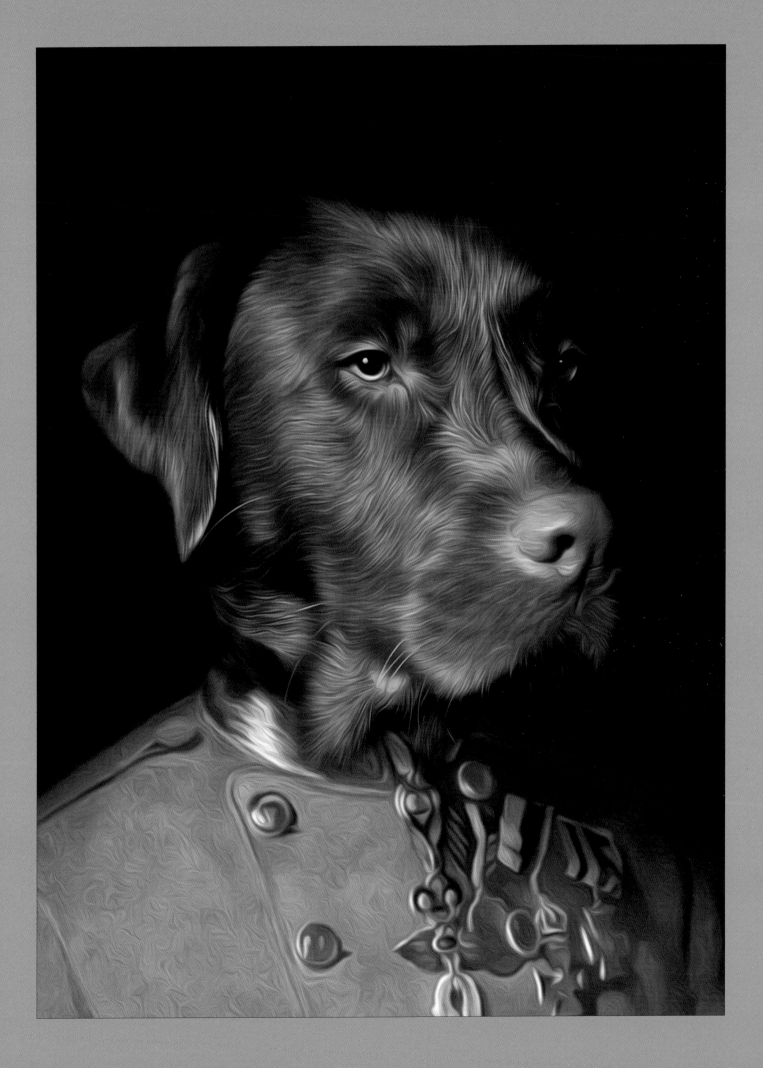

№ 43
Barbie

—

Beautiful Barbie has always been the prettiest
girl in school. Boys dreamed about her and
girls wanted to be her best friend. She was
popular without putting any energy into it.
She didn't understand why others were
struggling with their lives so much. Only
when her heart got broken for the first time
did she realize that life can be tough.

—

Die schöne Barbie muss stets das hübscheste
Mädchen der Schule sein. Jungen träumen
von ihr, Mädchen wollen ihre beste Freundin
sein. Sie ist ohne jegliche Anstrengung beliebt.
Sie versteht nicht, warum andere so sehr zu
kämpfen haben. Erst wenn sie das erste Mal
ein gebrochenes Herz hat, wird sie erkennen,
dass das Leben hart sein kann.

—

La bellissima Barbie deve essere sempre la più
carina della scuola. I ragazzi la sognano e le
ragazze vogliono essere la sua migliore amica.
È popolare senza che faccia fatica per questo.
Non comprende perché gli altri facciano così
tanta fatica nelle loro vite. Solo quando il suo
cuore si spezzerà per la prima volta, capirà
che la vita può essere dura.

—

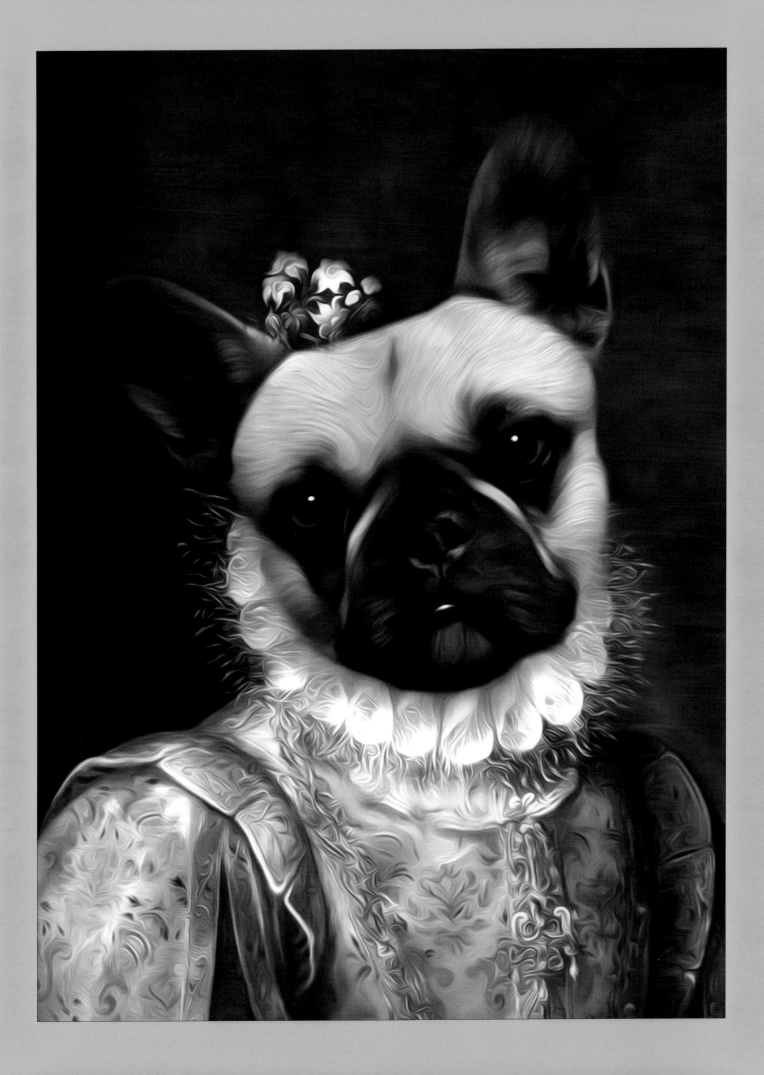

№ 44

Asia

———

She was known around the area for her perfect skin.
They called her 'a natural beauty'. Everybody expected
her to let a surgeon do some work on her when
gravity finally showed its marks and things started
to 'hang'. Asia has her own vision on being beautiful.
Eating healthy, staying out of the sun and going to bed
early is her contribution to growing old gracefully.
Unfortunately for her, spending your energy on
staying young is a battle you will lose anyways.

———

Sie ist in der Gegend für ihre perfekte Haut bekannt
und wird als natürliche Schönheit bezeichnet. Alle
denken, dass sie einen Chirurgen bemüht, wenn
die Schwerkraft später Spuren hinterlässt und
das „Hängen" einsetzt. Doch Asia hat ihre eigene
Vorstellung vom Schönsein. In Würde altern heißt für
sie gesunde Ernährung, Sonne meiden und früh zu
Bett gehen. Energie fürs Jungbleiben zu verwenden
ist ein Kampf, den man ohnehin verliert.

———

Tutti la conoscono per la pelle perfetta. La chiamano
una "bellezza naturale". La gente pensa che si affiderà
alle cure di un chirurgo quando la gravità inizierà a
lasciare i suoi segni e la pelle "penderà" dal suo corpo.
Asia ha la sua visione della bellezza. Per lei invecchiare
con grazia significa mangiare sano, trascorrere del
tempo al sole e andare a letto presto. Dedicare energie
a cercare di restare giovani è una battaglia
persa comunque.

———

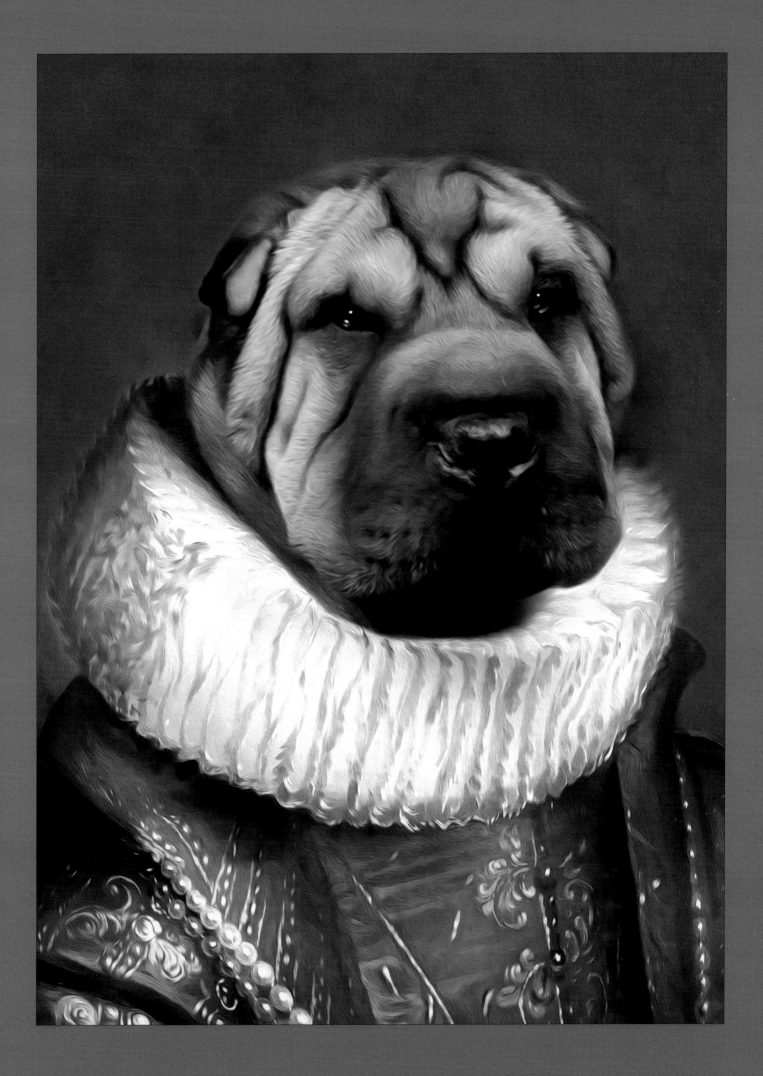

№ 45
vidi

————

The expensive-looking brand clothing hides his
loneliness. He wanted so badly to be loved and
accepted, but shiny objects and big logos attract
the ones who will never see inner beauty. It is just
a matter of time before Vidi bumps into someone
who will tell him about the real beauty of his heart
and that the façade he has built is actually not
really important.

————

Die teure Markenkleidung verbirgt seine
Einsamkeit. Er will so gern geliebt und akzeptiert
werden, aber Glitzerobjekte und große
Markenlogos ziehen all jene an, die seine innere
Schönheit nie sehen werden. Irgendwann trifft
Vidi bestimmt jemanden, der die wahre Schönheit
seines Herzens erkennt – und ihm sagt, dass die
Fassade nicht so wichtig ist.

————

Abiti firmati e dall'aspetto costoso nascondono
la sua solitudine. Desidera così tanto essere amato
e accettato, ma oggetti luccicanti e grandi loghi
attraggono chi non vedrà mai la sua bellezza
interiore. È solo una questione di tempo prima
che Vidi incontri qualcuno che percepisca la
vera bellezza del suo cuore e gli dica che l'aspetto
esteriore non è davvero importante.

————

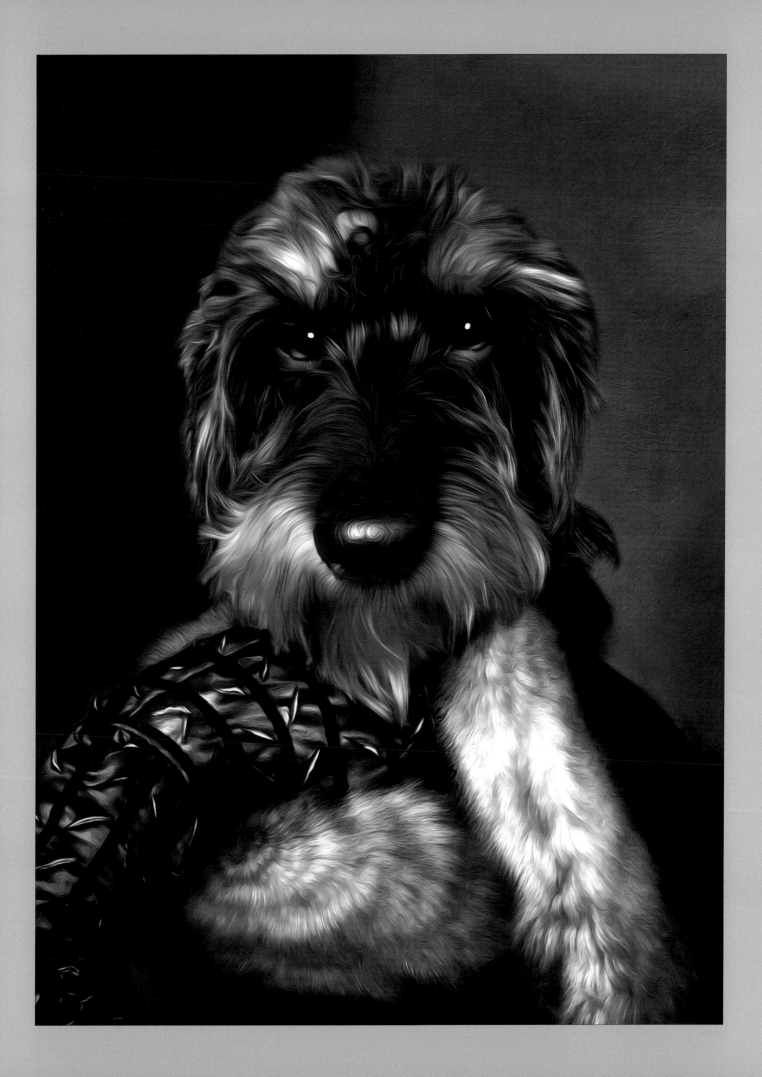

№ 46
Finn

―――

Finn fell in love with a girl from a family that
seems to be the enemy. He knows she will never
answer his love. Staying single is what he chooses,
but he keeps on hoping for a miracle. When he
ages, he notices the many broken hearts around
him and realizes that an unanswered love is
probably the best love one can have.

―――

Finn verliebte sich in ein Mädchen aus einer
„Feindesfamilie". Er wusste, sie würde seine
Liebe nie erwidern. Er blieb Single, hoffte aber
weiterhin auf ein Wunder. Mit dem Älterwerden
bemerkt er die vielen gebrochenen Herzen um
ihn herum und erkennt, dass eine unerwiderte
Liebe wahrscheinlich die beste Liebe ist, die
er haben kann.

―――

Finn si è innamorato di una ragazza di una
famiglia apparentemente nemica. Sa che non
ricambierà mai il suo amore. Così sceglie di
restare solo, ma continua a sperare in un miracolo.
Invecchiando, nota molti cuori infranti intorno
a lui e si rende conto che un amore non ricambiato
è probabilmente il migliore amore possibile.

―――

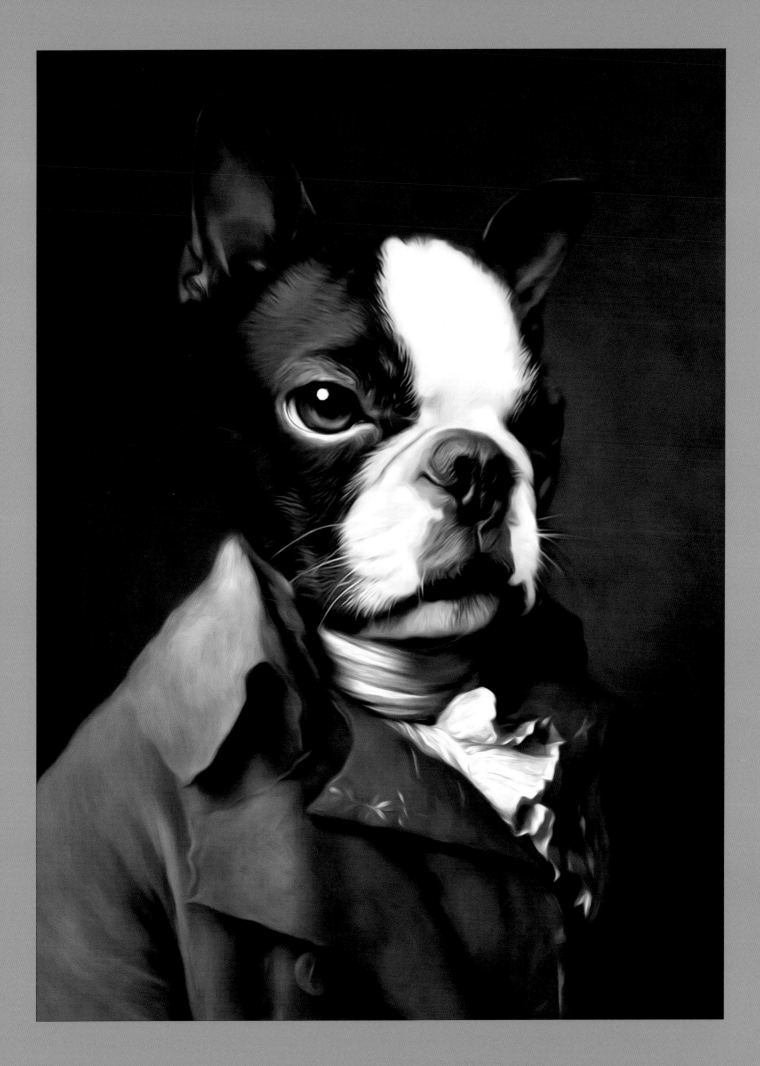

nº 47
Dexter

———

The most beautiful true and loyal friendship
started just after being rescued from a painful
situation. His heart will always have the need to
be protected, because his trust has been broken.
Anyone who cares for Dexter will be thanked
for their kindness, in the shape of friendship
for the rest of his life.

———

Die schönste wahre treue Freundschaft beginnt
kurz nach seiner Rettung aus einer schmerzlichen
Situation. Sein Herz wird immer das Bedürfnis
nach Schutz haben, da sein Vertrauen gebrochen
wurde. Jedem, der ihm zugetan ist, wird mit
Freundschaft fürs Leben gedankt.

———

L'amicizia più bella, vera e fedele inizia quando
si viene salvati da una situazione dolorosa.
Il suo cuore avrà sempre bisogno di essere protetto
perché la sua fiducia è stata tradita. Chiunque
abbia cura di lui sarà ringraziato sotto forma
di amicizia per la vita.

———

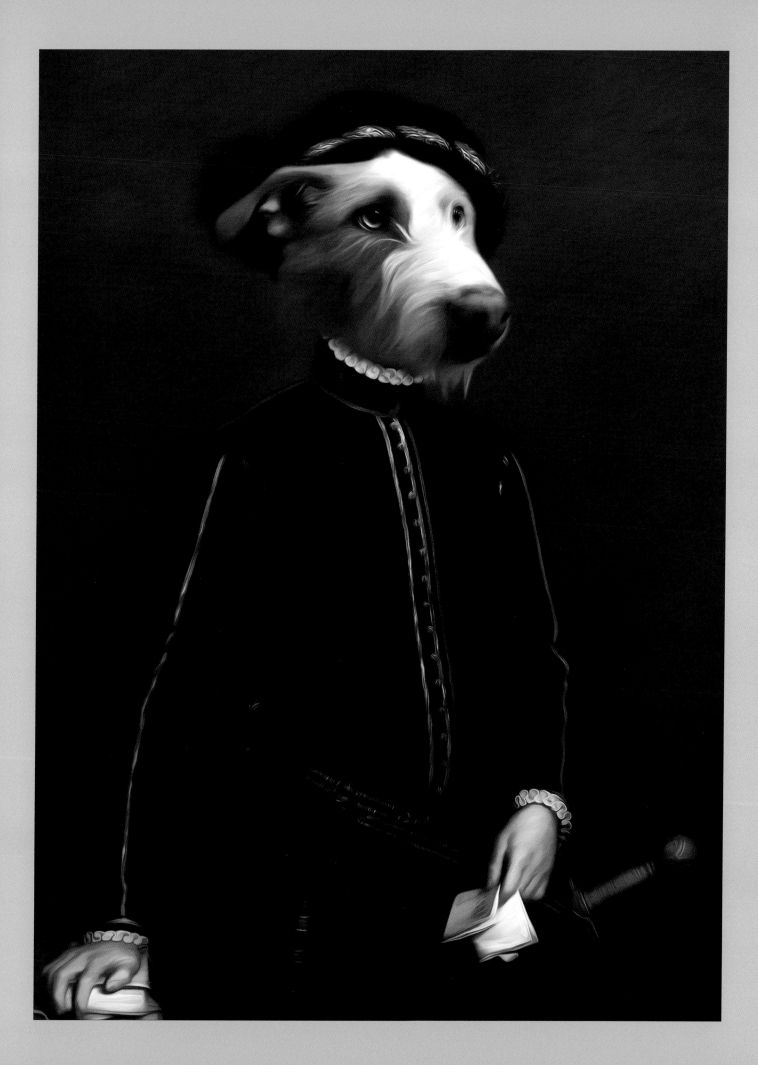

№ 48
Mac

―――

He doesn't think before he acts. In his childhood
that was something particularly challenging for
his parents. They had to learn to let go. It was no
surprise when Mac wanted to join the army where
they need fearless spirits, who don't think too
much about the result of their actions. Silly Mac
gave his life, and many body parts, in a stupid
war that will never end.

―――

Er denkt nicht nach, bevor er handelt. In seiner
Kindheit war das für seine Eltern sehr schwierig.
Sie mussten lernen, ihn gehen zu lassen.
Es überraschte kaum, als Mac zur Armee wollte,
wo ein furchtloser Geist, der nicht viel über die
Folgen seines Handelns nachdenkt, gebraucht
wird. Der dumme Mac gab sein Leben und
viele Körperteile hin in einem blöden, nie
endenden Krieg.

―――

Non pensa mai prima di agire. Quando era
bambino, questo era un problema per i suoi
genitori. Hanno dovuto imparare a lasciarlo
andare. Non è stata una sorpresa la sua decisione
di entrare nell'esercito, dove servono spiriti
impavidi, che non pensano troppo al risultato
delle loro azioni. Lo sciocco Mac ha offerto la sua
vita e parti del suo corpo in una stupida guerra
che non finirà mai.

―――

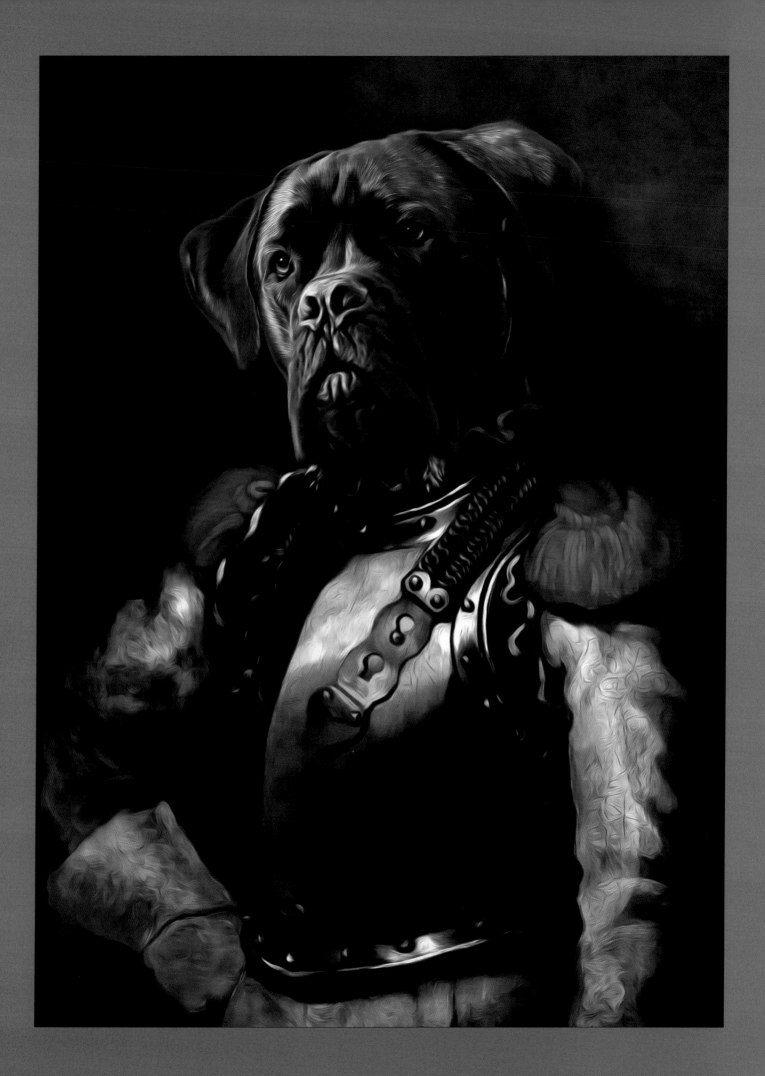

nº 49
Catherine

When Catherine entered a room, her being
"big" was always the subject of conversation.
She wished to be elegant, small, and petite
as the French say. Hiding or covering up the
truth was something that made people laugh.
Catherine learned that the only thing she
could do was being proud and happy with
who she is. Showing others how it's done to
pick a day, the very big way with grace.

Sobald Catherine den Raum betritt, ist ihr
„Großsein" Gesprächsthema. Sie wäre gern
elegant, klein, zierlich – „petite", wie die
Franzosen sagen. Will man die Wahrheit
verstecken oder zudecken, lachen die Leute.
Catherine hat gelernt: Das Einzige, was sie
tun kann, ist, stolz und zufrieden zu sein
mit dem, was sie ist, und anderen zu zeigen,
wie man den Tag stilvoll und mit Anmut
verbringt.

Quando Catherine entra in una stanza,
le sue "dimensioni" sono sempre l'oggetto
della conversazione. Vorrebbe essere
elegante, di dimensioni contenute, "petite"
come dicono i francesi. Nascondere o
camuffare la verità causa ilarità tra le
persone. Catherine ha imparato che l'unica
cosa che può fare è essere orgogliosa e
felice di ciò che è, mostrando agli altri come
affrontare la giornata pensando "in grande"
ma con grazia.

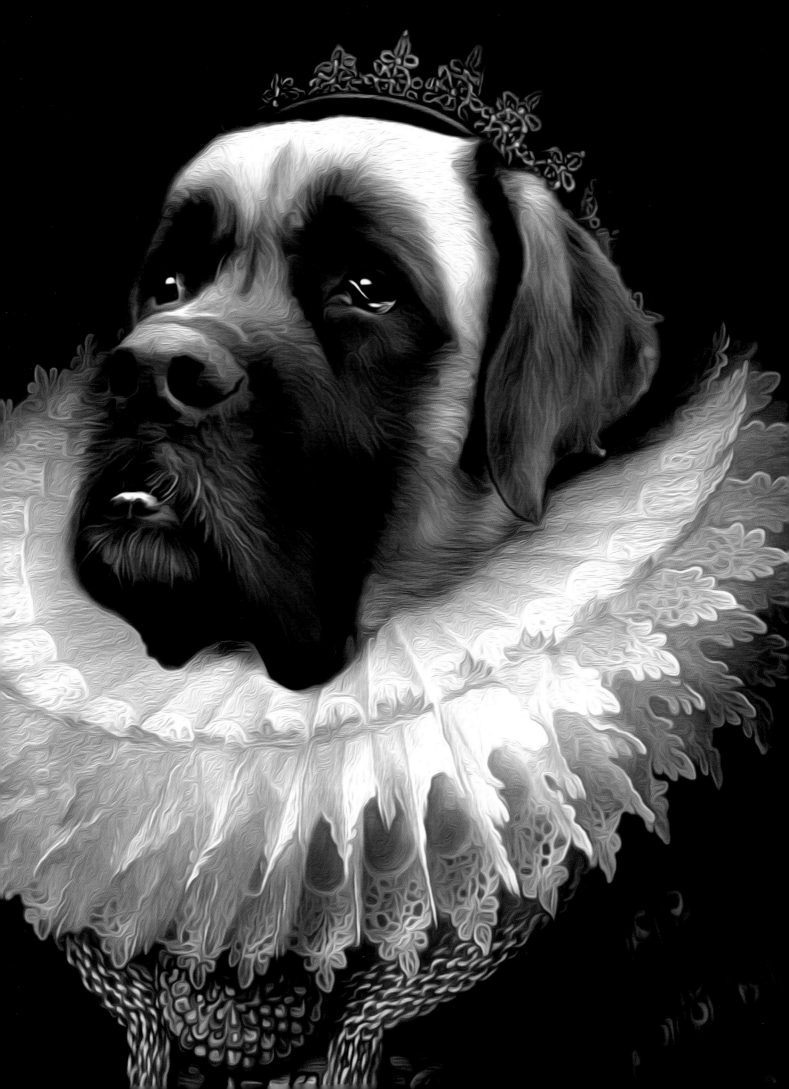

nº 50
Maisy
#MYDOGISAQUEEN

———

Slim and always happy, Maisy has been widowed
four times. Husband number five will be a keeper
she hopes. People in the little village say she
poisons her husbands. Some have seen that herbs
and medicines are stored in the same cabinet.
Maisy loves to cook for others, but she herself
hasn't eaten in 25 years. Bottled grape-juice is
the liquid diet she swears by to keep herself
slim and happy (in a spaced-out way).

———

Die anmutige, stets fröhliche Maisy ist vierfache
Witwe. Sie hofft, Nummer fünf wird der Mann
fürs Leben. In ihrer Kleinstadt sagt man ihr
nach, dass sie ihre Männer vergiftet. Angeblich
bewahrt sie Kräuter und Medizin im selben
Schrank auf. Maisy kocht gern für andere, hat aber
selbst seit 25 Jahren nicht gegessen. Sie schwört
auf Traubenmost-Flüssigdiät, um schlank und
(euphorisiert) zufrieden zu bleiben.

———

Snella e sempre felice, Maisy è stata vedova quattro
volte. Spera che il suo quinto marito resterà a
lungo con lei. La gente nella piccola città dove vive
pensa che avveleni i suoi mariti. Alcuni hanno
notato che conserva le sue erbe e le medicine nello
stesso armadietto. Maisy adora cucinare per gli
altri, ma lei non mangia da 25 anni. Il succo d'uva
è l'unica cosa di cui si nutre per restare snella e
felice (alterando la sua percezione della realtà).

———

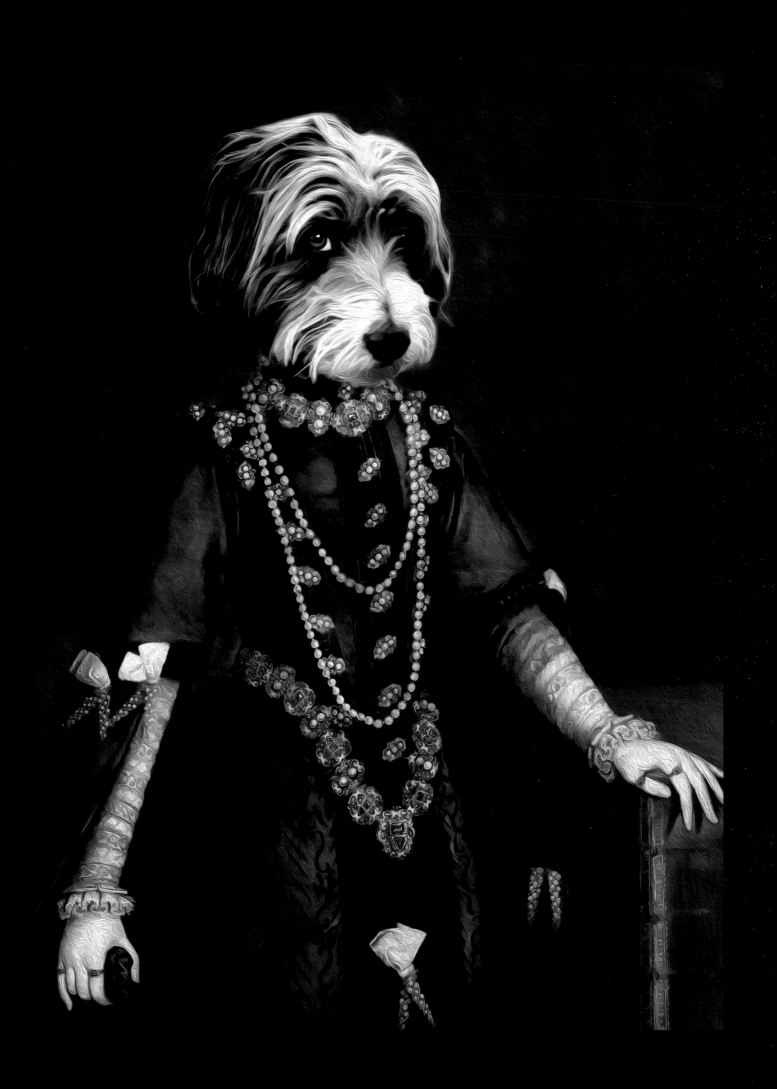

№ 51
Joey's mum

———

Little Joey is different. His brain works differently
than others. Mom understands who he is and loves
him to bits. Her job is protecting him from the
outside world. Out there, other people only have
'opinions' about him. No-one is curious enough
and no-one tries to communicate with her about
him. Mom knows that one day, Joey will need to
survive on his own. Her love is all she can give,
and she is so incredibly good at that!

———

Der kleine Joey ist anders. Sein Gehirn funktioniert
nicht so wie der Rest. Seine Mutter versteht, wer
er ist, und liebt ihn von ganzem Herzen.
Ihr Job ist es, ihn vor der Außenwelt zu schützen.
Draußen haben die Leute nur „Meinungen" über
ihn. Niemand ist interessiert genug, um mit ihr
über ihn reden zu wollen. Sie weiß, dass Joey eines
Tages allein überleben muss. Sie kann ihm nur ihre
Liebe geben, und darin ist sie sehr gut!

———

Il piccolo Joey è diverso. Il suo cervello non
funziona come quello degli altri. Sua madre sa
chi è e lo ama con tutto il cuore. Il suo compito è
proteggerlo dal mondo esterno. Là fuori la gente
ha solo "opinioni" su di lui. Nessuno è abbastanza
curioso da cercare di comunicare con lei in
merito al figlio. Lei sa che un giorno Joey dovrà
sopravvivere da solo. Il suo amore è tutto quel
può dargli, ed è bravissima a farlo!

———

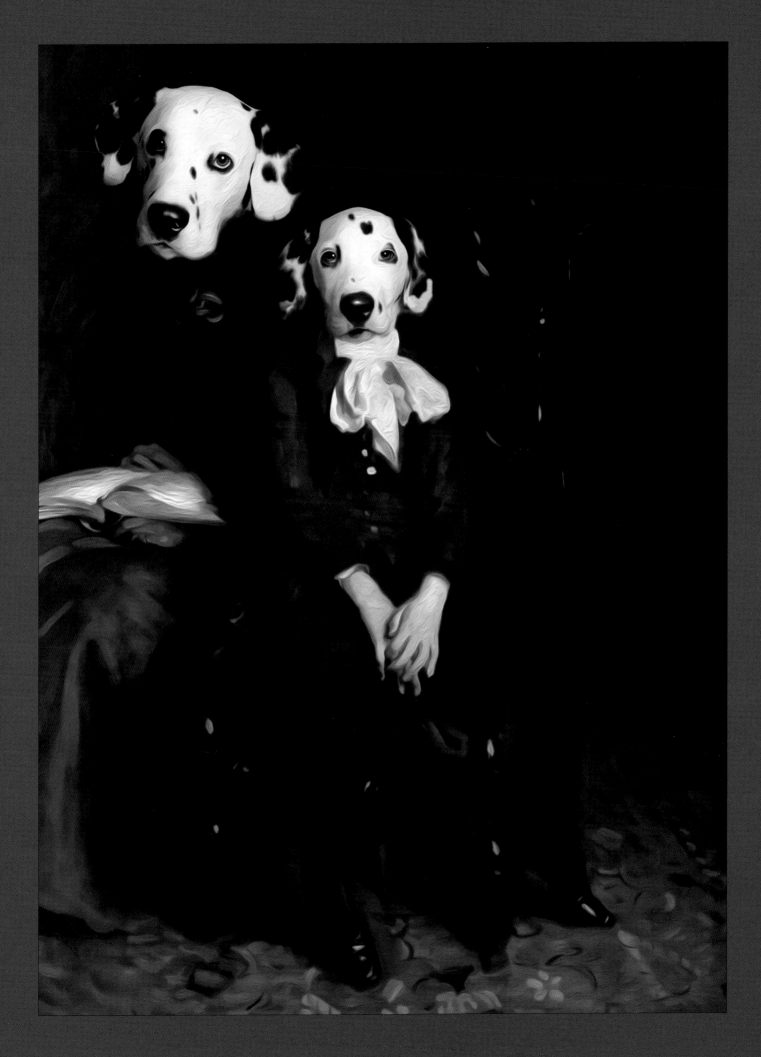

№ 52
zadig

———

He always knew he had a heart of gold, one of the
best around. He fell in love with someone who was
not ready for love. Sometimes doing your best is
not enough to make a partnership work. A long
time thereafter, when he had started a new life
elsewhere, his big love was able to see the beauty
that Zadig had offered. But it seemed too long
ago to apologize for betraying it.

———

Seit jeher wusste er, dass er ein Herz aus Gold hat.
Er verliebte sich, doch sie war nicht bereit dafür.
Sein Bestes tun reicht manchmal nicht, damit eine
Beziehung funktioniert. Später, als er anderswo
lebte, sah seine große Liebe das Schöne, das ihr
dargeboten worden war. Doch sie fand, es war zu
lang her, um sich dafür, dass sie es zerstört hatte,
zu entschuldigen.

———

Aveva sempre saputo di avere un cuore d'oro,
uno dei migliori in giro. Si innamorò di qualcuno
che non era pronto ad amare. A volte fare del
proprio meglio non è sufficiente a far funzionare
una relazione. Più avanti, dopo aver iniziato una
nuova vita altrove, il suo grande amore si rese
conto della bellezza che le era stata offerta, ma le
sembrò troppo tardi per chiedergli scusa per aver
rovinato tutto.

———

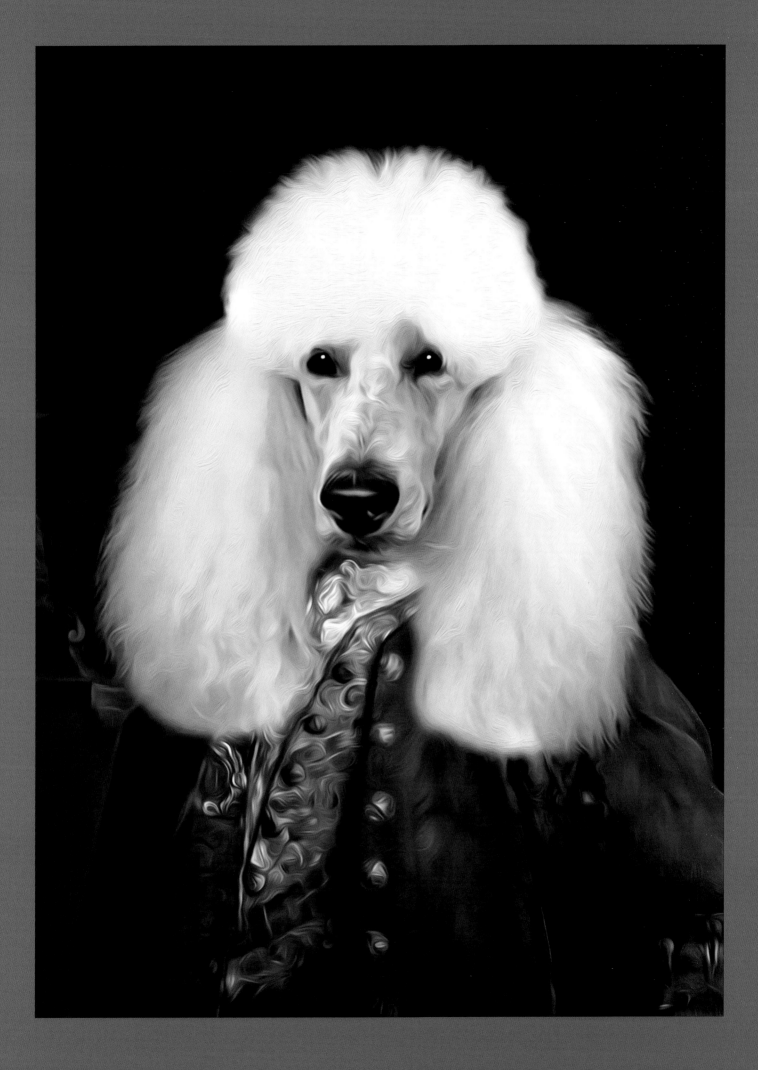

nº 53
Daisy

———

Daisy was very curious and had no bad intentions, but
curiosity is something not always appreciated by others.
She was just curious about how others live their lives and
wanted to understand how they can lie or cheat. Daisy
herself was not like that. She was a good girl, trying to
be there for others and help the ones in need. She has
learned however, that being too curious is not a good idea.
A lot of people are afraid to reveal their own darkness.

———

Daisy ist sehr neugierig. Sie hat zwar keine schlechten
Absichten, aber anderen gefällt ihre Neugierde nicht
immer. Sie will einfach nur wissen, wie andere leben,
und verstehen, wie manche lügen oder betrügen können.
Daisy selbst ist nicht so. Sie ist eine Gute, die für andere da
sein und Bedürftigen helfen will. Sie hat jedoch gelernt,
dass es nicht ratsam ist, allzu neugierig zu sein. Viele
Leute fürchten sich, ihre dunkle Seite preiszugeben.

———

Daisy è molto curiosa e non ha cattive intenzioni, ma gli
altri non sempre apprezzano la sua curiosità. È curiosa
di come vivono gli altri e vuole capire come fanno a
mentire o ingannare. Daisy non è così. È buona, cerca
di essere disponibile per gli altri e aiutare chi ha bisogno.
Ha tuttavia imparato che essere troppo curiosi non è una
buona idea. Ci sono tante persone che temono di
rivelare il proprio lato oscuro.

———

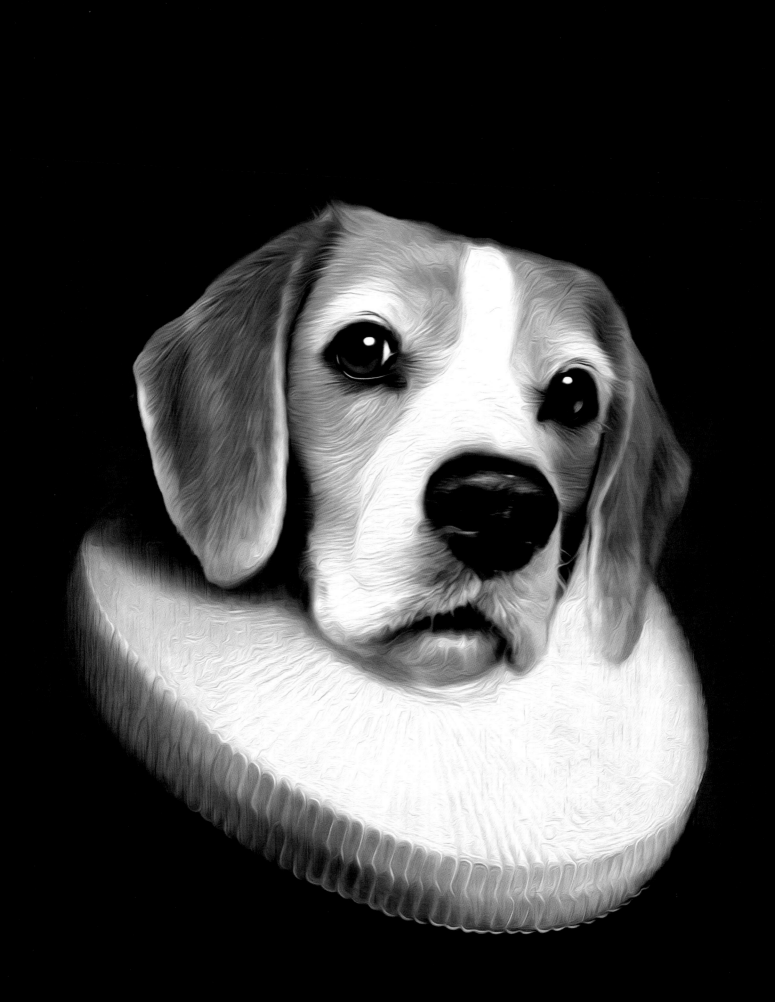

№ 54
Berber

———

Little Berber is a girl from the street. She is well-respected by the others who hang around, but she just doesn't want to fit in. She is happy in her own little mind. She looks at life the way she thinks is best and she believes that there is no need to try to fit in. Something good will come along her path. She is just patient.

———

Die kleine Berber ist ein Mädchen der Straße. Sie wird von anderen, die dort abhängen, geachtet. Einfügen will sie sich nicht. Sie ist zufrieden in ihrer kleinen Welt. Sie sieht das Leben so, wie sie es für richtig hält, und findet es unnötig, sich anzupassen. Etwas Gutes kommt schon noch. Sie ist geduldig.

———

La piccola Berber è una ragazza di strada. È rispettata dalle persone intorno a lei. Non ama uniformarsi alla massa, è felice con le sue piccole convinzioni. Guarda la vita nel modo che ritiene migliore e pensa che non serva cercare di adeguarsi al resto del mondo. Qualcosa di bello si presenterà sul suo cammino. Lei ha pazienza.

———

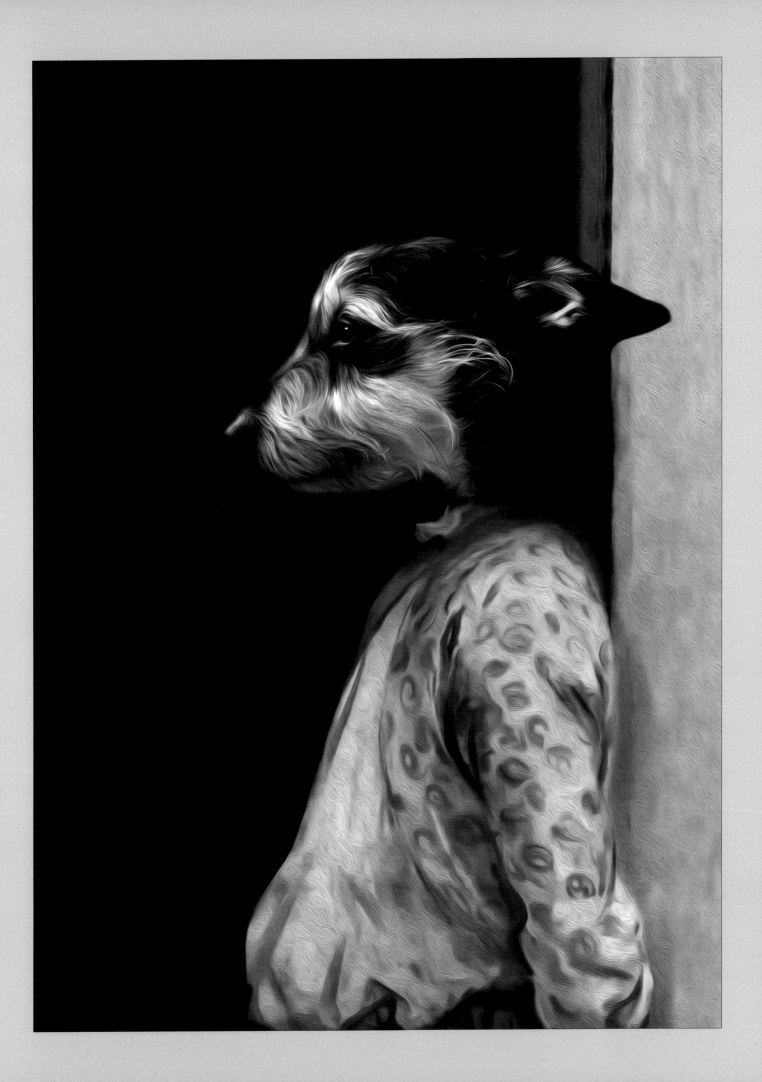

nº 55
Jip

———

Every year, his mom wants a nice photograph of him in a sailor uniform. Since he was little, this has been the way she likes to see him. But Jip thinks he is getting too old for this now. He doesn't even like the ocean or sailing. He told her "Mom, this is the last time I wear this stupid sailor outfit. I hope you will find something else next year and please be a little more creative!" So you want an innocent look? Here we go: eyes open, 'click', and mom is very happy for another year.

———

Jedes Jahr will seine Mutter ein nettes Foto in Matrosenuniform von ihm. Seit er klein war, sieht sie ihn gern so. Aber Jip denkt, dass er dafür zu alt wird. Er mag das Meer oder Segeln nicht mal. „Mom, das ist das letzte Mal, dass ich dieses dumme Matrosen-Outfit trage", sagt er zu ihr. „Ich hoffe, nächstes Jahr findest du ein anderes Outfit und lässt dir etwas mehr einfallen!" Der Fotograf fragt: „Ihr wollt also einen unschuldigen Look? Dann los: Augen auf!" Klick – und Jips Mutter ist für ein weiteres Jahr glücklich!

———

Ogni anno sua madre vuole una sua foto in uniforme da marinaio. Da quando era piccolo, è così che lei ama vederlo, ma Jip sta diventando troppo grande per questo. Non ama neanche l'oceano o navigare. Le ha detto "Mamma, è l'ultima volta che indosso questo stupido costume da marinaio. Spero che ne troverai uno diverso il prossimo anno e per favore, cerca di essere un po' più creativa!" Il fotografo chiede "Vogliamo ottenere un aspetto innocente? Siamo pronti: tieni gli occhi ben aperti!" "Clic." La madre di Jip è felice per un altro anno!

———

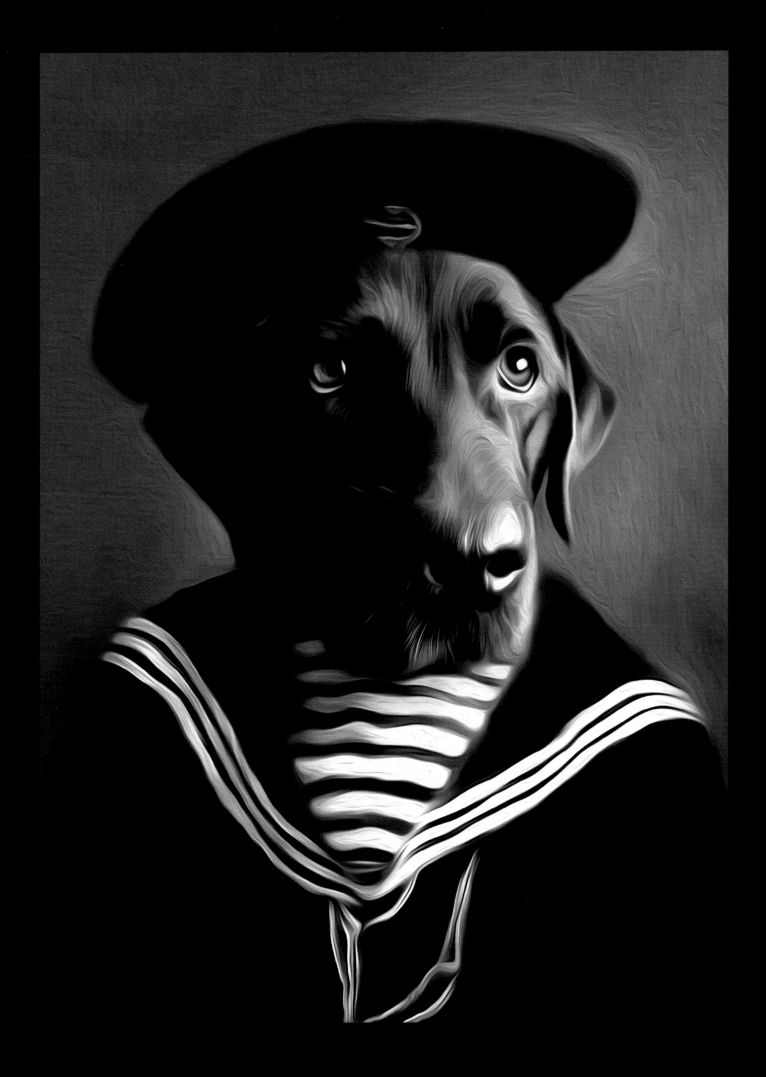

nº 56
Lola

———

Her stunning looks made many hearts beat faster. Lola was aware of her powers towards the opposite sex. She knew how to get things done and used this knowdlege in a manipulative way. Unluckily for Lola, other females envied her and her behavior so much that friendship with other girls was impossible. Lola just focused on the attention she got. Men are way more fun than other girls.

———

Ihr umwerfendes Äußeres lässt viele Herzen höherschlagen. Lola ist sich ihrer Macht über das andere Geschlecht bewusst. Sie weiß, wie sie ihren Willen bekommt, und spielt manipulativ damit. Leider beneiden ihre Geschlechtsgenossinen Lola so sehr, dass Freundschaften mit ihnen unmöglich sind. Lola konzentriert sich darauf, wer ihr Aufmerksamkeit schenkt. Männer sind ohnehin amüsanter.

———

I suoi look incredibili fanno battere molti cuori. Lola è consapevole dei suoi poteri nei confronti dell'altro sesso. Sa come fare le cose e riesce a manipolare persone e situazioni. Purtroppo per Lola, le altre donne invidiano lei e il suo comportamento al punto tale che avere un'amicizia femminile le risulta impossibile. Lola si concentra sull'attenzione che riceve. E comunque, gli uomini sono molto più divertenti delle ragazze.

———

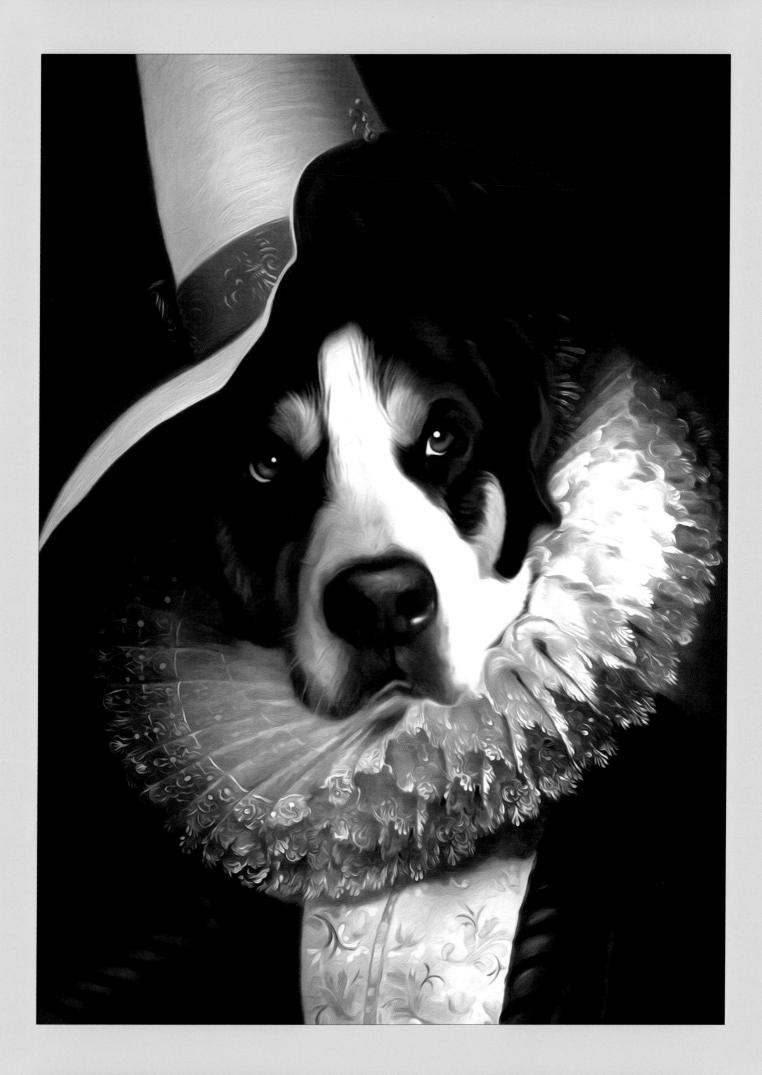

№ 57
wallie

Many girls worry about their hair being done
properly or about their nails being long, but Wallie
doesn't really care. She likes to wrestle and get
dirty. One day, she would like to be a loving mom,
raise beautiful kids, and watch them grow into
fine, caring adults. A career is not what she longs
for and some might call her old-fashioned.
Only a few find her very inspiring.

Manche Mädchen haben nur ihre Frisur oder lange
Fingernägel im Kopf. Nicht so Wallie. Sie ringt gern
und macht sich schmutzig. Eines Tages will sie
eine gute Mutter sein, hübsche Kinder großziehen
und sehen, wie sie zu anständigen, fürsorglichen
Erwachsenen werden. Sie will keine Karriere
machen. Manche nennen sie altmodisch.
Nur wenige finden sie inspirierend.

Alcune ragazze si preoccupano di avere capelli
ben pettinati o le unghie lunghe, ma a Wallie
non interessa tutto questo. Lei ama fare la lotta e
sporcarsi. Un giorno vorrebbe essere una buona
madre, crescere dei bellissimi bambini e guardarli
diventare degli adulti raffinati e premurosi.
Non ambisce a una carriera e qualcuno potrebbe
definirla una persona di vecchio stampo.
Solo alcuni la ritengono fonte di ispirazione.

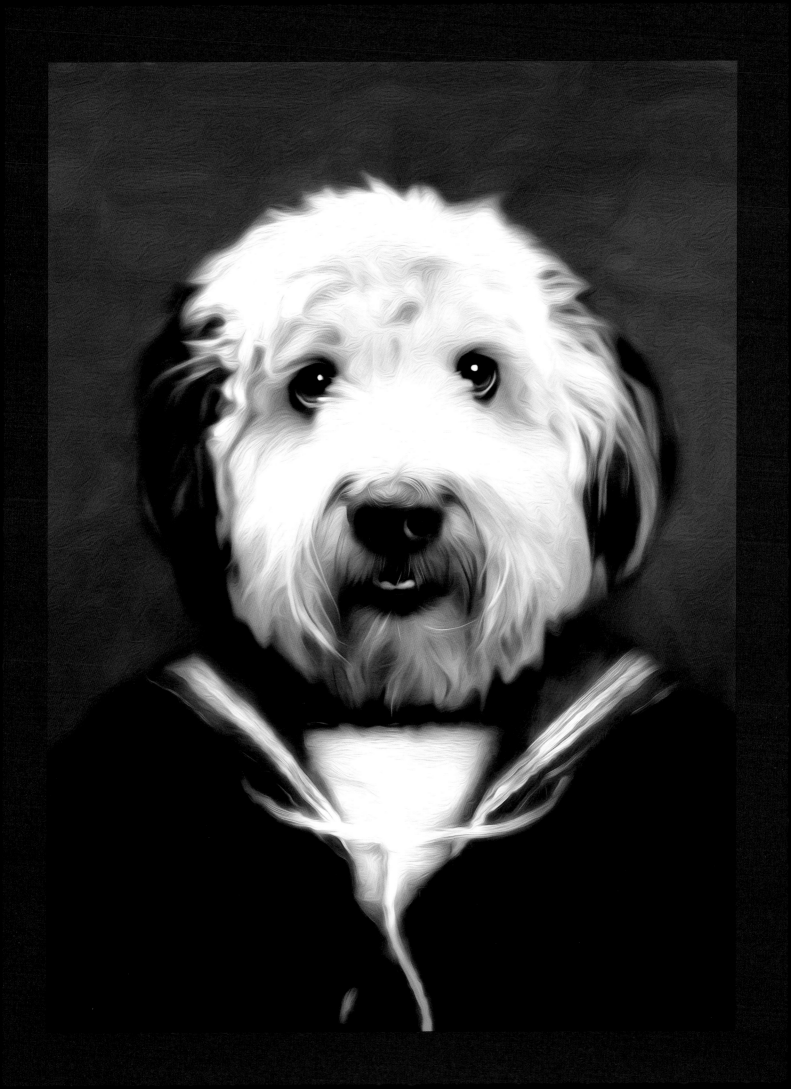

nº 58
Jazz

———

Little Jazz is easily distracted. Her mind always takes over when important things are being said. Jazz really does her best to be able to hear what the teacher says. But she asks herself why he is so uninspiring and tells stories with absolutely no passion or imagination. "Work on your performance," she wants to reply as the teacher comments on her continuous daydreaming. But she does not. Her mother once told her that no one likes rebels.

———

Die kleine Jazz ist schnell abgelenkt. Ihr Verstand schaltet sich nur ein, wenn etwas Wichtiges gesagt wird. Jazz tut ihr Bestes, um dem Lehrer zuzuhören, fragt sich aber, warum er so uninspiriert ist und eine Geschichte ohne jede Leidenschaft und Fantasie erzählt. „Arbeite an deiner Leistung", will sie entgegnen, wenn der Lehrer sagt, dass sie träumt. Doch sie tut es nicht. Ihre Mutter hat ihr einmal gesagt: „Niemand mag Rebellen."

———

La piccola Jazz si distrae facilmente. La sua mente prende il sopravvento quando vengono dette cose importanti. Jazz fa davvero del suo meglio per ascoltare ciò che dice il professore, ma si chiede perché sia così noioso e racconti le storie senza alcuna passione o immaginazione. "Lavori sulle sue prestazioni" vorrebbe rispondere all'insegnante che commenta il suo atteggiamento sognante. Ma non lo fa. Sua madre una volta le ha detto "A nessuno piacciono i ribelli".

———

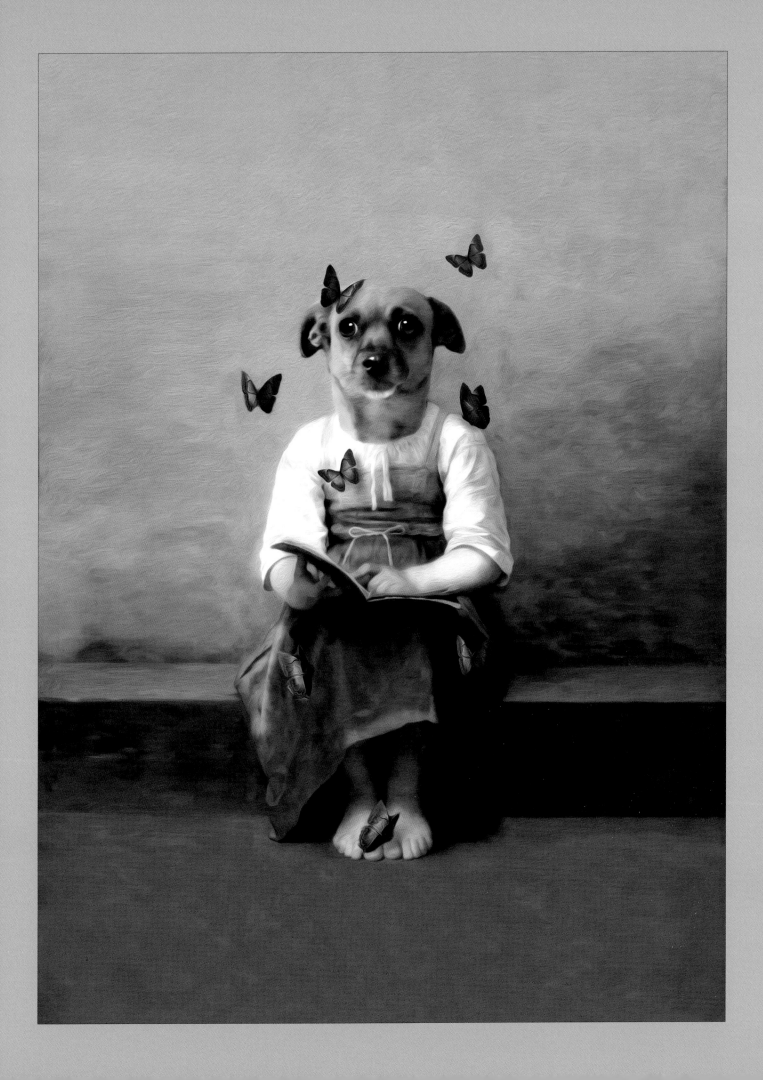

№ 59
E*dtje*

———

Ed was raised in a good family. He could have
never figured out that their staff would also
have feelings or would long for a personal life.
There was a clear line between family and staff.
When Ed's family passed away, he lived a long
but very lonely life.

———

Ed wuchs in einer guten Familie auf. Nie
verstand er, dass Angestellte auch Gefühle
haben oder gern ein Privatleben hätten. Es
gab eine klare Grenze zwischen Familie und
Personal. Als Eds Familie starb, lebte er noch
lang, aber sehr einsam.

———

Ed era cresciuto in una buona famiglia.
Non scoprì mai che anche il personale di
servizio aveva sentimenti o ambiva a una
vita personale. C'era una linea chiara tra
famiglia e personale di servizio. Alla morte
dei familiari di Ed, lui trascorse una vita
lunga ma di profonda solitudine.

———

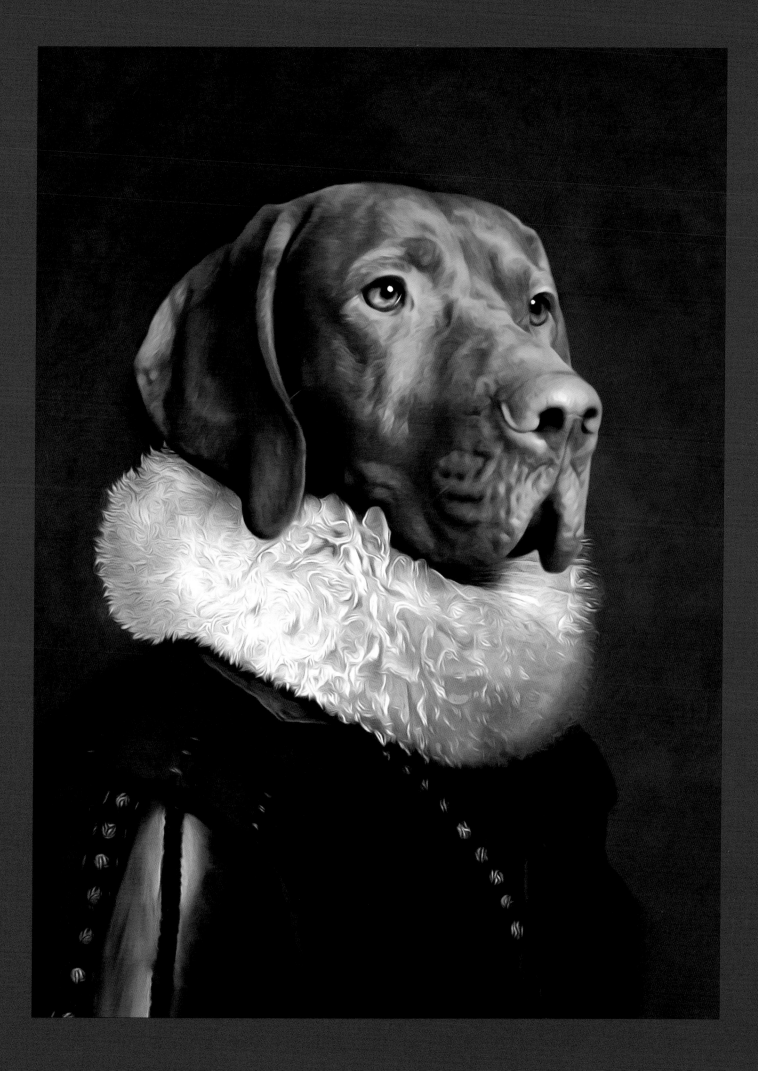

№ 60
Greta

———

Shy Greta always felt she doesn't really fit in.
She was a middle child and very sensitive and
pure. Others envied her beauty. She didn't care
about beauty but still tried to look her best,
just like anyone else. She longed for a sweet family
of her own and to love her kids as much as she
has been loved by her own parents.

———

Die schüchterne Greta hat stets das Gefühl, nicht
dazuzugehören. Sie ist ein Mittelkind, sensibel
und unverdorben. Andere beneiden sie um ihre
Schönheit. Doch Schönheit ist ihr egal. Sie will nur
möglichst gut aussehen, weil andere es auch so
machen. Sie möchte eine eigene Familie, damit sie
ihre Kinder so lieben kann, wie ihre Eltern
sie geliebt haben.

———

La timida Greta ha sempre la sensazione di non
essere al posto giusto. È la figlia mediana, molto
sensibile e pura. Gli altri le invidiano la bellezza.
A lei non importa del suo aspetto esteriore, anche
se cerca di apparire al meglio, come chiunque
altro. Desidera una famiglia amorevole tutta sua
per provare ad amare i suoi figli tanto quanto
lei è stata amata dai suoi genitori.

———

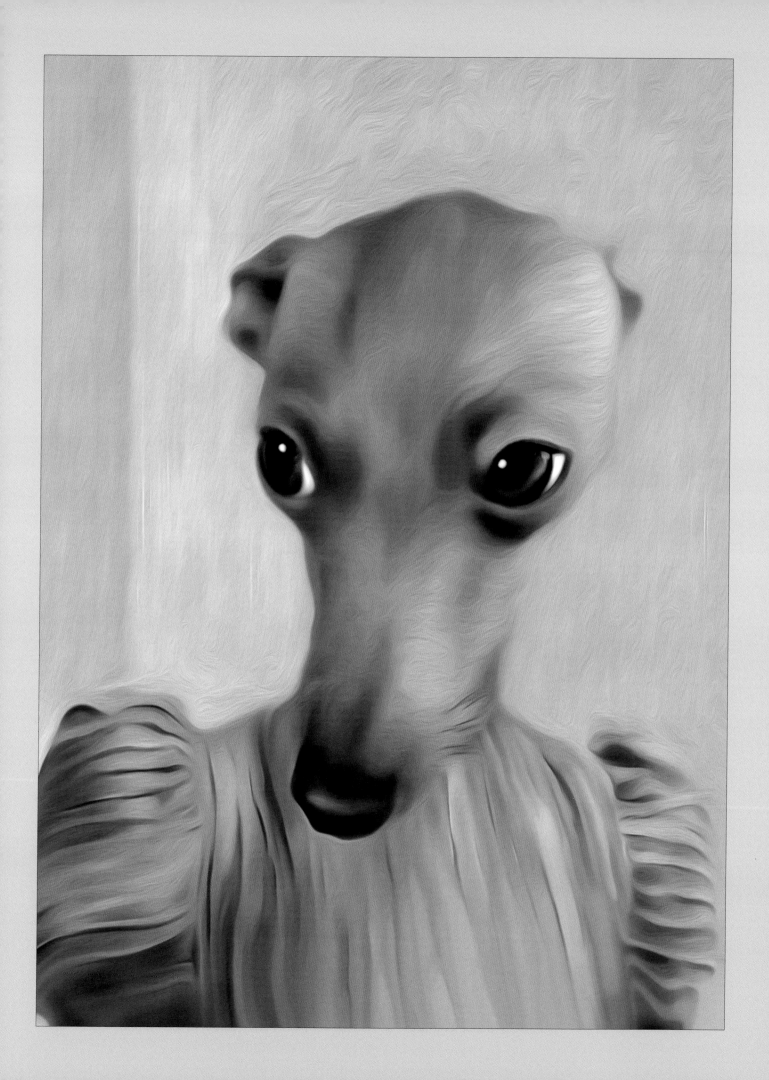

nº 61
Figaro

———

Figaro is trying to find out what he will become
when he is older. He needs to hurry up; he is
already turning grey. He knows that words
don't come easily and that shapes are made
better by others than by himself. While waiting
for his true destination, teachers are sent along
his path. It's not going to be easy, but it will
certainly be worth the ride.

———

Figaro will herausfinden, was er in höherem
Alter sein wird. Die Zeit drängt – er wird schon
grau. Er weiß, dass ihm Worte nicht leicht
zufallen und dass andere besser zeichnen als
er. Während er auf seine wahre Bestimmung
wartet, werden ihm zwischendurch immer
wieder Lehrer gesandt. Es wird zwar nicht
leicht sein, aber bestimmt lohnend.

———

Figaro sta cercando di capire cosa farà
da grande. Deve sbrigarsi però, si sta già
imbiancando. Sa che le parole non gli vengono
facilmente e che gli altri disegnano meglio
di lui. Mentre attende la sua vera vocazione,
gli vengono proposti diversi insegnanti. Non
sarà facile, ma ne varrà sicuramente la pena.

———

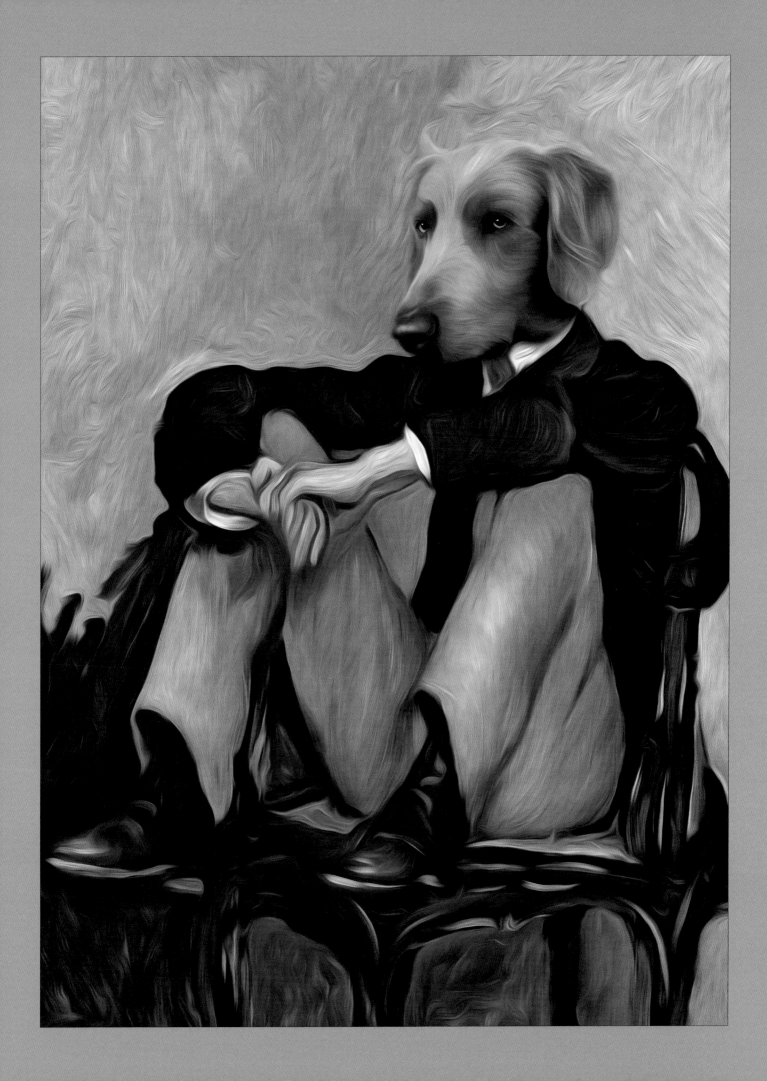

nº 62
Noisette

———

They call him nuts. He definitely knows he is not. He is a happy spirit that celebrates every new day. Those who call him stupid or superficial have much larger ambitions than he does. Noisette wishes them luck with their journey and simply cheers up with another new day. He lives happily ever after.

———

Andere nennen ihn verrückt. Er weiß, dass er es definitiv nicht ist. Er ist eine Frohnatur, feiert jeden Tag. Diejenigen, die ihn dumm oder oberflächlich finden, haben höhere Ambitionen als er. Noisette wünscht ihnen viel Glück, freut sich einfach an einem weiteren Tag und lebt glücklich bis an sein Lebensende.

———

Gli altri lo definiscono pazzo, ma sa per certo di non esserlo. È uno spirito felice che festeggia ogni giorno della sua vita. Chi lo definisce stupido o superficiale ha ambizioni più grandi di lui. Mentre augura agli altri buona fortuna nel loro viaggio, Noisette è grato di altro giorno e vive felice e contento.

———

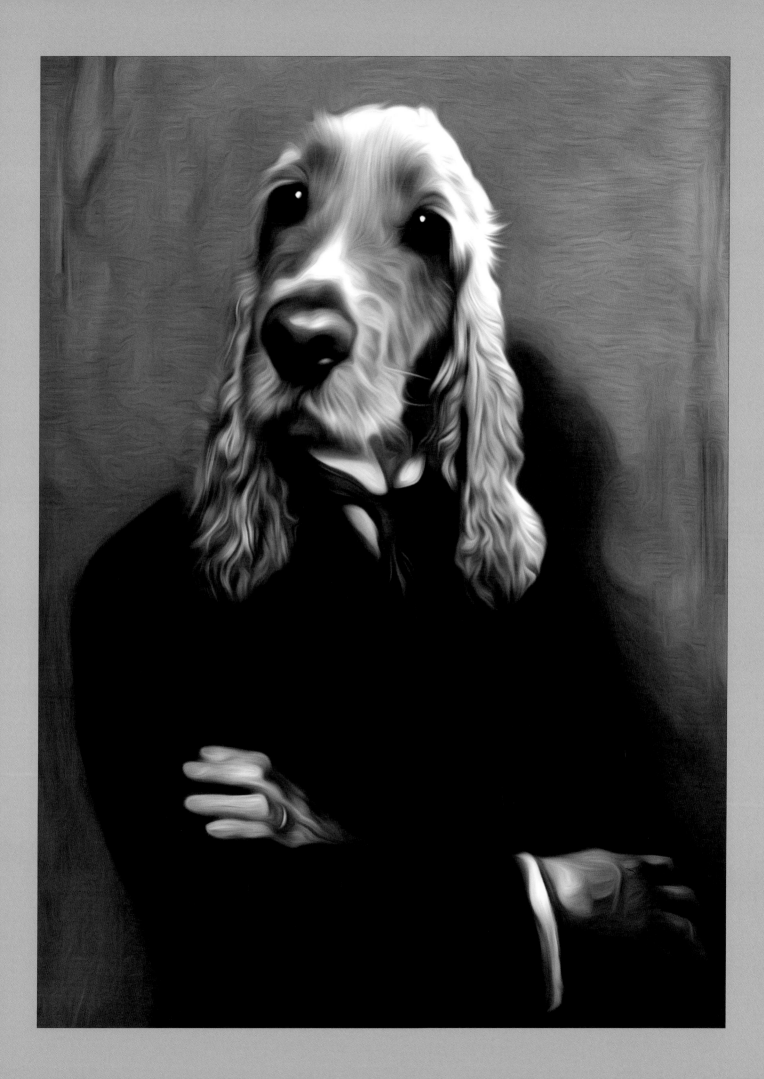

———

She was a self-made woman and had a big family
that she raised with love and care. When everyone
left the house, her dog became her pride and joy.
How did she succeed in making everything so
perfect? Tatiana learned that everything done
from the heart and with dedication will blossom
and be good.

———

Sie ist eine Selfmadefrau und hat viele Kinder,
die sie mit Liebe und Fürsorge aufzog. Als alle aus
dem Haus waren, wurde der Hund ihr ganzer Stolz
und ihre Freude. Wie kommt es, dass alles, was sie
anfasst, so perfekt wird? Tatiana hat gelernt, dass
alles, was von Herzen und mit Hingabe getan wird,
gut genug ist, um zu blühen und zu gedeihen.

———

Tatiana si è fatta da sé, ha una grande famiglia
che ha cresciuto con cura e amore. Quando se ne
sono andati tutti, il suo cane è diventato per lei
gioia e orgoglio. Come può accadere che tutto quel
che tocca diventa sempre così perfetto? Tatiana
ha imparato che tutto ciò che si fa col cuore e con
dedizione diventa abbastanza buono da fiorire e
prosperare.

———

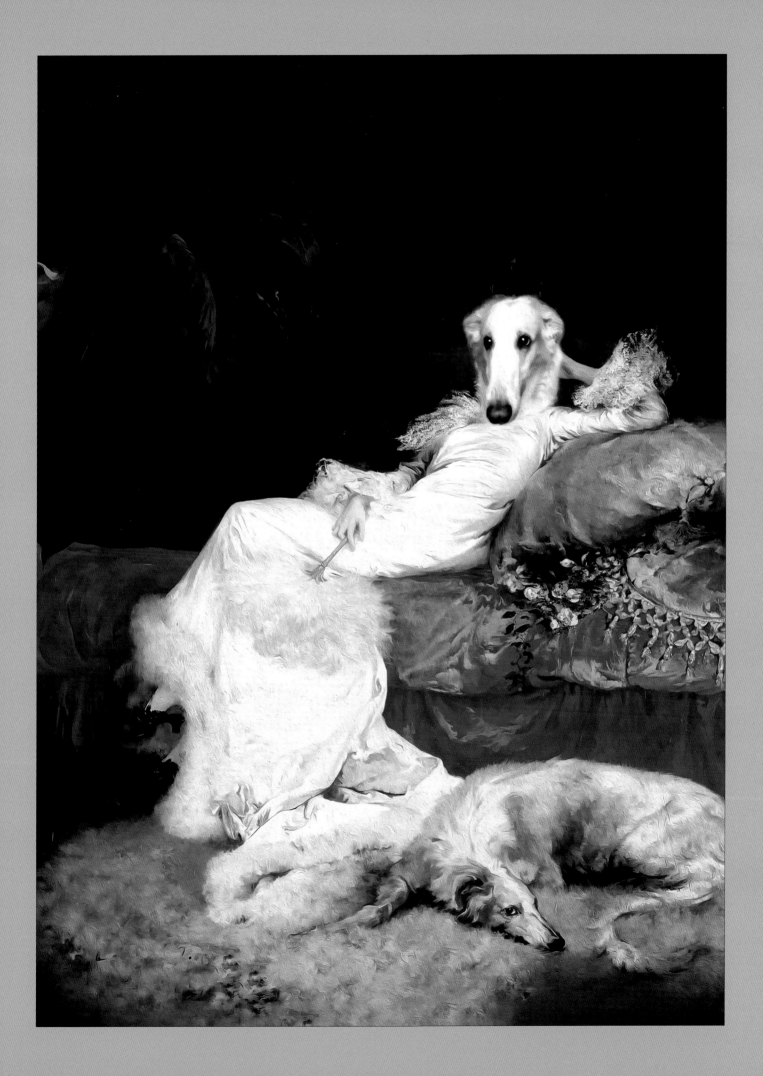

Monte

The leader of the pack. Despite his size, this
little man knows how true leadership works.
His good-hearted mom prepared him for his task:
"Always follow your heart, son." He never forgot
her kind words and tried to think what his mum
would do when situations were tough.

Rudelführer. Trotz seiner Größe weiß dieser kleine
Mann, wie echtes Führen geht. Seine gutherzige
Mutter bereitete ihn auf seine Aufgabe vor: „Folge
immer deinem Herzen, mein Sohn." Er vergaß
ihre freundlichen Worte nie und überlegt in
schwierigen Situationen, was seine Mutter täte.

Lui è un vero leader. Nonostante le sue dimensioni,
questo piccolo uomo sa come funziona la vera
leadership. La sua amorevole madre lo ha
preparato per questo compito: "Segui sempre il
tuo cuore, figliolo". Non ha mai dimenticato le sue
dolci parole e ha cercato di pensare cosa avrebbe
fatto sua madre nei momenti di difficoltà.

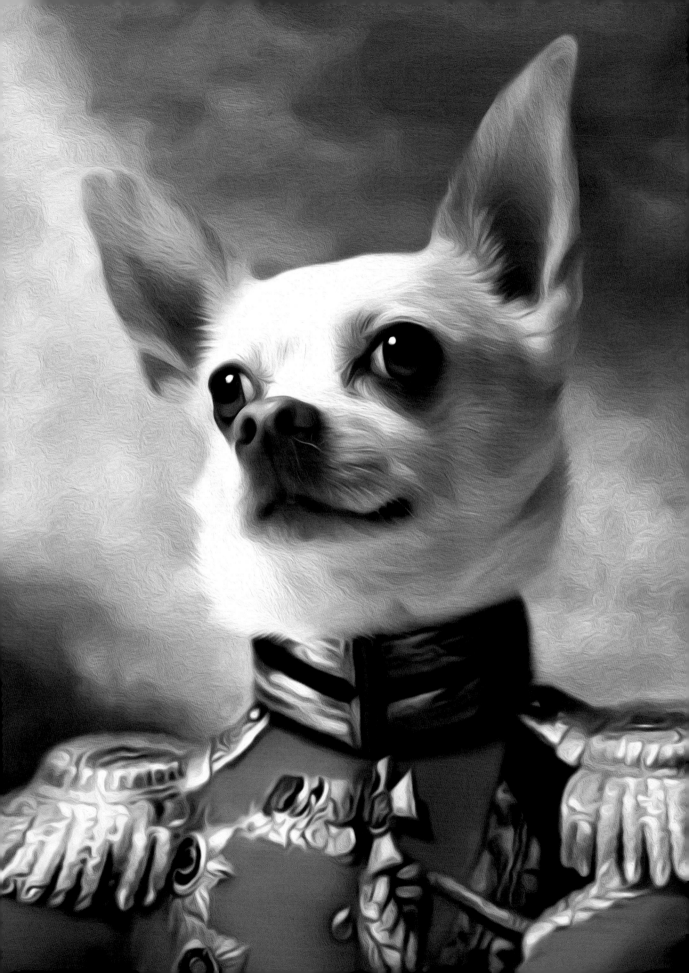

№ 65
Mik

―――

As a true king he has fought for justice.
Once his powers were slowly fading, he
realised the importance of his lifework. Doing
good will soon come to an end. He trusts that
new times will come after his departure.
Things will be different. Letting go will be
hard. But a life lived with a true heart will
always be remembered by the ones you
leave behind.

―――

Als wahrer König hat er für Gerechtigkeit
gekämpft. Mit dem Schwinden seiner
Kräfte erkannte er die Bedeutung seines
Lebenswerks. Gutes tun hat bald ein Ende.
Er hofft, dass neue Zeiten anbrechen, wenn er
gegangen ist. Es wird anders sein. Loslassen
fällt schwer. Doch an ein mit wahrhaftigem
Herzen geführtes Leben werden die, die
zurückbleiben, sich stets erinnern.

―――

Da vero re, si è battuto per la giustizia.
Quando i suoi poteri hanno iniziato ad
affievolirsi, si è reso conto dell'importanza del
suo lavoro di una vita. Fare del bene giungerà
presto a fine. Lui sa che dopo la sua partenza
arriveranno nuovi tempi. Le cose saranno
diverse. Lasciare andare sarà dura, ma una
vita vissuta con cuore autentico sarà sempre
ricordata da chi lasciamo dietro di noi.

―――

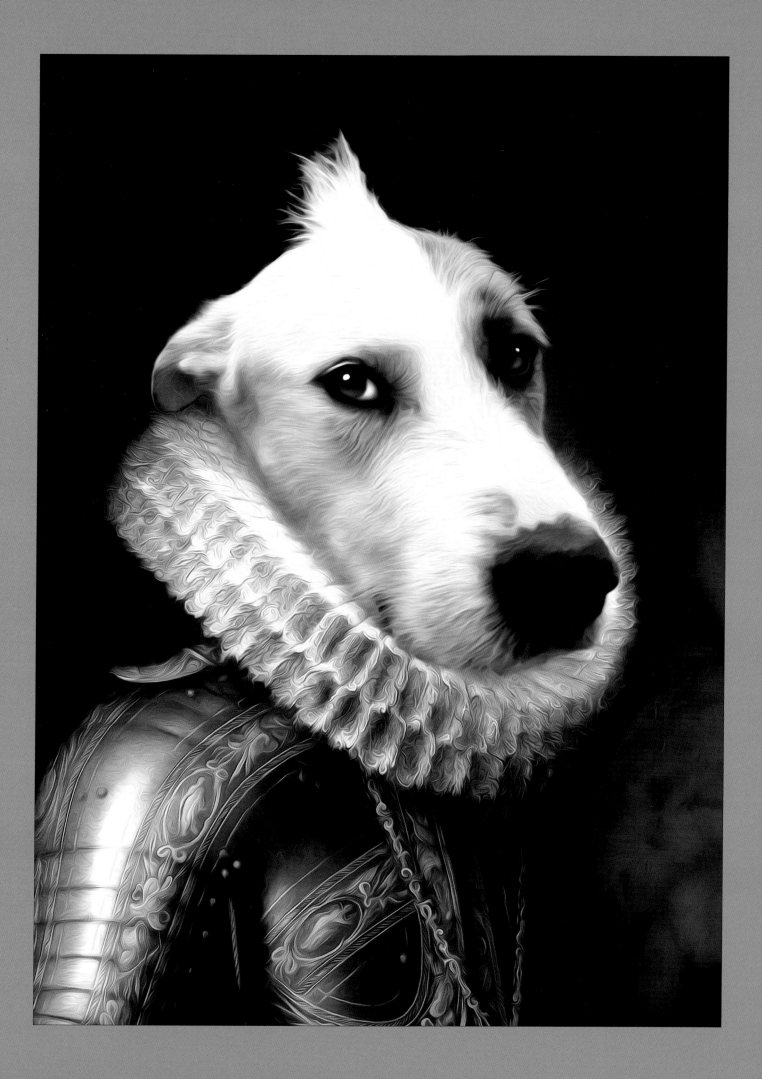

№ 66
oscar

———

During his childhood, Oscar got an overdose of
love from his troubled mother. This might have
caused his allergy to people with a good heart.
Oscar's big task is to forgive his mother. Accepting
her best intentions will make him able to receive
love as an adult. Will Oscar be brave enough to
face his biggest fear by forgiving his mom?

———

Als Kind erhielt Oscar von seiner besorgten Mutter
eine Überdosis Liebe. Vielleicht ist er deshalb
gegen gutherzige Leute allergisch. Seiner Mutter
zu vergeben ist Oscars Herausforderung. Damit er
als Erwachsener Liebe empfangen kann, muss er
akzeptieren, dass sie das Beste wollte. Wird Oscar
mutig genug sein, sich seiner größten Angst zu
stellen und seiner Mutter zu vergeben?

———

In gioventù, Oscar ha ricevuto un'overdose di
amore dalla madre instabile. Ciò deve avergli
causato un'allergia alle persone di buon cuore.
La sfida di Oscar è perdonare sua madre. Per
essere in grado di ricevere amore adesso che è
adulto, deve accettare il fatto che sua madre aveva
le migliori intenzioni. Oscar sarà abbastanza
coraggioso da affrontare la sua più grande paura,
ovvero perdonarla?

———

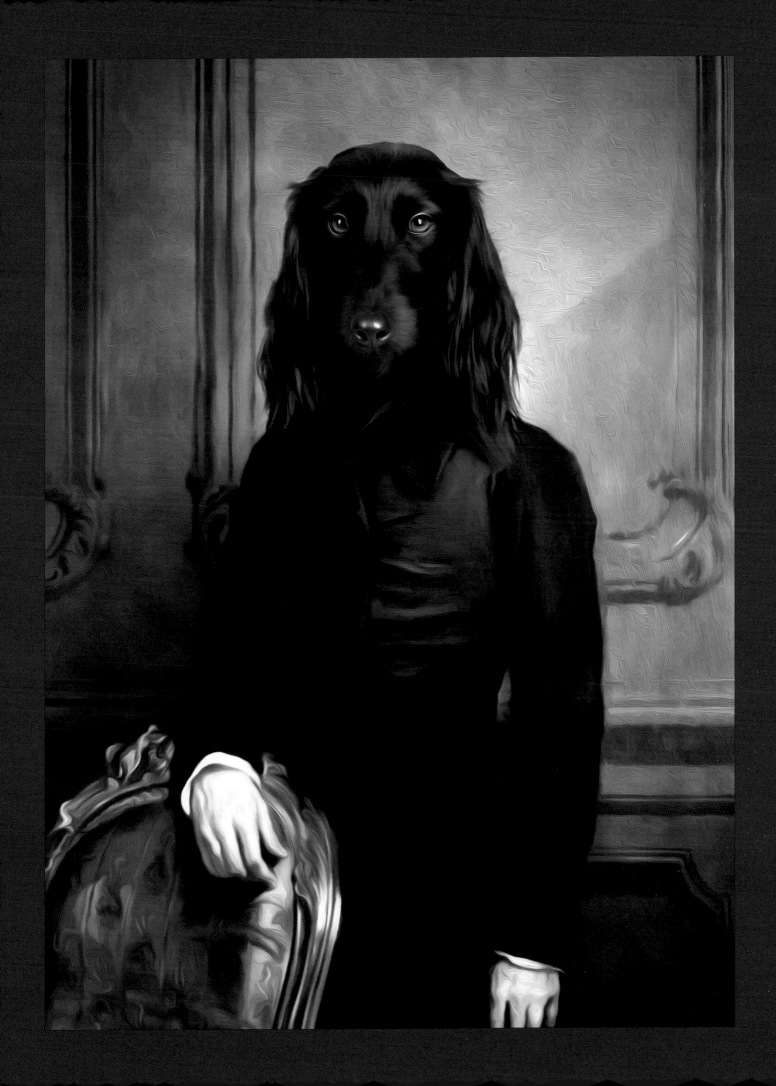

№ 67
Rando

———

His nature told him to protect the one he
cared for the most. She needed him as much as
he needed her. They have a true loyal friendship,
with the right intentions, straight from the heart.
Sometimes it's best to follow that which brings
you closer.

———

Es lag in seiner Natur, die zu schützen, die ihm
am meisten am Herzen lag. Sie brauchte ihn
ebenso wie er sie. Sie haben eine echte, treue
Freundschaft mit guten Absichten, direkt von
Herzen. Das allein bringt einen manchmal
schon näher zusammen.

———

La sua natura gli aveva detto di proteggere la
persona che amava di più. Lei aveva bisogno di lui
tanto quanto lui aveva bisogno di lei. La loro è un
amicizia vera e fedele, con le giuste intenzioni,
che viene dal cuore. A volte seguire semplicemente
questo cammino avvicina le persone.

———

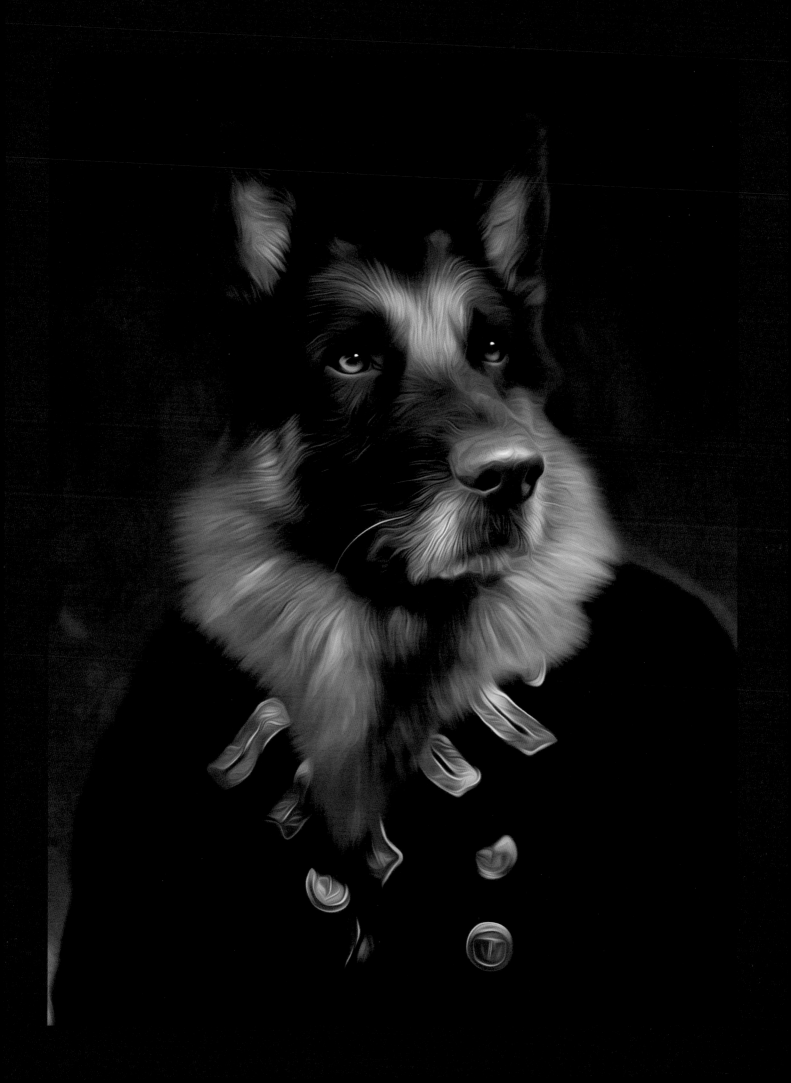

nº 68
Kristel

———

If you were searching for Kristel, chances are
that she was in the stables with the horse, or even
better, riding it through the fields, wind blowing
through her hair and endless horizons over
expansive fields to calm her mind. To surrender
to a higher power than herself is challenging.
Could this be her practicing for the next stage
in her life?

———

Wenn man Kristel sucht, ist sie wahrscheinlich
bei dem Pferd im Stall oder, besser noch, reitet
auf ihm über die Felder. Der Wind in ihren
Haaren und der endlose Horizont über weiten
Feldern beruhigen ihren Geist. Sich einer Macht
zu überantworten, die größer ist als sie, ist eine
Herausforderung. Könnte das ihr Training für den
nächsten Lebensabschnitt sein?

———

Se cercate Kristel, vi sono buone probabilità che
sia nelle stalle con il suo cavallo o stia cavalcando
nei campi con lui. Il vento tra i capelli e gli
orizzonti infiniti sui campi ampi calmano la sua
mente. Arrendersi a un potere più grande di lei
rappresenta una sfida. Si sta forse preparando alla
prossima fase della sua vita?

———

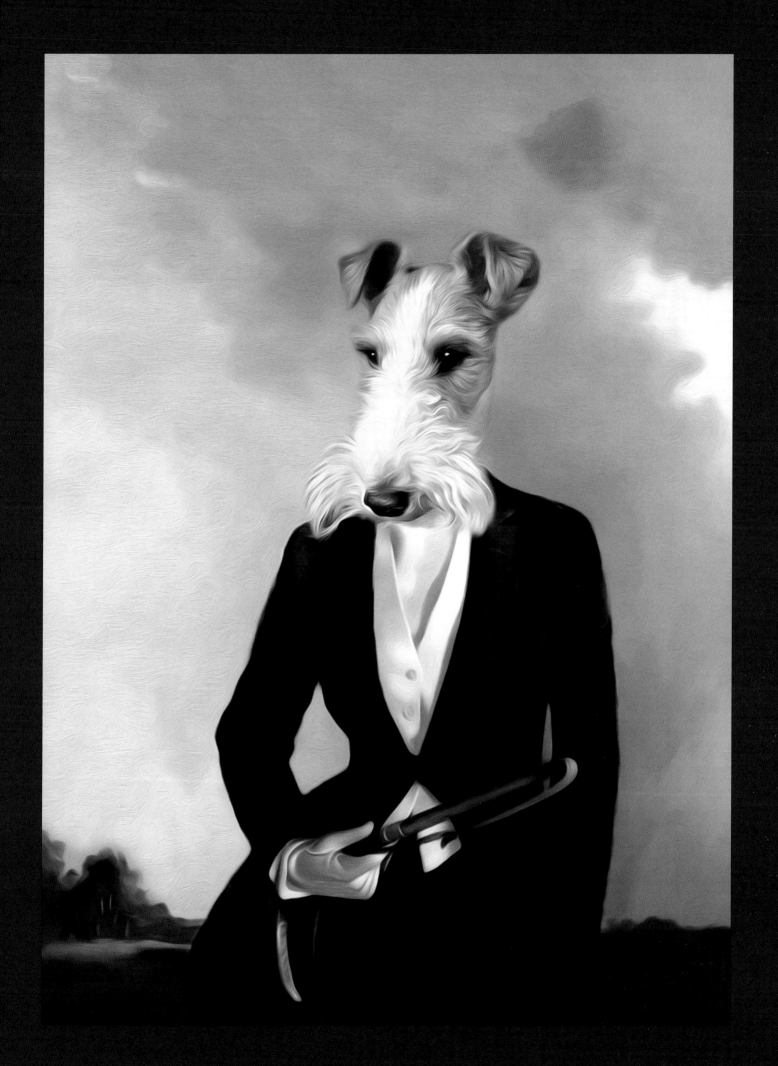

№ 69
sproet

————

Little Sproet gets all she wants. She knows that
all she has to do is ask and blink. If things are not
coming her way fast enough, she taps with her
finger, looking annoyed. And if no action follows,
she starts stamping her feet and behaving like
a little monster. What lesson will come along
her path to make her realise that this is not how
things work?

————

Die kleine Sproet bekommt alles, was sie will.
Sie weiß, eine Bitte und ein Augenaufschlag
genügen. Geht es ihr nicht schnell genug, trommelt
sie mit den Fingern und guckt verärgert. Wenn die
Reaktion ausbleibt, stampft sie mit dem Fuß auf
und benimmt sich wie ein kleines Monster.
Welche Lektion braucht sie, um zu erkennen,
dass es so nicht geht?

————

La piccola Sproet ottiene tutto quel che desidera.
Sa che le basta chiedere e sbattere gli occhi.
Se non ottiene rapidamente ciò che vuole,
picchietta le dita con atteggiamento scocciato.
Se non segue una risposta, inizia a battere i piedi
e a comportarsi come un piccolo mostro. Quale
lezione le serve per capire che non è così che
funzionano le cose?

————

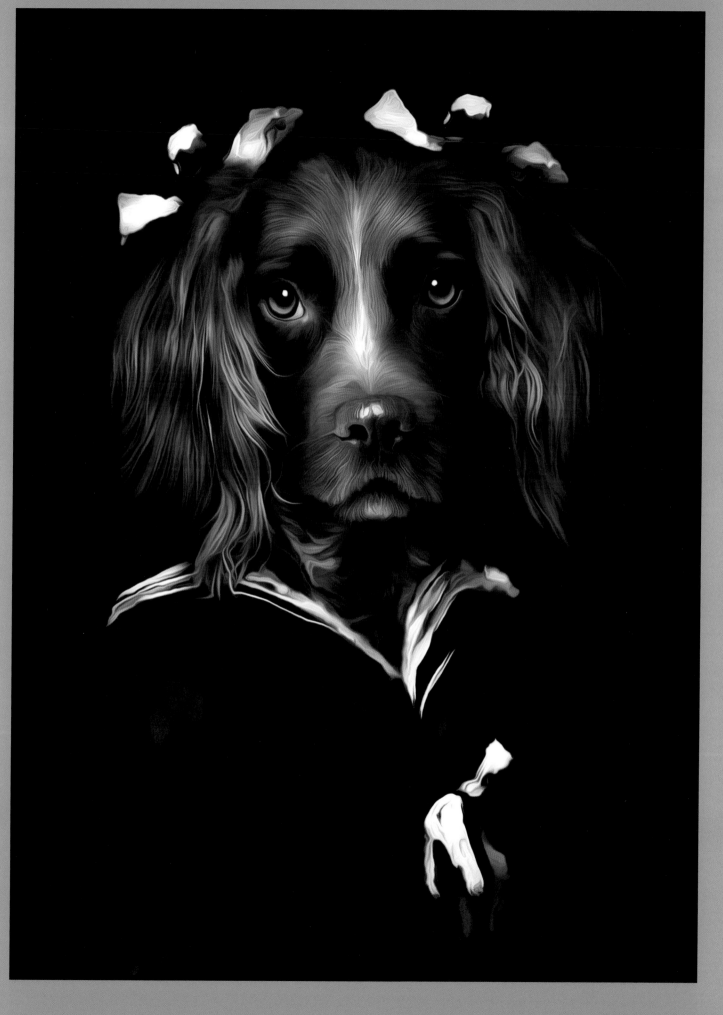

№ 70

olive

#OLIVE_ALLOFTHETIME

———

A young bride stares through the curtains.
On the other side there is a new world. Tomorrow
her life will change. She wonders if it will be
better. Life was good the way it was, wasn't it?
For a pure spirit like hers, it is already difficult
to become who you are meant to be. It is a real
challenge to stay that way when everyone wants
you to be different.

———

Eine junge Braut starrt durch die Vorhänge.
Auf der anderen Seite ist eine neue Welt. Morgen
ändert sich ihr Leben. Ob es wohl besser wird?
Das Leben war doch gut so, wie es war, oder?
Für ein reines Gemüt wie sie ist es schon
schwierig, die zu sein, die sie ist. Es ist eine echte
Herausforderung, so zu bleiben, wenn alle einen
anders haben wollen.

———

Una giovane sposa guarda attraverso le tende.
Dall'altra parte c'è un nuovo mondo. Domani la
sua vita cambierà. Si chiede se sarà migliore. La
vita era bella così com'era, vero? Per uno spirito
puro come il suo, è già difficile essere ciò che si è.
È una vera sfida restare così quando tutti vogliono
che tu sia differente.

———

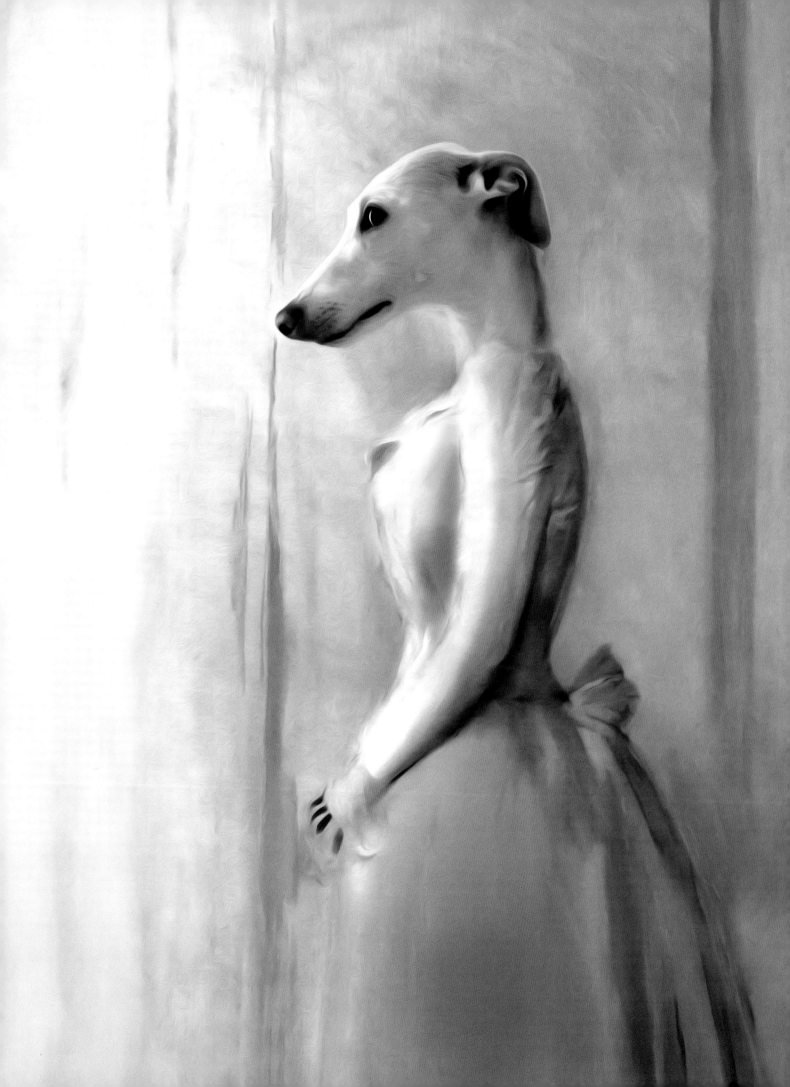

№ 71
Lou

———

'The sweet giant' is what those who get to
know Lou call him now, But life hasn't always
been this way for him. In the past, others imagined
him to be impressive and tough, so they drove him
into becoming a fighting machine. None of them
imaged him hiding a sensitive clown beside his
tough looks. It took a lot of trust, love, and a few
therapists, to trust others again. He has always
been a good one he just had a little too
much energy.

———

Einen „gutmütigen Riesen" nennen ihn diejenigen,
die Lou heute kennenlernen. Doch nicht immer
war das Leben für Lou so. Früher meinten andere,
er sei imposant und hart, und trieben ihn in
ein Dasein als Kampfmaschine. Keiner sah den
sensiblen Clown hinter dem harten Äußeren.
Es erforderte viel Glauben, Liebe und mehrere
Therapeuten, damit er anderen wieder vertraute.
Er musste lernen, wieder an sich selbst zu
glauben. Denn er war schon immer ein Guter –
er hatte nur etwas zu viel Energie.

———

Il "gigante gentile": è così che chi conosce Lou
lo chiama adesso. Ma la vita non è sempre stata
così per Lou. In passato, gli altri lo vedevano
grande e imponente, così lo spinsero a diventare
una macchina da guerra. Nessuno vedeva il
clown sensibile che si nascondeva dentro quel
massiccio involucro esterno. Gli ci sono voluti
determinazione, amore e vari terapisti per tornare
ad avere fiducia negli altri. Ha dovuto imparare a
credere nuovamente in se stesso. Era sempre stato
un buono, aveva solo un po' troppe energie.

———

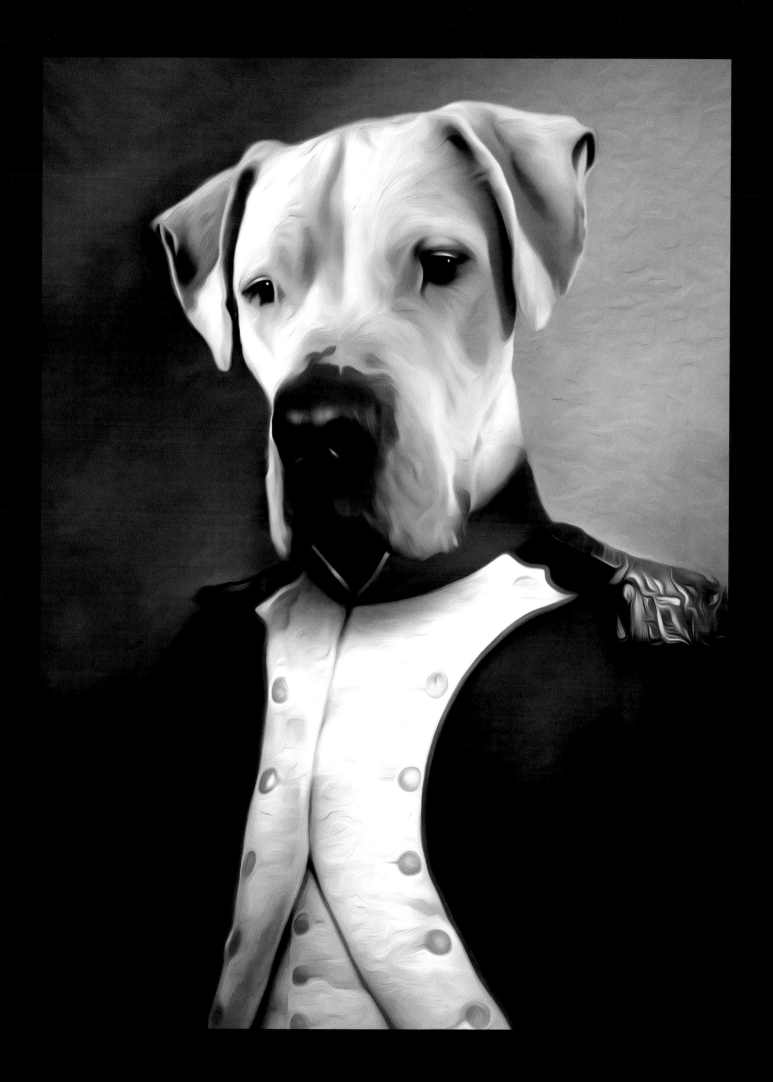

nº 72
Lois

Definitely not a personality to joke with.
She looked through people when they
were up to something. Lois was straight,
she liked you or she hated you. Based on
her good feeling, others were judged. She
knew what to do if she gave you a negative
assessment. Ignore the ones who can do
nothing for you anyway.

Mit ihr war definitiv nicht zu spaßen. Sie
durchschaute alle, die etwas im Schilde
führten. Lois war rigoros, entweder sie
mochte oder sie hasste einen. Andere
wurden nach ihrem Gespür beurteilt. Sie
wusste, was zu tun war, wenn sie eine
schlechte Beurteilung abgab. Jemanden,
der nichts für einen tun kann – ignorieren.

Senza dubbio una personalità da non
prendere alla leggera. Guardava attraverso
le persone quando avevano in mente
qualcosa. Lois era diretta, amava oppure
odiava. Gli altri venivano giudicati in base
alla sua sensazione. Sapeva cosa fare se
avesse espresso un giudizio negativo:
Ignorare coloro che non possono fare
comunque niente per te.

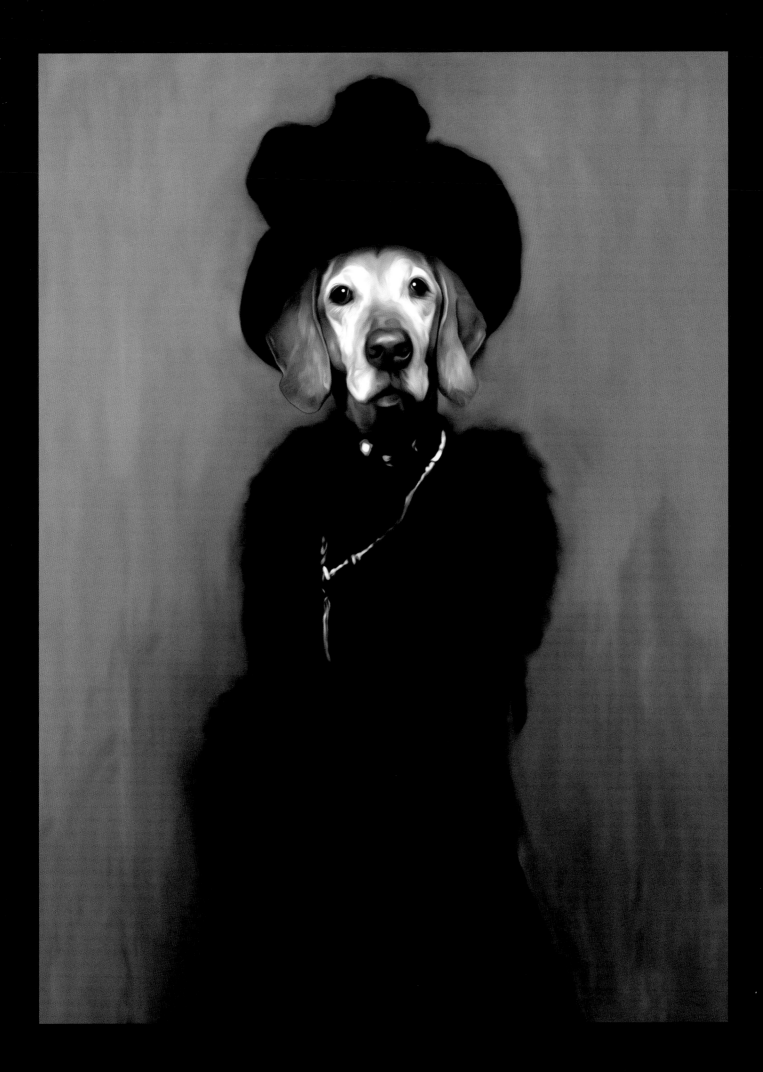

№ 73
Hostario

———

Little Hostario disappeared from the park on a beautiful sunny day. Some say he was kidnapped. Others—who believe in magic—think he jumped into a rabbit hole and is living happily ever after with some white rabbits and a beautiful blonde girl, named Alice.

———

An einem Sonnentag verschwand der kleine Hostario im Park. Manche sagen, er wurde entführt. Diejenigen, die an Magie glauben, denken, er sei in einen Kaninchenbau gesprungen und lebe glücklich mit einigen weißen Kaninchen und einem blonden Mädchen namens Alice zusammen.

———

In un bellissimo giorno di sole, il piccolo Hostario è scomparso dai giardini. Alcuni dicono che sia stato rapito. Altri, che credono nella magia, pensano che sia saltato nella tana di un coniglio e viva felice e contento con alcuni conigli bianchi e una bellissima ragazza bionda dal nome Alice.

———

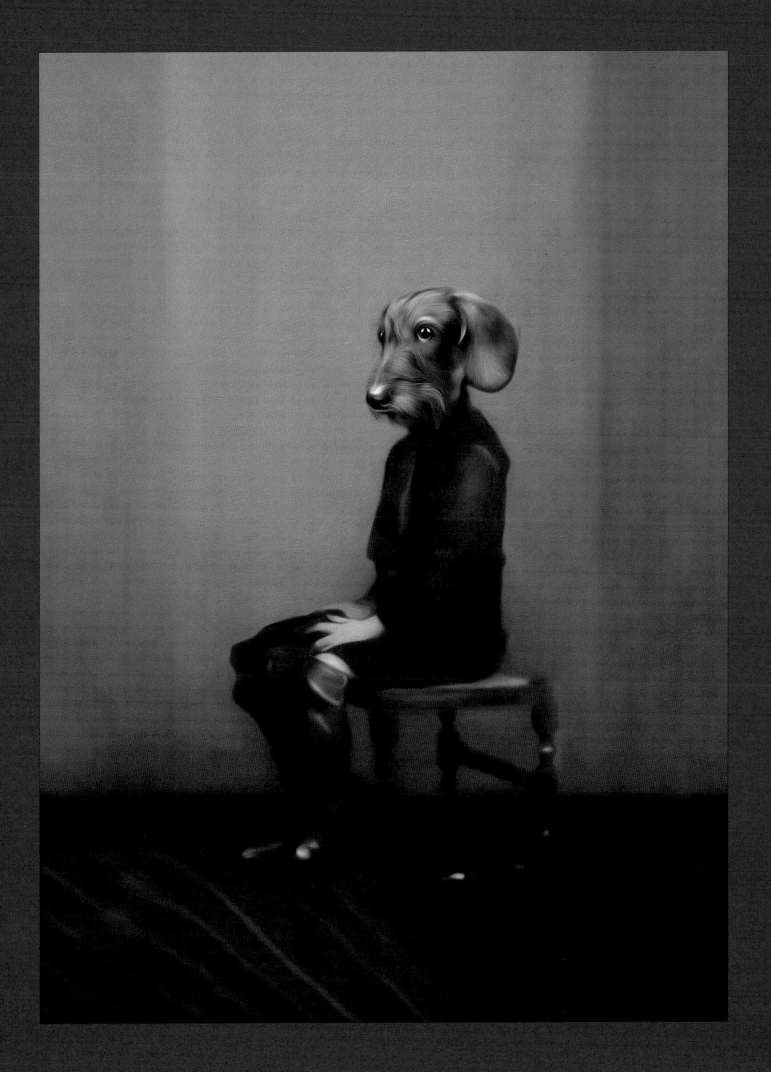

№ 74
Misty

———

She was always a weak one, but despite that,
she was a very happy spirit. Misty was grateful for
her caring mom, who dedicated the biggest part
of her life to her. Mom was grateful when Misty
came her way. Life had been harder when she was
just surviving on her own. They were meant to be
together. There is no such thing as coincidence.

———

Sie war schon immer schwach, hatte aber
dennoch ein sonniges Gemüt. Misty war dankbar
für ihre fürsorgliche Mutter und opferte ihr den
größten Teil ihres Lebens. Die Mutter war dankbar,
als Misty zu ihr kam. Es war schwieriger, allein zu
überleben. Sie waren dafür bestimmt, zusammen
zu sein. Es gibt keinen Zufall.

———

Era un tipo debole, ma nonostante ciò era un
spirito molto felice. Misty era riconoscente verso
la sua amorevole madre e le aveva dedicato gran
parte della vita. Sua madre era grata a Misty
quando le faceva visita. La vita era più dura da
sola. Erano fatte per stare vicine. Le coincidenze
non esistono.

———

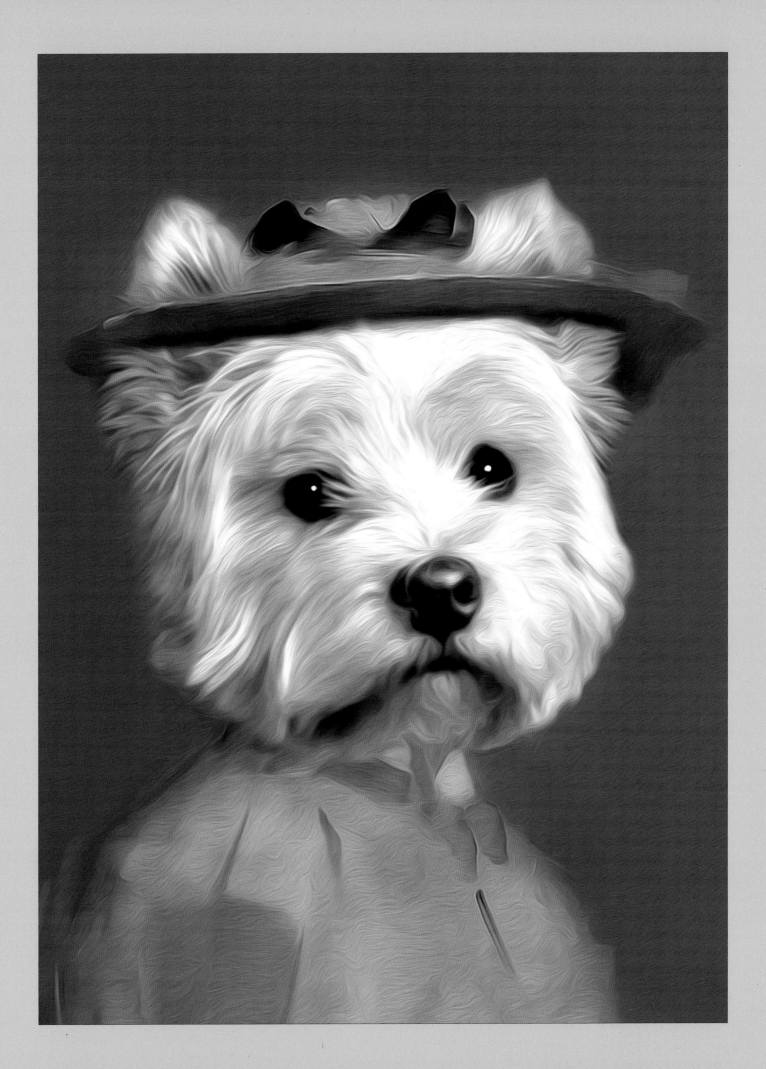

№ 75
Kato

———

She didn't really care what others think about her.
She lived her life outside the community. She only had
her evil cat Nero to look after. She tried to teach him some
manners, but some cats seem to choose to be evil.
Kato knew about nature and the healing power of herbs.
Being teased by illnesses over and over, she experimented
with the powers given by nature. Kato was happy, and
liked to keep others at a safe distance.

———

Was andere über sie denken, schert sie kaum. Sie lebt
ihr Leben außerhalb der Gemeinschaft. Ihr böser Kater
Nero ist der Einzige, um den sie sich kümmern muss. Sie
wollte ihm einige Manieren beibringen, aber manche
Katzen sind eben lieber übellaunig. Kato kennt sich mit
der Natur und Heilkräutern aus. Immer wieder von
Krankheiten geplagt, hat sie damit experimentiert. Kato
ist zufrieden; andere hält sie gern auf sicherer Distanz.

———

Non le importa molto di quel che gli altri pensano di lei.
Vive la sua vita fuori dalla comunità. Ha solo Nero, un
gatto cattivo, di cui occuparsi. Ha provato a insegnargli
le buone maniere, ma alcuni gatti sembrano scegliere
di avere un cattivo temperamento. Kato conosce la
natura e il potere curativo delle erbe. Colpita più volte
da malattie, ha sperimentato il loro uso. Kato è felice e
preferisce tenere gli altri a distanza di sicurezza.

———

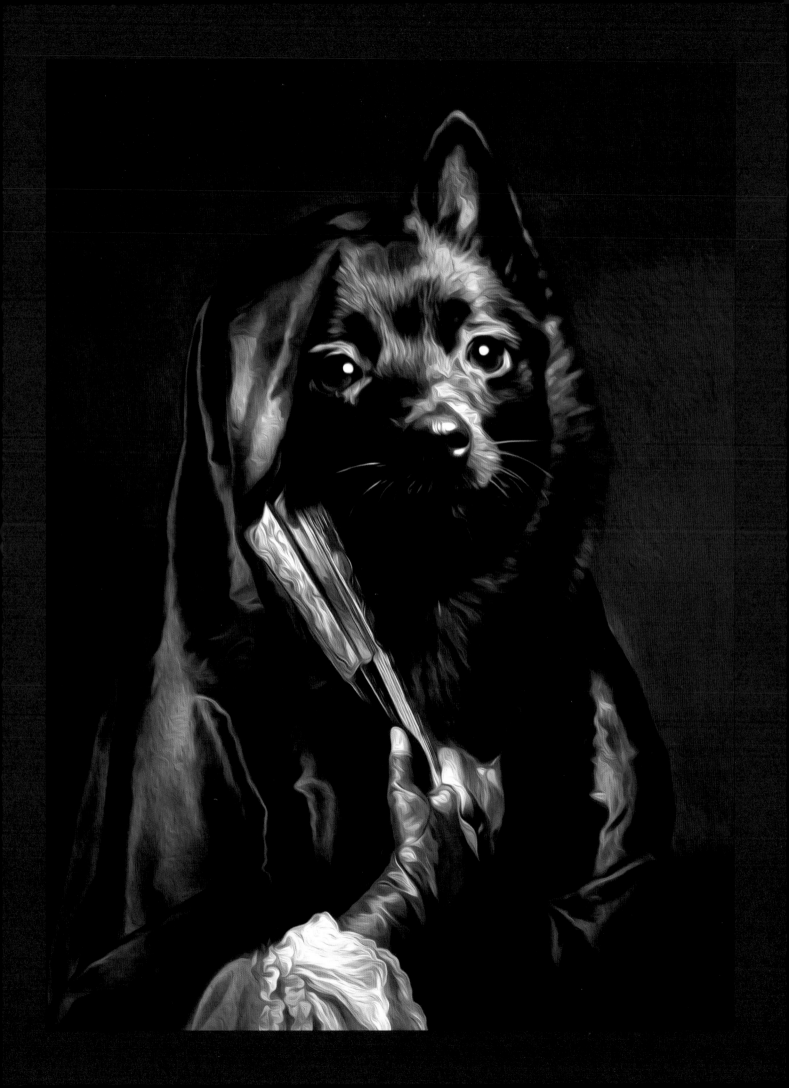

№ 76
Merlin

Magic doesn't happen just like that. Some
have the ability to use magic to help the ones
who need it most. Magic Merlin took his tasks
seriously. He himself enjoyed life to the fullest
and died a happy old man. Saying goodbye
was difficult when he used to give so much
love in return.

Magie ergibt sich nicht einfach so. Manche
können mit ihrer Magie denen helfen, die es
am nötigsten haben. Der Zauberer Merlin
nahm seine Aufgaben ernst, genoss das Leben
voll und starb als glücklicher alter Mann.
Abschiednehmen ist schwer, wenn einem so
viel Liebe entgegengebracht wird.

La magia non succede così per caso. Alcuni
hanno la capacità di usarla per aiutare chi ne
ha più bisogno. Merlin il mago ha preso sul
serio il suo compito. Ha vissuto appieno
la propria vita ed è morto vecchio e felice.
Dire addio è stato difficile dopo aver
ricevuto così tanto amore.

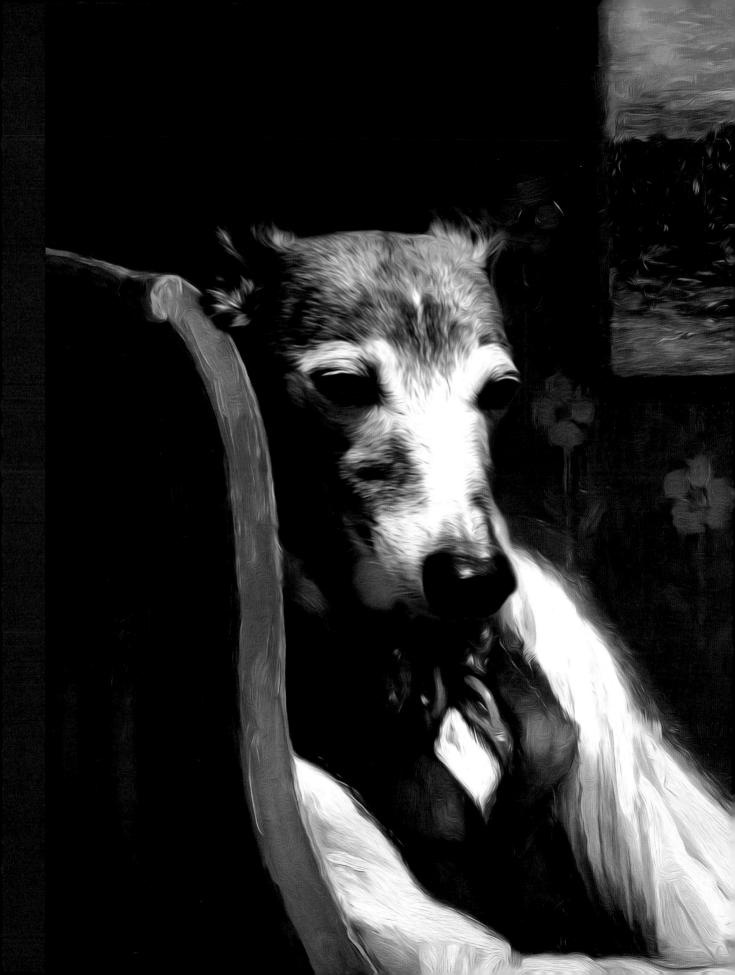

№ 77
whippy

———

Sweet and lovely Whippy shows herself to the world as a caring and sweet lady. She doesn't tell anyone about the imaginary friend she has created from the grief for the child she longed for but never received. Her days are filled with drinking tea together, and taking long walks through the fields around the small village in the countryside where they live. She promised her "William" to keep it their little secret. People in small towns don't understand these kinds of things.

———

Die süße, reizende Whippy wirkt auf die Welt wie eine fürsorgliche, herzige Lady. Sie erzählt niemandem von dem imaginären Freund, den sie aus Trauer um das Kind, das sie gern gehabt hätte, kreiert hat. Ihre Tage sind angefüllt mit gemeinsamem Teetrinken und langen Spaziergängen durch die ländlichen Felder rund um die Kleinstadt. Sie hat ihrem „William" versprochen, ihr kleines Geheimnis zu bewahren. Menschen in Kleinstädten verstehen solche Dinge nicht.

———

La dolce e adorabile Whippy per il mondo sembra una signora attenta e amorevole. Non racconta a nessuno dell'amico immaginario che si è creata per il dolore di un figlio tanto desiderato e mai avuto. Le sue giornate sono riempite da tè in compagnia e lunghe passeggiate nei campi intorno alla piccola cittadina di campagna in cui vive. Ha promesso al suo "William" di mantenere il loro piccolo segreto. La gente di paese non comprende questo tipo di cose.

———

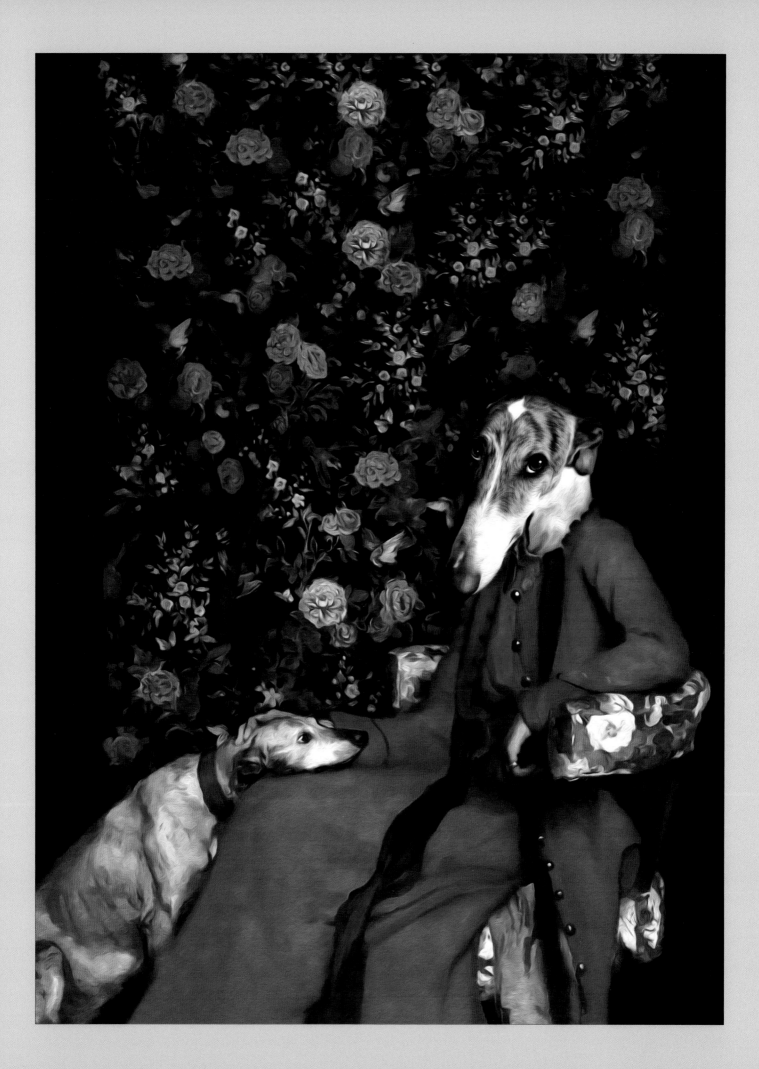

№ 78
Muk

———

The doctor said that hormones created
irregularities on his skin. For a long time, he hid
himself from the big world outside. The spots on
his face were the first thing that others noticed
about him. He decided to change his perspective
and instead made them his trademark! From that
day, he even thought about naming himself Spot!

———

Der Arzt sagte, Hormone verursachten seine
Hautunregelmäßigkeiten. Lange mied er die
Außenwelt. Die Flecken auf seinem Gesicht
waren das Erste, was anderen an ihm auffiel.
Er beschloss, das Ganze umzukehren und sie
zu seinem Markenzeichen zu machen.
Er überlegte sogar, sich Fleck zu nennen.

———

Il dottore disse che gli ormoni erano la causa
di quelle chiazze sulla pelle. Per molto tempo
si nascose dal mondo esterno. Le macchie erano
la prima cosa che gli altri notavano in lui. Decise
di cambiare le cose e farne il suo tratto distintivo.
Pensò anche di darsi un nuovo nome, Macchia.

———

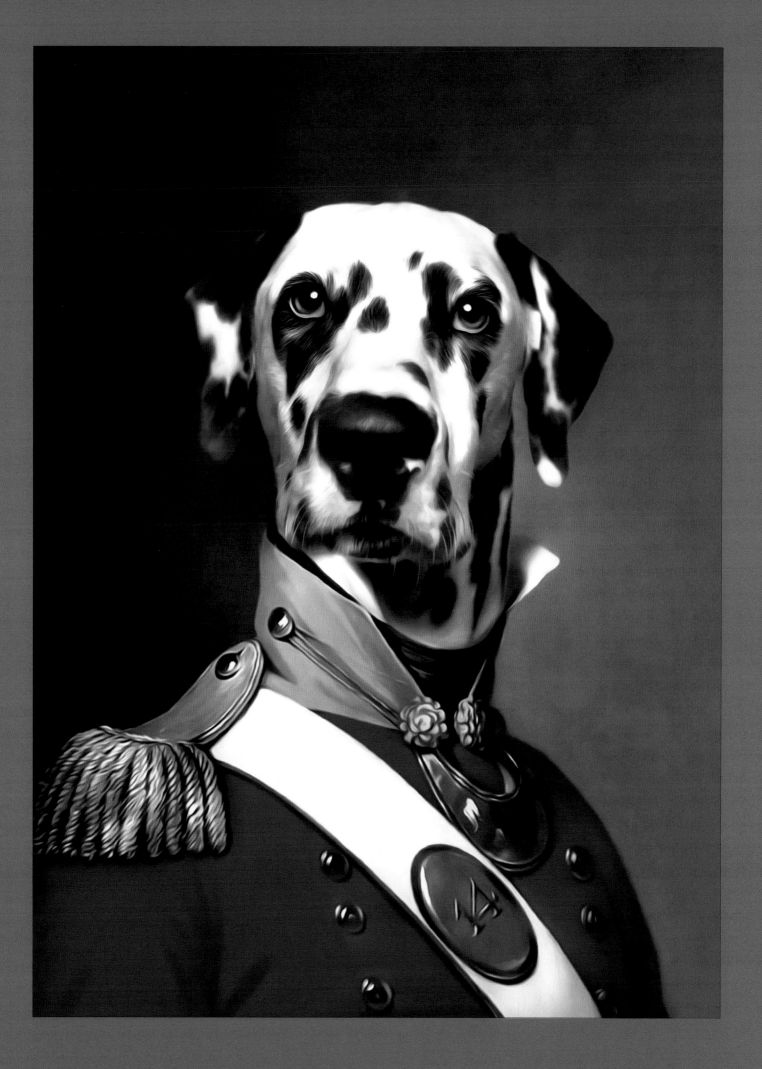

№ 79
ziggy

———

Lady Zig is the leader of the pack without being
tough or nasty to the others. She has learned how
to show guidance when needed to keep them all in
line. Ziggy was not there to make friends, although
she had some favourites in the group. She never
showed them how much she cared for them and
enjoyed every minute of being their leader.

———

Lady Zig ist Rudelführerin, ist aber nicht hart
zu den anderen. Sie hat gelernt, wie sie sich
nötigenfalls durchsetzt, damit keiner aus der Reihe
tanzt. Ziggy ist nicht da, um Freunde zu finden,
hat aber in der Gruppe Favoriten. Nie hat sie
gezeigt, wie viel ihr an ihnen liegt und wie sehr sie
jede Minute genießt, die sie ihre Anführerin ist.

———

Lady Zig è una vera leader, ma non è dura o cattiva
con gli altri. Ha imparato come guidare le persone
quando devono essere mantenute in riga. Ziggy
non è qui per farsi degli amici, anche se all'interno
del gruppo ha i suoi preferiti. Non ha mai mostrato
quanto sia affezionata e quanto ami ogni minuto in
cui si occupa di loro.

———

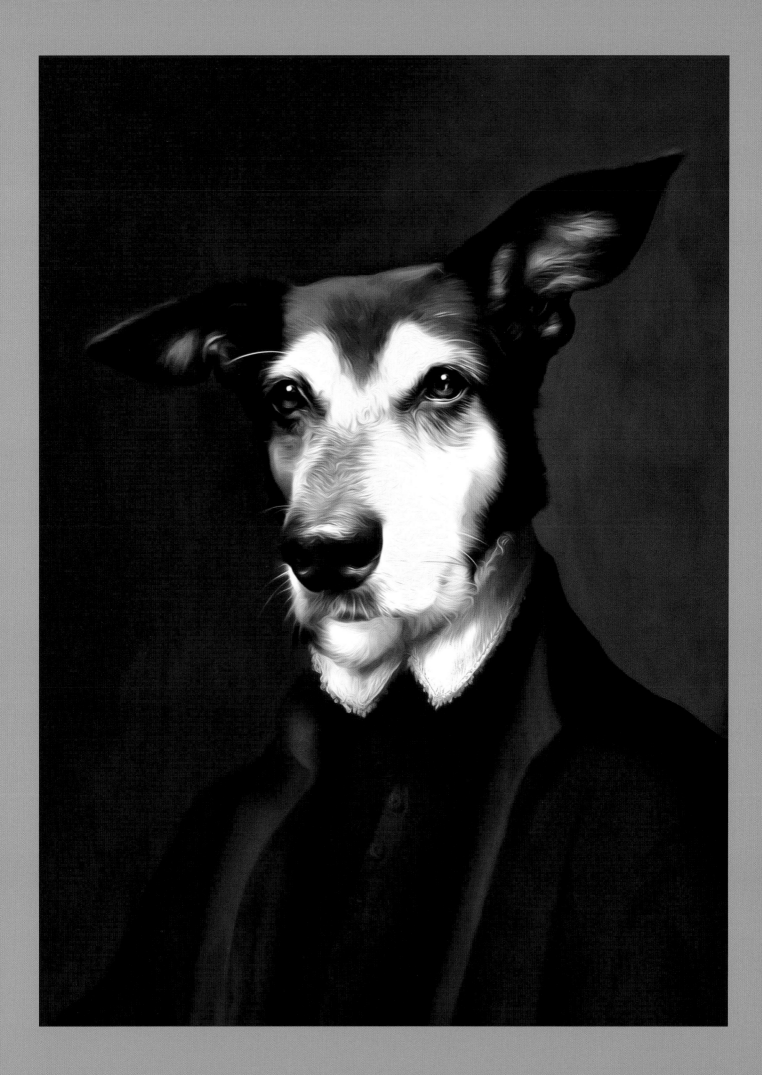

———

Letting go is never easy. Lizzy was a hardworking single mom who cared too much for her little ones. She knew that one day they would have to start a life of their own, and that later she would become a wonderful grandma. She is looking forward to that happening and has decided to travel the world until that day comes.

———

Loslassen ist nie leicht. Lizzy ist eine hart arbeitende alleinerziehende Mutter, die sich zu sehr um ihren Nachwuchs sorgt. Ihr war immer klar, dass ihre Kinder eines Tages ein eigenes Leben führen, und später wird sie eine wunderbare Oma sein. Sie freut sich darauf und will die Welt bereisen, bis dieser Tag kommt.

———

Lasciare andare non è mai facile. Lizzy è una madre single, grande lavoratrice, che si prende sin troppa cura dei suoi piccoli. Sa che un giorno si creeranno la propria vita e poi diventerà una bellissima nonna. Non vede l'ora che ciò accada e ha deciso di viaggiare per il mondo fino a quel giorno.

———

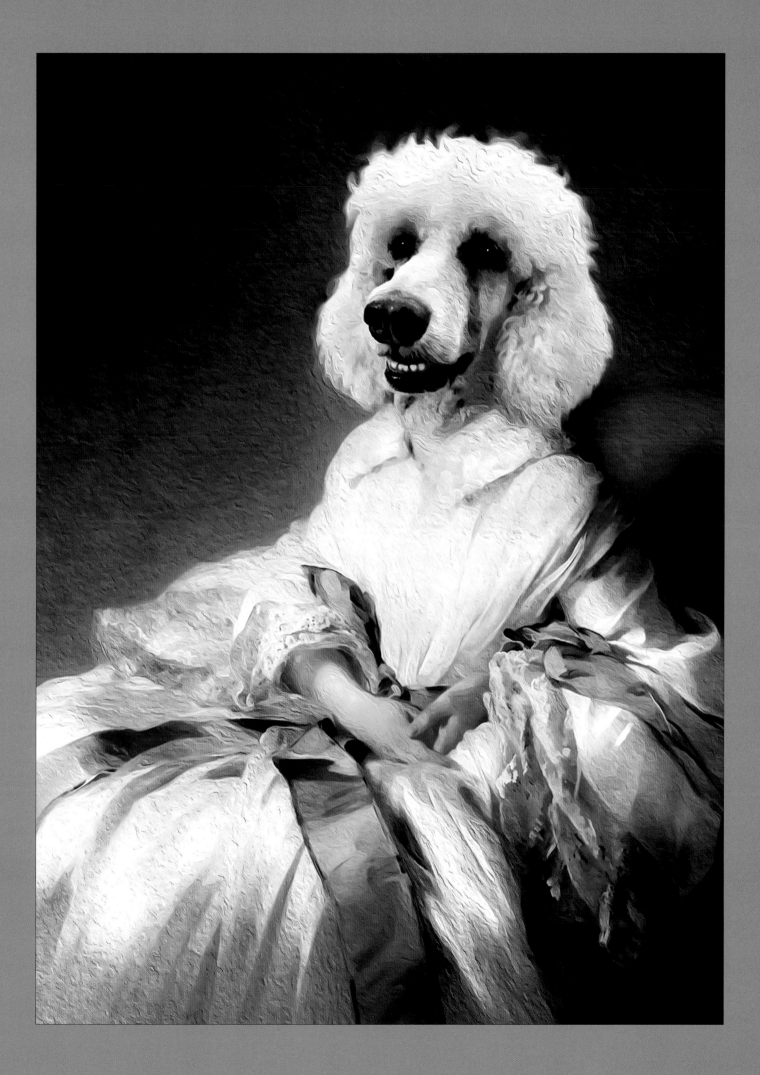

№ 81
Blue

———

He had a warm heart, but expressing himself
wasn't easy in a cold society where everyone is
screaming. Blue had no fear of singing in the
streets. One day, a powerful stranger heard his
voice and asked him to perform on stage. That
night, an unknown audience was thrilled by his
voice and his words. Blue finally got recognised
by other warm people. From that day on, he just
ignored the ones who envied him.

———

Er ist warmherzig, aber es ist nicht leicht, sich
in einer kalten, lauten Gesellschaft zu äußern.
Blue hat keine Angst, auf der Straße zu singen.
Eines Tages hörte ein einflussreicher Fremder
seine Stimme und bat ihn, auf seiner Bühne
aufzutreten. An jenem Abend war ein fremdes
Publikum begeistert von ihm. Endlich hatten
andere warmherzige Leute Blue erkannt. Von da
an ignorierte er einfach die, die ihn beneideten.

———

Era un cuore buono, ma esprimersi non è facile
in una società fredda dove tutti gridano. Blue
non aveva paura di cantare per strada. Un
giorno, uno straniero facoltoso sentì la sua voce
e gli chiese di esibirsi sul suo palco. Quella sera
un pubblico sconosciuto restò affascinato dalla
sua voce e dalle sue parole. Blue finalmente
aveva ottenuto il riconoscimento di altre persone
di cuore. Da quel giorno, ha semplicemente
ignorato chi lo invidiava.

———

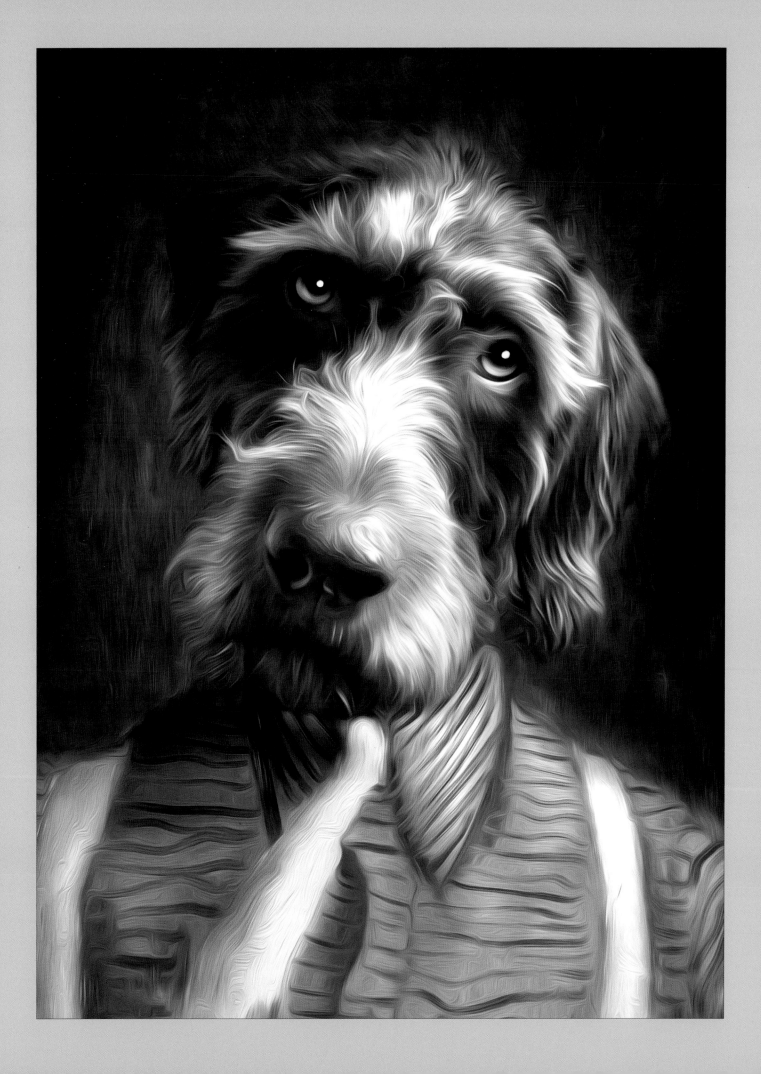

nº 82
zena

———

The dark queen is always working on plans to ruin other people's happiness. She is nosy and always butting into other people's business. Why can't she be happy with the wealth and beauty she has? It's about time that someone gave her a taste of her own medicine. But there is a big chance that she has no heart with real feelings, and her only response will be one of anger.

———

Die dunkle Königin wälzt immer Pläne, um das Glück anderer zu zerstören. Sie steckt ihre Nase fortwährend in die Angelegenheiten anderer. Warum kann sie bei ihrem Reichtum und ihrer Schönheit nicht froh sein über das, was sie hat? Höchste Zeit, dass es ihr jemand mit gleicher Münze heimzahlt, damit sie es auch mal zu spüren bekommt. Aber wahrscheinlich hat sie kein Herz mit echten Gefühlen und reagiert dann nur wütend.

———

La regina oscura ordisce costantemente piani per rovinare la felicità altrui. È una ficcanaso, sempre pronta a frugare negli affari degli altri. Come è possibile che, con tutto quel che ha e con la sua bellezza, non possa essere felice? È giunto il momento che qualcuno la ripaghi con la sua stessa moneta, per farle capire cosa si prova. Ma c'è la reale possibilità che non abbia un cuore con veri sentimenti e che la sua unica risposta sia di rabbia.

———

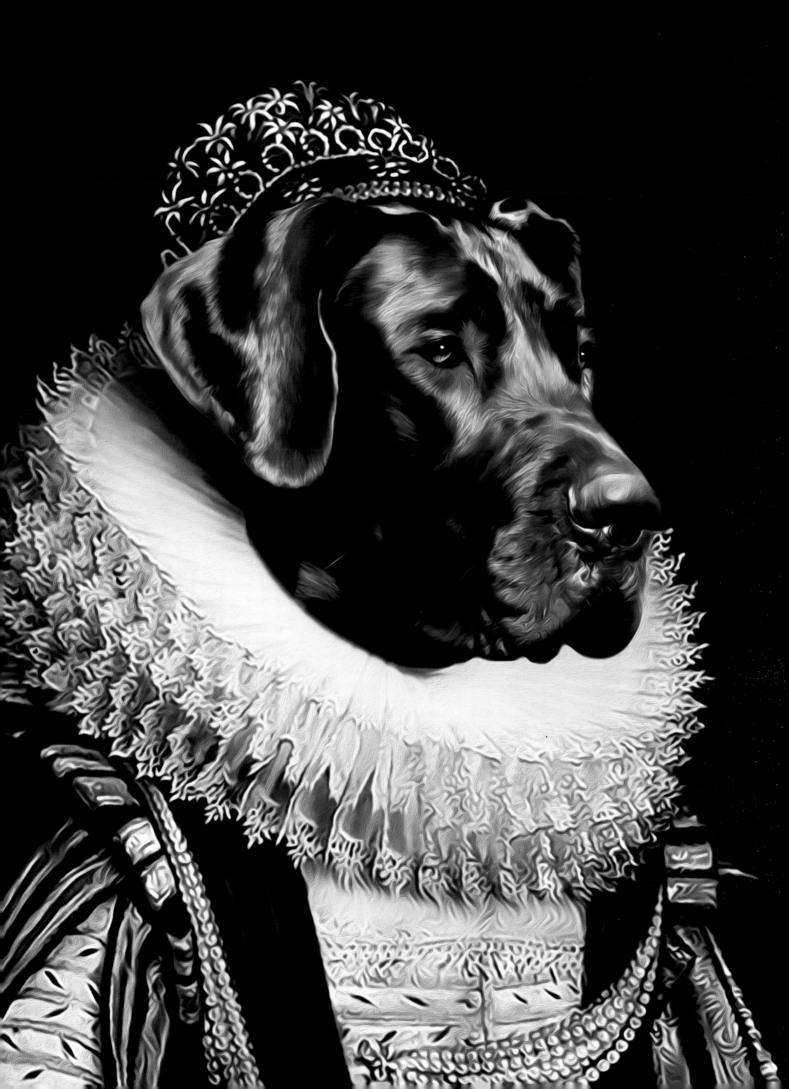

№ 83
Door

―――――

She never imagined she was important to others.
She simply cared for whoever needed her help.
No-one ever valued her hard work and dedication,
until one day she disappeared. Then they realised
how great she'd been, but at that time no-one was
able to let her know anymore.

―――――

Sie glaubte zwar nie, dass sie anderen wichtig sei,
aber dennoch war Door für jeden da, der ihre Hilfe
brauchte. Niemand schätzte je ihre harte Arbeit
und ihr Engagement, bis sie verschwand und man
erkannte, wie toll sie gewesen war. Nun konnte man
es ihr nicht mehr sagen.

―――――

Non aveva mai pensato di poter essere importante
per gli altri, ma Door si preoccupava di chiunque
avesse bisogno di aiuto. Nessuno apprezzava mai il
suo duro lavoro e la sua dedizione, fino a quando un
giorno scomparve e tutti si resero conto di quanto
fosse stata importante; ma adesso non avevano
più la possibilità di farglielo sapere.

―――――

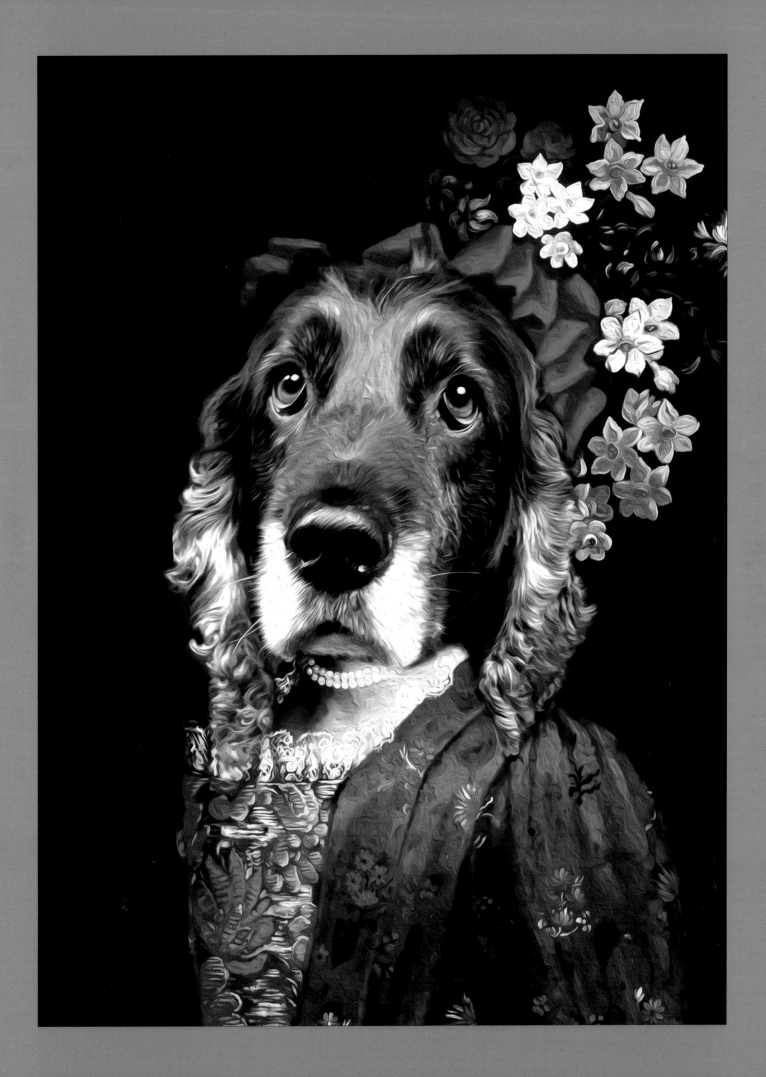

№ 84
Pluk

———

A lot was expected from little Pluk. She was replacing the emptiness of something that was once. However, it was only a matter of time before she stole their hearts in her own way and filled the emptiness with a lot of fun, innocent looks, and naughty behaviour that was corrected without laughing out loud. "It is never good to be compared," is the lesson Pluk learned.

———

Von der kleinen Pluk wurde viel erwartet. Sie ersetzte die Leere von etwas, das einst „war". Es war jedoch nur eine Frage der Zeit, bis sie die Herzen auf ihre eigene Weise eroberte und die Leere mit viel Spaß, unschuldigem Blick und mutwilligem Verhalten füllte, das korrigiert wurde, ohne laut loszulachen. Pluk brachte die Lektion mit, dass es nie gut ist, mit jemand anderem verglichen zu werden.

———

Ci si aspettava molto dalla piccola Pluk. Riempiva il vuoto di qualcosa che un tempo c'era stato. Ma era solo una questione di tempo prima che rubasse i loro cuori a modo suo e riempisse il vuoto con tanto divertimento, sguardi innocenti e birichinate, corrette senza sonore risate. Pluk portò con sé la lezione che non è mai bello essere paragonati con qualcun altro.

———

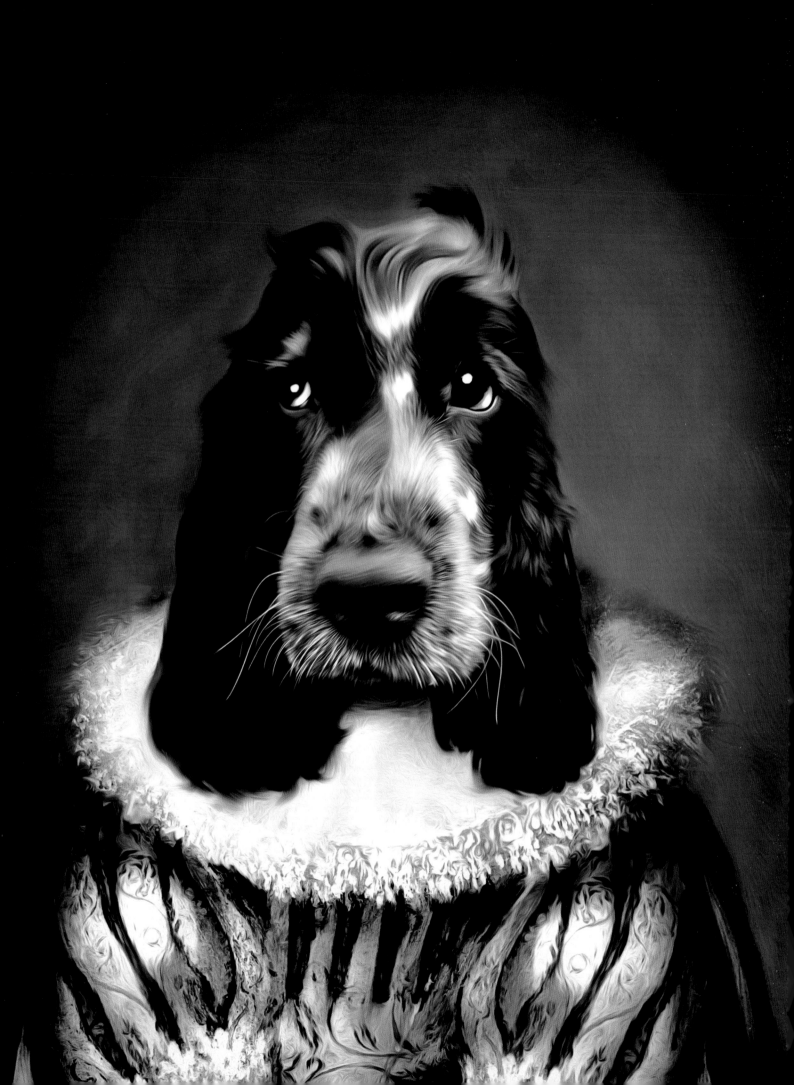

nº 85
carrie
#OSCARDELARETNA

———

After losing a parent once, you promise yourself
that it will never happen again. You stick to the
new good-hearted mom, who offers you her
unlimited love. Carrie believes in new beginnings.
All she did is behave better, love even more and
hope that it will never happen again.

———

Wer einen Elternteil verloren hat, will nicht, dass
es wieder passiert, und hängt an der neuen,
gutherzigen Mutter, die grenzenlose Liebe schenkt.
Carrie glaubt an einen Neuanfang. Sie versuchte,
es besser zu machen, mehr zu lieben, und sie
hofft, dass es nie wieder geschieht.

———

Quando perdiamo un genitore, non vogliamo
che succeda di nuovo. Ci afferriamo alla nuova
madre di buon cuore che ci offre amore illimitato.
Carrie crede nei nuovi inizi. Ha cercato di
comportarsi meglio e di amare di più, e spera
che non succeda mai più.

———

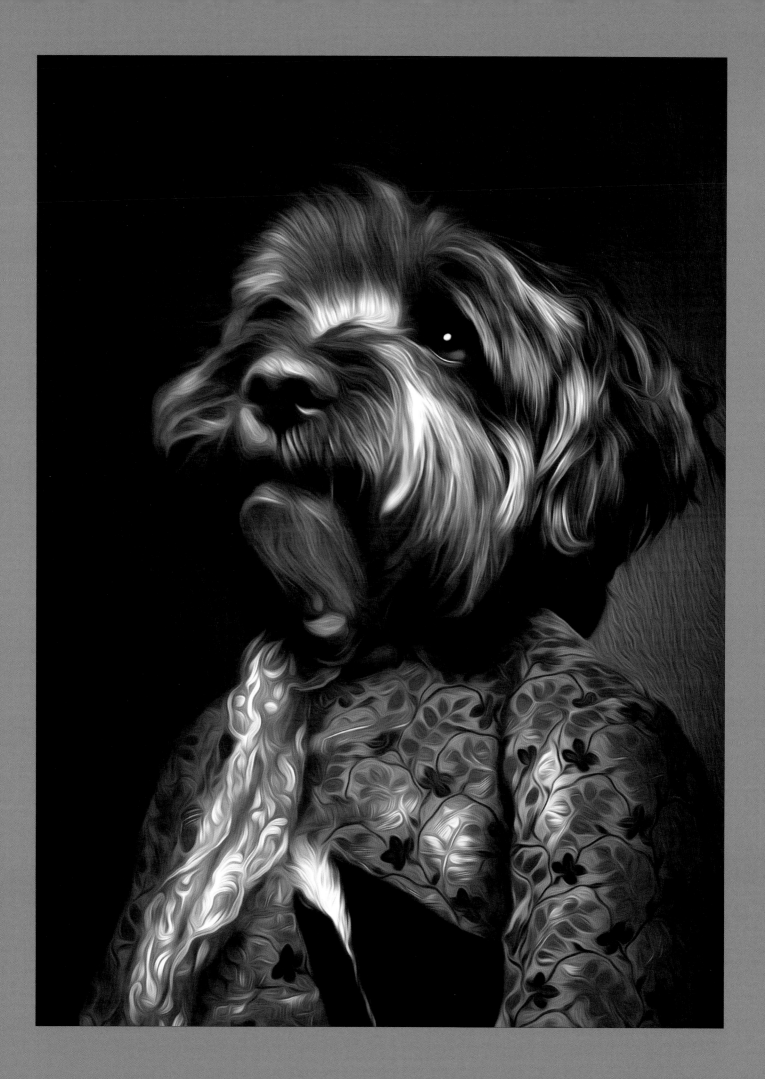

№ 86
Bali

———

As a young girl, she learned how to be invisible.
Her parents were too busy and she needed to take
care of herself. She noticed that not being noticed
was a special power and she used it to gather
valuable information. One day, she knew how
things worked and left for good to start a life of
her own and she lived happily ever after.

———

Als kleines Mädchen lernte Bali, unsichtbar zu
sein. Ihre Eltern waren beschäftigt, und sie musste
allein zurechtkommen. Sie merkte: Unbemerkt
bleiben ist eine Stärke. Sie nutzte es, um wertvolle
Informationen zu sammeln. Als sie wusste, wie es
läuft, ging sie fort und begann ein eigenes Leben.
Sie lebte glücklich bis ans Ende ihrer Tage.

———

Da ragazza, Bali imparò a essere invisibile. I suoi
genitori erano troppo impegnati e lei doveva
badare a se stessa. Si rese conto che non essere
notata era un potere speciale, che utilizzò per
raccogliere informazioni preziose. Sapeva come
funzionano le cose e un giorno se andò per
iniziare una vita per conto proprio. Visse così
felice e contenta.

———

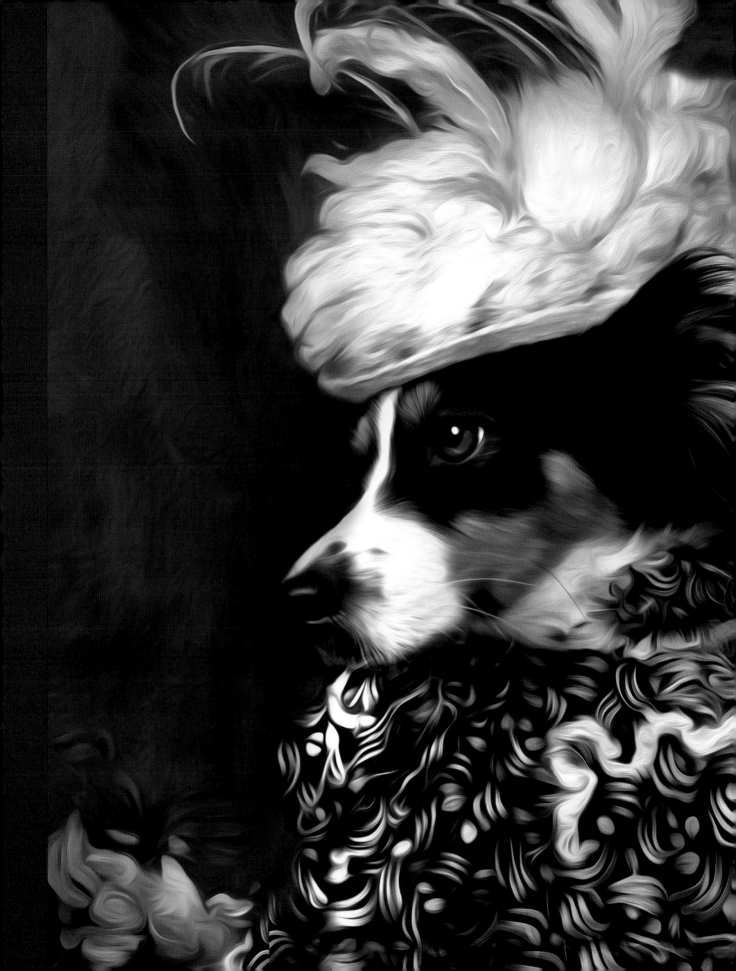

———

He never longed for fame and success, it just happened. Singing with his best buddy was what he liked to do best. While performing privately for fun in the car, it was secretly taped and published online. He couldn't have realized that 'having a little fun' would turn into a worldwide success. Junior learned that just doing what his heart tells him to do is all you need to impress the rest of the world.

———

Er war nie auf Ruhm und Erfolg aus, es passierte einfach. Mit seinem besten Kumpel zu singen tat er am liebsten. Als sie privat zum Spaß im Auto performten, wurde es heimlich aufgenommen und online gestellt. Er wusste nicht, dass „ein bisschen Spaß haben" zu einem weltweiten Erfolg werden könnte. Junior lernte: Einfach das tun, was sein Herz sagt, genügt, um den Rest der Welt zu beeindrucken.

———

Non aveva mai aspirato a fama e successo, semplicemente era accaduto. Cantare con il suo migliore amico era ciò che amava più fare. Mentre si esibiva privatamente per divertimento nella sua auto, era stato filmato di nascosto e pubblicato online. Non si era reso conto che "divertirsi un po'" avrebbe potuto trasformarsi in un successo mondiale. Junior imparò che fare semplicemente ciò che il cuore detta è tutto quel che serve per sorprendere il resto del mondo.

———

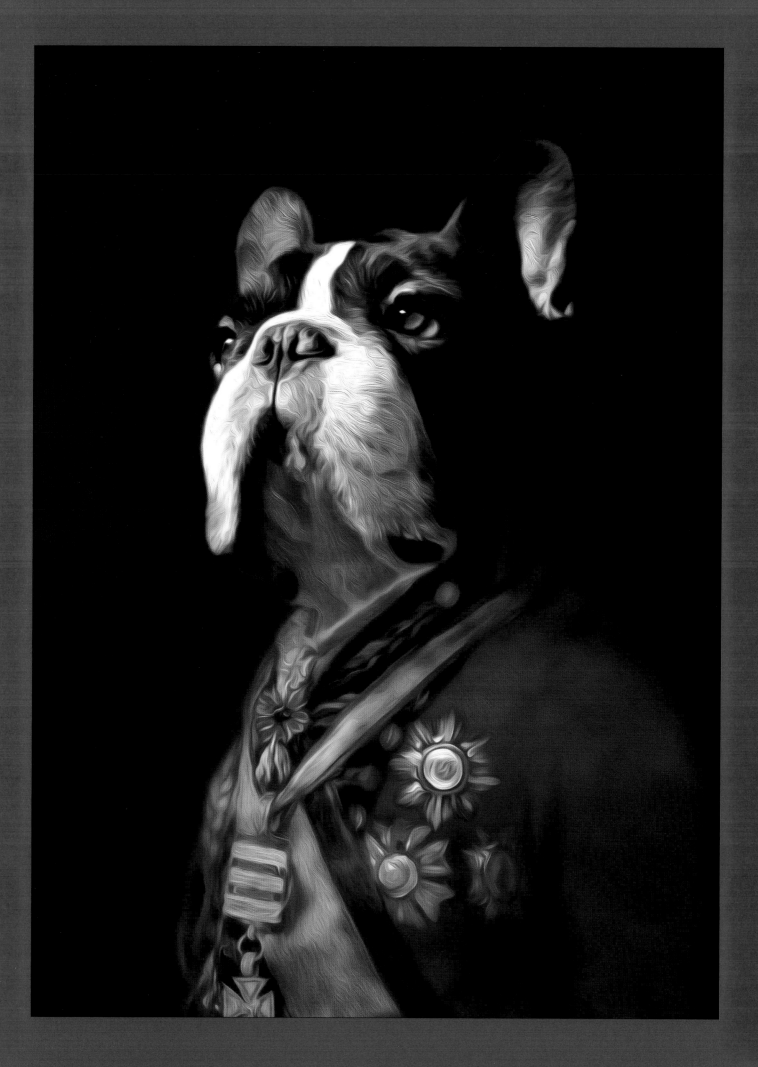

№ 88
Luna

———

Staring at the full moon, Luna thought about the many winters she loved playing in the snow. She knew that in her stage of life, winter had started. She accepted the process of growing old. Her sight was fading slowly, and all that was left are the good and happy memories. Of course, there was pain, but it was bearable. Meanwhile, she was being taken care of by the ones she loves best. She decided to enjoy every moment until the black crow knocks on her window.

———

Luna betrachtet den Vollmond und denkt an die vielen Winter, in denen sie voller Freude im Schnee spielte. Sie weiß, in ihrer Lebensphase ist ihr „Winter" angebrochen. Sie hat das Altern akzeptiert. Sie sieht immer schlechter; alles, was ihr bleibt, sind die guten, frohen Erinnerungen. Natürlich ist da auch Schmerz, aber er ist erträglich. Inzwischen wird sie von denen betreut, die sie am meisten liebt. Sie will jeden Moment genießen, bis der schwarze Rabe an ihr Fenster klopft.

———

Osservando la luna piena, Luna pensa ai tanti inverni in cui amava giocare nella neve. Sa che è iniziata la fase dell'inverno della sua vita. Ha accettato il fatto di invecchiare. La vista si sta gradualmente appannando e le restano solo i ricordi più belli e felici. Ovviamente c'è anche il dolore, ma è sopportabile. Nel frattempo di lei si occupano le persone che ama di più. Fino a quando il corvo nero busserà alla sua porta, ha deciso di godersi ogni momento.

———

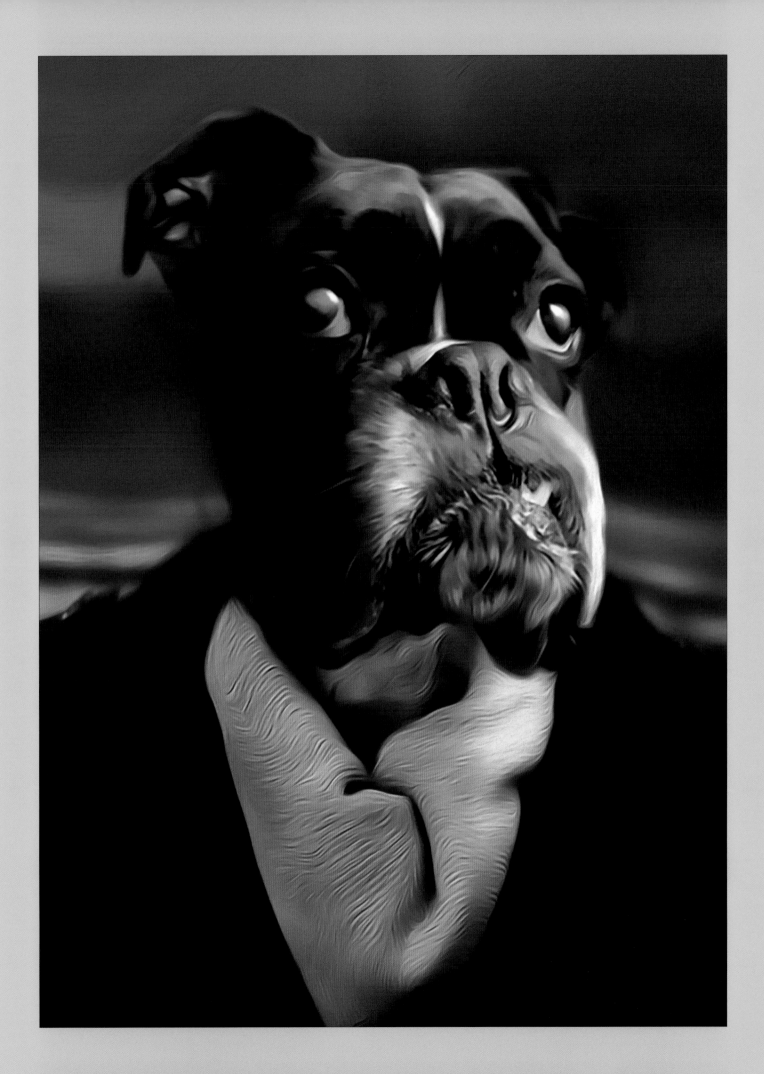

+ 1
Nino

———

Every year, Nino did his best to be a good boy. Mom told him that if he behaved well, Santa Claus would give him presents. Every single year, Nino asked for a doll, just like the one his sister got, but disappointment covered his face when the last package was unwrapped and cars and boats were all he got. "What if I stop behaving like a good boy and be naughty next year?", Nino thinks.

———

Jedes Jahr bemüht sich Nino, ein braver Junge zu sein. Seine Mutter sagt, der Weihnachtsmann bringe ihm dann Geschenke. Nino wünscht sich jedes Jahr, dass er eine Puppe bekommt, wie seine Schwester. Nach dem Auspacken der Pakete ist er enttäuscht, wenn wieder nur Autos und Boote darin waren. „Was wäre, wenn ich kein braver Junge mehr bin, sondern nächstes Jahr ein böser Junge werde?", denkt Nino.

———

Ogni anno Nino fa del suo meglio per essere un bravo bambino. Sua madre gli ha detto che se si comporta bene, Babbo Natale gli porterà dei regali. Ogni anno Nino chiede una bambola come sua sorella, ma il suo volto mostra grande delusione quando apre l'ultimo regalo e tutto quello che riceve sono auto e barche. Nino si chiede "E se smettessi di comportarmi come un bravo bambino e fossi cattivo il prossimo anno?"

———

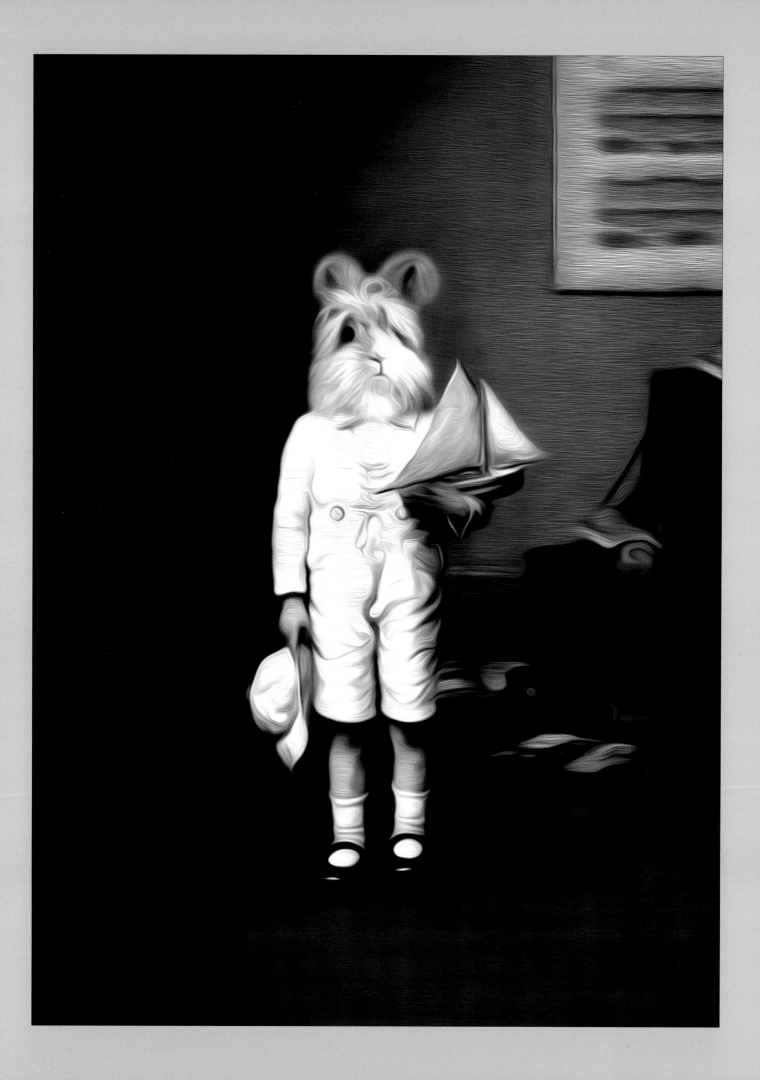

acknowledgments

When I was 19, I got introduced to Edward through a mutual friend. He was much older than me, no idea why he was so nice to me. He was an extravagant and also a very interesting person to talk with. He noticed something in me, I had no clue what. At that time I had just finished graphic design school and was a very insecure boy from a little Dutch town in the countryside. I was way too sensitive. I did not know he had a plan. He took me to Tuscany, Paris. He made sure my eyes saw a lot of beautiful paintings in Florence and showed me the aesthetics of Paris. My L'animorphes should be shown in little French antique stores, hidden in little Parisian streets.

22 years later I realised why he did this. It must be some kind of love fathers normally give to their son. Probably I am the son he never had. His friendship and guidance and mentorship always came from a good heart. The last 15 years we lost the contact. My own father suggested to call Edward again when my life was about to lose track. I never expected that response when I finally called him in January this year. "It took you some time to return!" As if he knew that one day, I would come back. At this point, he is my agent and manager. I want to thank Edward for helping me trusting myself. I am not the only son he has. This magic angel helps many others to make dreams and wishes come true. A fair businessman with a heart of gold. I hope your spirit and dedication will inspire others to give everyone the possibility to follow their hearts and make this world a more beautiful place. So a big thank you, Edward!

This summer I finished the CAT-book at teNeues' Munich office. A friendly man, to whom I was introduced but I was so focussed on my screen so forgot his name, brought cake. I asked him why that was. I didn't get a clear answer. "It's always good to celebrate Tuesdays," I said to him. I had no idea, until two days later, that this was the big Mr. teNeues himself. As we were eating cake, we had a nice talk about life journeys and art in Italy. The suggestion to "celebrate Tuesdays" and pick the day with cake must have been something he must have really appreciated. I was shocked to hear that Mister teNeues passed away this October. While reading the condolences of other published artists on the teNeues social media page, I figured out that that friendly and curious man had been doing very good things for artists for a long time. He gave them the possibility for the world to see their works. I am happy I have met him without realising who he was. I would have stuttered or spilled coffee over the table, had I known. I hope I get the chance to send Mr teNeues a big thank you through the universe. He helped me realise to change my life for the better. I hope he got a warm McDoodle welcome him when he arrived where he went.

More thanks go to my editor Roman and all the wonderful teNeues people who work there. Roman spotted my work first on my social media page. I work with him most of the time. Working with such a professional team is really wonderful, trusting both our professionalism helps me reach a higher level in making a book I am truly proud of.

TEIN LUCASSON

dank

———

Als ich 19 war, wurde ich Edward von einem gemeinsamen Freund vorgestellt. Er war viel älter als ich, keine Ahnung, warum er so freundlich war. Extravagant und fröhlich, war er zudem ein interessanter Gesprächspartner. Irgendetwas fand er an mir, aber ich hatte keine Ahnung, was. Damals war ich unsicher und zu sensibel. Er nahm mich mit in die Toskana und nach Paris und ermunterte mich, London zu besuchen. Zu jener Zeit wäre ich nie darauf gekommen, was er damit beabsichtigte. Heute weiß ich, dass ich von ihm die Liebe erhielt, die Väter normalerweise ihrem Sohn geben. Ich bin wahrscheinlich der Sohn, den er nie hatte. Er war mir stets ein Freund, Ratgeber und Mentor; all das entsprang immer einem guten Herzen. In den letzten 15 Jahren haben wir den Kontakt verloren. Mein Vater schlug mir vor, Edward noch einmal anzurufen, als mein Privatleben kurz vor dem Zusammenbruch stand. Derzeit ist er mein Agent und Manager. Nie hätte ich gedacht, dass er bei meinem Anruf einfach sagen würde: „Bist du endlich zurück?", als hätte er gewusst, dass ich zurückkomme. Ich möchte Edward dafür danken, dass er mir geholfen hat, mir selbst zu vertrauen. Und dafür, dass er viele andere beim Verwirklichen ihrer Träume und Wünsche unterstützt hat. Deine Geisteshaltung und dein Engagement sollten andere inspirieren, diese Welt zu einem schöneren Ort zu machen. Darum dir ein großes Dankeschön, Edward!

Im Sommer 2019 habe ich *Cat* im Münchner Büro von teNeues fertiggestellt. Ein eleganter Herr, der dort bei der Arbeit war, hatte an jenem Tag Kuchen bestellt. „Es ist immer gut, dienstags zu feiern", sagte ich zu ihm. Erst zwei Tage später erfuhr ich, dass dieser Mann der Verleger Herr teNeues selbst gewesen war. Wir führten ein gutes Gespräch über das Leben und Reisen nach Italien. Der Vorschlag, Dienstage mit Kuchen zu feiern, muss ihm gefallen haben. Herr teNeues starb im Oktober darauf. Als ich die Beileidsbekundungen anderer veröffentlichter Künstler in den Social Media las, realisierte ich, dass dieser nette Mann sehr lang viel Gutes getan hatte. Er ermöglichte vielen Künstlern, dass ihr Talent von der Welt gesehen wurde. Ich bin froh, dass ich ihm begegnet bin, ohne zu wissen, wer er war. Mein Dank gilt darum Herrn teNeues, der mir geholfen hat zu erkennen, wie ich mein Leben zum Besseren verändern kann. Ich hoffe, seiner Seele wurde ein herzliches McDoodle-Willkommen zuteil, wo auch immer sie hingegangen ist.

Zu guter Letzt danke ich meinem Lektor Roman, der meine Arbeit erstmals auf meiner Social-Media-Seite sah. Ich arbeite meistens mit ihm zusammen. Welch eine wunderbare Art, ein schönes Buch zu machen und dabei gleichzeitig weiterzukommen! TeNeues' Professionalität und Engagement sind sehr inspirierend.

TEIN LUCASSON

Quando avevo 19 anni, ho conosciuto Edward attraverso un amico comune. Era molto più grande di me e non sapeva cosa volesse. Era una persona felice, stravagante, interessante nella conversazione. Trovò qualcosa in me, non so cosa. All'epoca ero insicuro e troppo sensibile. Mi portò in Toscana, a Parigi e mi spinse a visitare Londra. Non ho mai immaginato quali fossero le sue intenzioni. Adesso capisco di aver ricevuto da lui l'amore che i padri solitamente riservano ai figli. Forse sono il figlio che non ha mai avuto. Amicizia, guida e supporto vengono sempre da un buon cuore. Negli ultimi quindici anni ci siamo persi. Mio padre mi ha suggerito di cercare nuovamente Edward quando la mia vita personale stava per collassare. Adesso è il mio agente e manager. Non mi sarei mai aspettato la risposta che mi ha dato quando l'ho chiamato, "Sei tornato finalmente?", come se sapesse che lo avrei ricercato. Desidero ringraziare Edward per avermi aiutato ad avere fiducia in me stesso e per aver aiutato molte altre persone a realizzare i propri sogni e desideri. Il tuo spirito e la tua dedizione dovrebbero ispirare molte altre persone a rendere questo mondo un posto più bello. Quindi infinitamente grazie a Edward! Nell'estate 2019 ho terminato il libro Cat nell'ufficio di Monaco di Teneues. Un uomo più anziano che lavorava lì aveva ordinato un dolce quel giorno. Gli ho chiesto il motivo. "È sempre bello festeggiare i martedì" gli ho detto. Ho saputo solo due giorni dopo che si trattava del Sig. Tenneues in persona. Abbiamo fatto una bella chiacchierata sulla vita e sui viaggi in Italia. Non avevo idea che si stesse preparando ad andarsene. Deve aver apprezzato molto il mio suggerimento di festeggiare i martedì con un dolce. Il Sig. Teneues è mancato a ottobre. Mentre leggevo sui social media i messaggi di condoglianze di altri artisti che erano stati pubblicati grazie a lui, ho capito che quell'uomo cordiale aveva fatto grandi cose per molto tempo, dando a tanti artisti la possibilità di far conoscere al mondo il proprio talento. Sono felice di averlo conosciuto senza sapere chi fosse. Ringrazio il Sig. Teneues anche per avermi aiutato a capire come cambiare la mia vita in meglio. Spero che abbia ricevuto un caldo benvenuto da McDoodle, ovunque il suo spirito si sia trasferito.

L'ultimo ringraziamento va al mio editore Roman, il primo a scoprire il mio lavoro nella mia pagina social media. Collaboro principalmente con lui. Che modo fantastico di realizzare un libro meraviglioso e raggiungere nel contempo un nuovo livello! La professionalità e la dedizione di Teneues sono fonte di grande ispirazione.

TEIN LUCASSON

already available

———

CAT

———

89 stories
about:
*cruel
teachers*

———

IN STORES
NOW

www.teneues.com

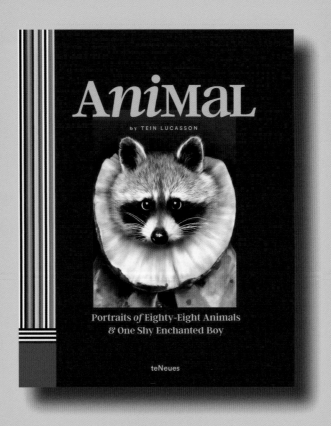

ANIMAL

———

89 stories
about:
*great
variation*

———

EXPECTED
AUTUMN 2020

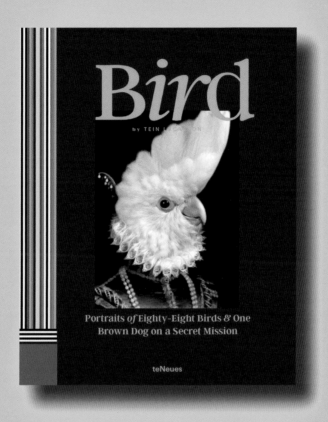

BIRD

—

89 stories
about:
wise
helping

—

EXPECTED
SPRING 2021

imprint

———

© 2020 teNeues Media GmbH & Co. KG, Kempen
© 2020 Tein Lucasson. All rights reserved.

Text and Pictures by Tein Lucasson
Translations by Cillero & de Motta
Copyediting by Judith Kahl, Alison Kimber-bates,
Marlie Geldens and Frank Varney
Design by Tein Lucasson
Editorial coordination by Roman Korn
Production by Sandra Jansen-Dorn
Color separation by Jens Grundei

ISBN 978-3-96171-251-9

Library of Congress Number: 2019956751

Printed in Slovakia / Polygraf Print.

MIX
Papier aus verantwortungsvollen Quellen
Paper from responsible sources
FSC® C023577
FSC
www.fsc.org

Bibliographic information published by the Deutsche
Nationalbibliothek
The Deutsche Nationalbibliothek lists this publication in
the Deutsche Nationalbibliografie; detailed bibliographic
data are available on the Internet at http://dnb.dnb.de.

Published by teNeues Publishing Group

teNeues Media GmbH & Co. KG
Am Selder 37, 47906 Kempen, Germany
Phone: +49-(0)2152-916-0
Fax: +49-(0)2152-916-111
E-mail: books@teneues.com

Press department: Andrea Rehn
Phone: +49-(0)2152-916-202
E-mail: arehn@teneues.com

teNeues Media GmbH & Co. KG
Munich Office
Pilotystrasse 4, 80538 Munich, Germany
Phone: +49-(0)89-904213-200
E-mail: bkellner@teneues.com

teNeues Media GmbH & Co. KG
Berlin Office
Mommsenstrasse 43, 10629 Berlin, Germany
Phone: +49 (0)1520 8 51 10 64
E-mail: ajasper@teneues.com

teNeues Publishing Company
350 7th Avenue, Suite 301, New York, NY 10001, USA
Phone: +1-212-627-9090
Fax: +1-212-627-9511

teNeues Publishing UK Ltd.
12 Ferndene Road, London SE24 0AQ, UK
Phone: +44-(0)20-3542-8997

teNeues France S.A.R.L.
39, rue des Billets, 18250 Henrichemont, France
Phone: +33-(0)2-4826-9348
Fax: +33-(0)1-7072-3482

www.teneues.com

teNeues Publishing Group
Kempen
Berlin
London
Munich
New York
Paris

teNeues